ART DECO TEXTILES

THE FRENCH DESIGNERS

Alain-René Hardy

ART DECO TEXTILES
THE FRENCH DESIGNERS

with 316 illustrations, 304 in color

Thames & Hudson

ACKNOWLEDGMENTS

The author wishes to thank all of those who have given him their help, cooperation, support and encouragement and so made a difficult job much easier. Special thanks must go to:

Lô Angelloz, Mme Eric Bagge, Bertrand Bagge, Mme Bourdier, Marianne Clouzot, Philippe Sebert, photographer, and Delorme & Fraysse in Paris, Patrick Lafaite, Frédéric and Jean-Baptiste Lapierre, Florence Langer-Martel, Anne Van Melle, Marc Van Melle

Pierre Frachon (Bianchini-Férier), Marie-Louise de Clermont-Tonnerre and Marika Genty (Chanel), Patrick Frey (Lauer), Guillaume Verzier, Thierry Bouëxiere (Prelle), Patrick Lelievre and Dominique Fabre (Tassinari & Chatel), Xavier Peticol (expert), M. and Mme Jacques De Vos (Galerie De Vos, Paris)

At UCAD: Véronique Belloir (Musée de la Mode et du Textile) who was an invaluable help on many afternoons; as well as Marie-Hélène Poix (UFAC), Marie-Noël de Gary (Design Collection), Véronique de la Hougue (Wallpaper Department), Sonia Edard and Rachel Brishoual (photo library) and Chantal Bouchon (former librarian)

At the Musée de la Mode et du Costume, Palais Galliera, Paris: Valérie Guillaume, Annie Barbera and Sylvie Roy

At the Musée Historique des Tissus, Lyons: Evelyne Gaudry, Catherine Scalliet-Calba, Odile Blanc, Pierre Verrier

At the Musée de l'Impression sur Etoffes, Mulhouse: Jacqueline Jacqué, Nathalie Peyron, Jean-François Keller

At the Victoria & Albert Museum, London: Valerie Mendes, Sonnet Stanfill, Nick Wise

Anne-Claude Lelieur, Sylvie Pitoiset (Bibliothèque Forney, Paris), Brigitte Lainé (Archives de Paris) and François Calame (D.R.A.C. Picardie)

Lastly, thanks to my publisher, Jean-Luc Langlaude for his faith in this project, and of course to all my family and friends who have coped with my obsession with textiles with patience and humour.

Translated from the French *Tissus Art Déco en France* by Ian Monk and Harriet Mason

First published in the United Kingdom in 2003 by
Thames & Hudson Ltd, 181A High Holborn, London WC1V 7QX

www.thamesandhudson.com

First published in hardcover in the United States of America in 2003 by
Thames & Hudson Inc., 500 Fifth Avenue, New York, New York 10110

thamesandhudsonusa.com

British Library Cataloguing-in-Publication Data
A catalogue record for this book is available from the British Library

Library of Congress Catalog Card Number 2002094854

ISBN 0-500-51117-9

Printed and bound in Italy

CONTENTS

INTRODUCTION

Paintings (by modern artists) have spilled from
their frames on to our clothes and our walls.
RAOUL DUFY

This book provides a complete retrospective of French Art Deco textiles between the two wars, drawn from the fullest of historical sources.[1] The textile production of this period is far richer, more powerful, more vibrant, diverse and varied than many preconceptions and stereotypes would have us believe. The resulting collection can be used both as a work of reference containing many previous unpublished designs, and also as a book to be browsed for pleasure, a store of images that are still fascinating, still eye-catching, and still enthralling in their originality and liveliness. Freed from dusty museum collections, the striking originality and modernity of these fabrics shines through. Their remarkable intensity today stands as proof of the spark of artistic energy that went into their creation.

THE ART DECO MOVEMENT

Dynamism may be one of the most important values of the early twentieth century; a period which, like the Renaissance, felt sure that it had set off on an adventure where everything had to be reinvented, and was full of unfailing enthusiasm for the task ahead. While the growing complexity of social structures, economics and ideologies sometimes makes this phenomenon difficult to perceive, it can nonetheless be seen in the working careers of many decorative artists of the period (Dufy, Delaunay, Marrot) and in the histories of some of the companies that were closely involved in the rebirth of the textile business (Bianchini-Férier, Ducharne, Rodier).

All over the world, the will, the desire, the need to rebuild was paramount: from Soviet totalitarianism, which wanted to create a new type of man, to the Constructivist movement in all of its forms, which forged a radically new way of seeing. The decorative arts were bound up with this dynamic movement, since their close relationship to the fine arts put them directly in the line of key avant-garde movements such as Fauvism and Cubism. As early as 1910, we see in this closed self-regarding world young people rebelling against routine, fighting against the stifling atmosphere of the present in search of fresh ideas from outside, whether it be from another field (the fine arts), another sector (industry), another age (the French Restoration and the July Monarchy), or another country (Germany). These combined influences not only brought about healthy excitement and spectacular transformations, but also created some confusion of roles: architects produced furniture, department stores opened art studios, jewelers moved into the glass industry and painters began to design fashionable fabrics.

This seemingly *sui generis* movement was caused, supported and prolonged by many different factors from the fields of education, science, industy and commerce, which all converged and foreshadowed the dynamism and inventiveness of the decorative arts in the first few decades of the twentieth century. France was far from alone in this; the same causes created the same effects in other Western countries, so that new attitudes manifested themselves across Europe. The year 1912, in which Poiret and the Atelier Martine first introduced Fauvist colour into contemporary interiors, and Louis Süe and Jacques Palyart's Atelier Français caused a revolution in textile production in Lyons, roughly coincides with the rise of the Wiener Werkstätte (Viennese Workshops), first founded in 1903 but producing little before 1910, and with the founding of the Munich Werkbund in Germany (1907), the Omega workshops in England (1912) and the Art Workshop of Prague, whose professed aims and underlying motivations were all comparable to developments in France. Similarly, the foundation of the Union des Artistes Modernes (U.A.M.) by the most progressive French decorative artists in 1930 came as a result of the emergence and expansion of a similarly innovative approach to artistic theory and practice at the Bauhaus in Germany. This overall perspective gives a better understanding of why we are justified in isolating and conceptualizing an 'Art Deco' style that was typical of the period,

and provides us with a better grasp of the distinctive regional variations which the universal form underwent, according to the historical and cultural background of the different countries where it became rooted.[2]

THE ART OF TEXTILES

Let us now focus on the textile production and creation of those thirty years (1910 to 1940) which witnessed the birth, rise and decline of Art Deco style.

In France, the efforts of the two previous generations to promote 'beauty in utility', which could be seen in the work on the Union Centrale des Arts Décoratifs, brought about a number of reforms in the teaching of applied art. In the classes and workshops of provincial art schools, in Paris at the Ecole des Arts Appliqués on the rue Dupetit-Thouars, or the Ecole des Dames on the rue Beethoven, or else at the Arts-Décos, which was then on the rue de L'Ecole de Medécine, or the countless municipal art classes, students (including an increasingly high proportion of women) learnt from their elders (Dufrène, Follot, Jallot, Benedictus). These were often disciples of Art Nouveau but still sufficiently versatile to be able to embrace a modern aesthetic. They taught the rules of design and composition, and the complex science of colour, and also passed on the technical expertise which was vital to textile designers. Once these youngsters had turned professional, their aptitude for innovation provided designs and decorative schemes for an industry that, although still recuperating from the First World War, had realized that its future depended on the work of the next generation of designers, and so opened its doors to them.

Whether they worked in Paris or the provinces, in the studios of decorative artists or pattern designers, in the textile companies of northern France or the silk factories of Lyons, with couturiers or in department stores' art studios, these specialists found a vital source of pictorial inspiration in the 'portfolios' or pattern books which were published specifically for this purpose. These collections of stylized plates of floral patterns, gradually evolving towards strict geometric abstraction, were coloured with gouache, using stencils, which gave their illustrations the freshness of originals. They allowed working artists to copy and adapt, according to their needs or whims, a large number of decorative patterns invented by the most prestigious designers: Benedictus's *Relais*, for example, was advertised as 'Fifteen plates with forty-two decorative patterns'. These professional source books were widely used and created a link between the different centres of artistic activity in France. Emile Séguy's *Primavera* (*c.* 1913) was the first of these pattern books to embrace an Art Deco aesthetic openly, especially in its colours, with its precocious use of the innovations of Fauvism. Many similar books followed, some clearly indicating their practical intent in titles such as *Ideas for Fabrics and Rugs* (Séguy, 1924), and showcasing the talents of Benedictus (*Variations,* 1923, *Relais,* 1930), Camus, Garcelon, Burkhalter and the prolific Gladky, among others. Then, from 1927–28 onward, new completely geometric pattern books appeared that were directly inspired by abstract art, including works by Sonia Delaunay (*Compositions, Couleurs, Idées, c.* 1930), Verneuil (*Kaléidoscope,* 1927) and the painter Georges Valmier (*Album No. 1,* 1930). Like the books by Séguy and Benedictus, these collections were so suited to the field of textile design that the different motifs simply had to be combined in an attractive way (if they were not so already) and they were ready for production.[3]

There were also many scientific and technological advances, such as the creation of new types of chemical dye, the mechanization of the weaving process, the use of artificial fibres such as rayon, and improvements in silk-screen printing. These new developments offered a wealth of new working methods to the new generation and the companies that employed them, from Dufy and Poiret's Petite Usine[4] and the small workshops of Alsace to the huge factories of the North. These ways of working were infinitely richer, more flexible, faster and cheaper; deadlines were reduced, as was the time lag between design and execution, and between orders and deliveries, and this opened the door to

forms of experimentation which would have spelt financial ruin in the past.

The most daring and varied productions were taken up by the world of commerce, which had already begun to change by the eve of the First World War in 1914. Alongside the shopping arcades where decorative artists and pattern designers were selling their new lines exclusively to an elite clientele (Michel Dufet at M.A.M, Süe with the Atelier Français, Chez Francis Jourdain and the Boutique Chareau), major Parisian department stores began to set up their own art studios, following the example of Printemps which opened the Atelier Primavera in September 1912, and these played a key role in popularizing the modern decorative arts, and textiles in particular. Acting as middlemen between manufacturers and a new middle-class clientele, these stores succeeded in carrying off the lion's share of the distribution of mass-produced textiles.

Another important factor was that the fashion business, with its ever-tightening hold on society, had a great demand for novelty and was becoming increasingly interested in the speed at which the textile industry was now able to respond to orders. Fashion is after all dependent on textile production, and this fast turnover allowed it to adapt better to the requirements of each new season's collections. Consequently, the expectations and demands of the industry had a knock-on effect on the field of textile design which, once it had grown accustomed to the fleeting nature of fashion, found itself permanently transformed. Fashion also managed to infiltrate the realm of the decorative arts through annual shows such as the Salon d'Automne and the Salon des Artistes Décorateurs, forcing them for better or worse into a spiral of constant, compulsory renewal.

French public institutions, the state and the local authorities also provided a new method of promoting the decorative arts by at last agreeing to the long-postponed Exposition Internationale des Arts Décoratifs et Industriels Modernes which took place in Paris during the spring and summer of 1925. In the absence of a contingent from Germany, who had been half-heartedly invited to participate, this became a unique opportunity for French craftsmen to promote their excellence worldwide in a field that at the time had strong links with the fashion industry. Textiles could be seen all over the exhibition: not only in the 'Section 13' galleries, on the first floor of the Grand Palais, where around six hundred French textile designers displayed their wares, but also in the many pavilions on the Esplanade des Invalides, where fabrics were ostentatiously on show in the form of countless tapestries, curtains, seat covers, cushions, clothes and fashion accessories. Textiles were everywhere, from the 'French Embassy' pavilion by the Société des Artistes-Décorateurs, to the La Maîtrise stand belonging to the Galeries Lafayette, from Ruhlmann's 'Hôtel du Collectionneur' to the 'Boutique Simultanée', which Sonia Delaunay shared with Jacques Heim on the Pont Alexandre III, or from the Ensembles Mobiliers' Villa Primavera to the Pavillon de Lyon-St-Etienne which was entirely devoted to silk and passementerie; right down to the ornate display cabinet that the young designer Paule Marrot managed to acquire to display her creations.[5]

The stimulative effect of the salons and the specialist press, as well as the 1925 exhibition, on the market for the modern decorative arts was not only intensified by fashion, as we have already seen, but also by means of collaborative and promotional projects, both collective and individual, with cultural and media institutions (for example, Georges Cornille was vice president of UCAD). Just two years after the exhibition which had showcased the textile industry had closed, Henri Clouzot, the curator of the Musée des Arts Décoratifs in Paris (later the Musée Galliera) who was a great supporter of the modern movement, was talked into organizing two successive specialist exhibitions: one in 1927 dedicated to 'The Art of Silk', and thus to the greater glory of Lyons, and a second one devoted to 'Printed Cloth and Wallpaper' in 1928. The artists exhibited their most striking and innovative work and the manufacturers added their promotional dynamism, with the result that these exhibitions had an enormous public impact, as is borne out in the highly detailed and heavily illustrated articles published in decorative arts magazines of the day. These exhibitions allowed the profession to

gauge its vitality and creativity, and allowed a cultivated audience to discover the latest creations, and there were soon to be more of them. In 1934, the Ecole de Tissage in Lyons held a retrospective exhibition of thirty years of its 'Modern Silk Furnishings': then, ten years later, during the Nazi Occupation, the Musée de Marsan held an exhibition on a similar theme ('Lyons Silks from 1800 to the Present'), with the intention of attracting publicity for new designs, which had been overlooked due to the tragic political events.

While the earliest specialist exhibitions were aimed only at a few thousand potential visitors, most of whom were already familiar with modernism, the sixteen million visitors to the 1925 International Exhibition were a whole new audience with no experience of the Art Deco style, although they were not without prejudices of their own. Nevertheless, their eyes were dazzled by the striking harmonies of woven silk and the sparkle of luxurious brocades, and their imaginations were stirred by the huge variety of original designs, ranging from detailed figurative designs inspired by modern life ('On Holiday' by Lorenzi, ill. 82) to avant-garde geometric patterns dominated by circles and squares. When these visitors returned to their own homes, often in the provinces, they suddenly thought them distinctly outdated and in need of modernization. So it was surface decoration, and textiles in particular, that received the biggest boost from the International Exhibition. The new textile styles, many of them shown for the first time, were a resounding success, and the exhibition itself changed public tastes and became the culmination of all the earlier efforts to educate and inform, including professional shows, specialist magazines and the department stores' investments in art studios. With the exception of a small number of very expensive luxury fabrics, textiles were now aimed at a very wide market. A general increase in incomes and a rise in the standard of living meant that the middle classes became ever more avid consumers of interior decorations, fabrics and wallpaper, while technological advances in manufacturing meant that both the production costs and the shop prices of these items grew lower and lower.

DEFINING ART DECO TEXTILES

What is the best way to categorize these fabrics, which captured the imaginations of a clientele that was still caught up in the blandishments of Art Nouveau or, worse still, historicist eclecticism, and won them over to modernism? Even omitting the reprints of older designs which made up the greater part of the textile production of the period, the fabrics illustrated in this book are so hugely varied that it is impossible to single out any morphological traits which would help to provide a clear definition. The fabrics themselves (silk, cotton, rayon), the weaves (damask, lampas, satin), the motifs (floral, historical, geometric), the repeat sizes, the colours and their combinations: none of these factors can be used to define an 'Art Deco textile', either individually or in combination. Because there is no single Art Deco style, but rather a collection of Art Deco styles, then despite the title of this book, there can be no such thing as a single textile form that can be termed Art Deco, either in practical or theoretical terms. This difficulty can only be resolved by taking a chronological approach. Art Deco textiles en masse certainly do exist, but these can only be named and categorized within a historical timeframe, rather than according to the 'salient features' which we would usually use to define a concept.

From the 1910s to the 1940s, the entire textile industry was, like all the decorative arts, in constant evolution. Nothing was fixed, nothing stopped moving. Within this perpetual motion, the only discernible points are clean breaks, which establish clear boundaries. For example, between 1910 and 1915, a rejection of Art Nouveau could be found both in artists' statements of intent and in their experimental works (such as André Mare's 'Maison Cubiste' at the Salon d'Automne in 1912), in new furnishings and of course in fabrics, whose formal syntax, vocabulary and colour evidently came from a new source, with Art Nouveau no longer serving as a reference (see Follot, Süe, Martine and Groult); it is at this point that Art Deco begins to emerge.

Similarly, from 1935 to 1945, the most popular themes, designs and colour palettes had completely broken away from

the geometric motifs and the colour schemes which had so recently been a success for Burkhalter, Bagge, and Henry. A new aesthetic was feeling its way forwards, not even defining itself in terms of a reaction against the old creed of functionalism, but instead spontaneously developing its own values. Art Deco was in its dying throes.

These qualitative breaks, which mark the outer boundaries of this discussion, were in themselves the result of a constant stream of changes caused by a great many scientific, technological, economic and cultural factors. Added to these is, of course, the relentless pursuit of novelty, and the market being constantly beset with new young artists who trampled over what had gone before them and were obliged to raise the stakes higher and higher in order to make an impression. Within this evolving continuum, however, distinct phases can be discerned, although their temporal limits remain hazy and there is often a good deal of overlap between them. These phases include:

1. A **foundation** period, beginning in 1910–12 and continuing beyond the disruption of the First World War, until just before the International Exhibition of 1925.

2. A flourishing phase of **floral Art Deco**, which began at the end of the First World War and grew to become a remarkably homogeneous and distinctive style. This lasted for a good decade before being killed off by the 1929 Crash.

3. Well before that point, **geometric Art Deco**[6] had begun in around 1923–25. Its radical agenda led at first to great success, but it had run its course by the time of the Exposition des Arts et Techniques of 1937. By this time, decorative artists and in particular fashion designers had grown bored with over-stylized designs, which were increasingly criticized for their dryness, and their tastes moved on.

4. Fabrics in a **baroque or neoclassical** style began to appear in around 1933 and became increasingly popular. Straight lines and right angles were replaced with curves, fantasy, lyricism and reverie, signposting an aesthetic which eventually signalled the end of Art Deco.[7]

As this brief chronology shows, it is only possible to discuss Art Deco textiles coherently when their extreme diversity over different periods of time has been taken into account.

DISTINGUISHING FEATURES

There are some specific external traits which can legitimately be seen as characteristic of the textile art of this period. The first striking point is that, as in all the visual arts, the most important, lasting trends that became historically significant were not begun by groups or institutions, but by isolated individuals, with an artistic training and inclinations, whose creative innovations happened to fulfil the unconscious demands of a socially dominant group, often connected to the world of fashion, as is the case for Raoul Dufy and Sonia Delaunay. Their designs were dependant on industry in that they were eventually intended to be mass-produced, but they nevertheless began as hand-made productions, partly because of a lack of financial resources. This meant that a textile designer was often also a manufacturer. In 1912–13, it was Dufy himself who printed the small swatches which had been ordered by Poiret; it was Sonia Delaunay that personally took care of the marketing of her 'simultaneous fabrics', following the production process step by step (engraving of the plates, choice of materials, printing); it was Hélène Henry herself that wove fabric orders from Chareau, Herbst and Dupré-Lafon on her Jacquard loom; and it was Paule Marrot that discovered her vocation by printing fabrics with hand-made linocut boards in her tiny lodgings. This was not merely the result of a wish to avoid the division of labour, but of a desire not to separate design and manufacture, a wish to maintain artistic control over the entire production process, as any visual artist usually would.[8]

Such homespun techniques notwithstanding, industry nonetheless made a major contribution to the Deco style, with key personalities including Charles Bianchini, François Ducharne, Lucien Bouix and the Rodier family. Most of these played an important role as trendsetters, discovering and promoting new ideas and talents. Producers and manufacturers, such as Tassinari-Chatel, Brunet-Meunié, Lauer and Cornille in the field of furnishings, Bianchini-Férier, Lesur, Albert Godde & Bedin and Coudurier, Fructus & Descher[9] in the field of fashion design, and Rodier in both sectors, carried out their role as entrepreneurs with diligence and conviction. They took on all of the financial risks that their activities required, and often became extremely wealthy; for instance, François Ducharne grew rich from his exports to America, and had a superb town house built by Ruhlmann. On the other hand, few of them managed to anticipate the decline of the style they had invested in, and most of their companies went out of business shortly after the Second World War.

Women also played a crucial role in the development of Art Deco textiles. Although the majority of professional pattern designers (Stéphany, Coudyser, Garcelon, Fressinet, Bonfils, Dubost, Camus) were men, as were most of the famous decorative artists that produced textile designs (Dufy, Süe, Mare, Groult, Follot, Dufrène, Bagge), many female designers also made their names in this field and brought a personal and striking originality to their fabrics. Notable among these were some very young women with little artistic training, the most famous of whom were the 'Martines' who worked in Paul Poiret's Atelier Martine. Likewise, Suzanne Fontan, Marianne Clouzot, Colette Gueden, Paule Marrot and Charlotte Perriand also saw their work lauded by the critics before most of them had reached their twentieth birthdays. Among the older generation, Max Vibert, Lina de Andrada, Ketty Raisin and Elise Djo-Bourgeois also achieved undisputed and well-deserved fame.

In fact, surface decoration was often considered a female domain, meaning that male artists, decimated by the war and pressed by fierce competition in the decorative arts, often left this field to them because it was thought to correspond to their 'innate abilities' (and as a consequence, their access to the field of three-dimensional design was often blocked because it was considered to be too complex!). This was an insidious hangover from the traditional confinement of women to the field of needlework – tapestries, lace and embroidery. Nonetheless, it was with embroidered dress designs that Sonia Delaunay, the best-known female artist of this period, first made her name as a fashion designer. Her 'simultaneous fabrics' became the jewel in the crown of innovation, their avant-garde style blasting away everything that had come before them. A few years later, it was once again women, first Hélène Henry, then Paule Marrot, who produced the innovative textiles that would lead the next phase in fabric evolution.

Beyond the most obvious external characteristics, the contradictory nature of many intrinsic qualities of Art Deco tends to defy analysis. With its incessant appetite for new forms, colours and textures, the work of this generation of artists leaves the senses reeling: from the sumptuous sophistication of lampas to the rustic simplicity of handweaving, from the brilliance of striking colour combinations to the subtle sobriety of grey or brown monochromes, from the endless variety of naturalistic motifs to the austere rigour of geometric designs. This chaotic profusion drew its legitimacy from claims for creative freedom which pushed artists into making the most of their spontaneous ideas and forced the period to accept the polymorphous diversity of its artistic output. In this way, Art Deco fabrics prefigure the idiosyncratic nature of modern art that was later established by the abstract movements of the 1950s and 1960s. In the sparkling confusion of its wildest years, the Art Deco aesthetic was remarkable for its blatant freedom of representation, through which the old rigidly ordered foundations (even if they were governed by Art Nouveau) gave way to a freer, more expressive design vocabulary, which produced a proliferation of allusive, organic, geometric, even surrealist forms, which found its justification in the imagination of its inventors and the precarious yet skilled balancing act of their artistic expertise.

Though a combination of practical, social and aesthetic factors, dynamic developments in the field of textiles brought art into the street. In salons, offices and shops, in the cities and on the cinema screen, on the walls of town houses and in the curtains of suburban homes, in the dresses designed by Chanel, Vionnet or Schiaparelli and those worn by the shop girls, in the carriages of the Orient Express or the cabins of Farman aeroplanes, a totally new variety of patterns and shapes could now be seen. Public taste had been radically altered, at least until the time came when familiarity would once more demand the creation of something new.

1. The sources used in this work must be treated with critical caution, given their limited reliability. Before the age of modern-day museums, very few institutions were discerning and farsighted enough to consider contemporary fabric production to be worth collecting and preserving for posterity. Those that did were often professional bodies such as the Lyons Chamber of Commerce and the Société Industrielle, Mulhouse, and their collections were often guided by ad hoc criteria that generally reflect their primarily utilitarian aims. Collections were often routine and grew through gifts and legacies rather than because of any logical acquisitions policy. Because of this, modern researchers are confronted by patchy collections, whose guiding principles have become arguable or obsolete, and in which chance has played a large part, leading to unfortunate oversights (for instance, the swatches kept at Mulhouse's Musée de l'Impression are dated but do not bear the names of their designers or manufacturers). Often the authoritativeness of a collection is undermined by extraordinary omissions. For instance, none of the three largest collections of French fabrics of this period contain any samples of the work of Rodier, even though the firm was one of the greatest innovators of the 1920s. Similarly, Eric Bagge, an outstanding Art Deco designer, is represented in the Mulhouse museum by only two small swatches, and even these are uncredited. It is therefore easy to understand why the large donations of patterns, samples and swatches given by Sonia Delaunay in 1966 to the Musée des Arts Décoratifs, Paris, and the Musées de l'Impression sur Etoffes, Mulhouse, have given her pride of place while important artists such as Stéphany, Bagge, Séguy, Rodier and the Atelier Primavera have had no such donations or purchases made of their work and so do not appear in the collections that have been consulted. Although this book is intended to be as complete as possible, those artists are for this reason unfortunately under-represented.

2. This dialectic was illustrated perfectly by the exhibition 'Art Deco en Europe', at the Palais de Beaux-Arts in Brussels (March–May 1989), which took an intelligent approach to such thorny questions as definitions and time frames.

3. Because of their intended practical purpose, several sample pages from these pattern books have been included in this collection.

4. This so-called 'usine' on the boulevard de Clichy was only a 'factory' in joking terms, since it never employed more than three people, including Dufy himself!

5. Some twenty of the fabrics reproduced in this book were exhibited at the 1925 exhibition, mainly in the Pavilions; these are indicated in the list of illustrations (p. 236).

6. The floral/geometric division has been borrowed from Siegfried Wichmann (*Jugendstil Art Nouveau: Floral and Functional Forms*, Boston, 1984) who demonstrated its validity and relevance to Austro-German Art Nouveau; it can also be applied to Art Deco in general.

7. These four chronological divisions of textile design form the framework for the illustrated sections of this book; the characteristics of each are discussed at the beginning of each chapter.

8. The personal, handcrafted qualities of French avant-garde textile innovations could also be seen elsewhere in Europe in this period; for example, in the work of Guido Ravasi or the Futurists, in particular Balla and Depero, in Italy, or the work of Anni Albers and Gunta Stölzl in the Bauhaus weaving workshop.

9. The latter were all nationally and even internationally important silk producers, based in Lyons, with offices on the rue de la Paix or the avenue de l'Opéra in Paris, and sometimes with branches in New York. The size of their export market shows that Art Deco style had found widespread popularity with a rich foreign clientele, which could only be maintained by providing a constant stream of new creations. This in turn had a stimulating effect on the domestic market in France.

A NEW BEGINNING (1910–23)

As a decorative artform, textiles are able to adapt to new trends rapidly and easily, and so experienced an increasing number of new developments from the 1910s onwards. Firstly, attention should be drawn to the early work of Boisgegrain, the founder of the Toiles de Rambouillet, who were the first firm to produce updated versions of traditional Toile de Jouy prints, inspired by an 1907 exhibition of printed fabrics at the Palais Galliera in Paris. The designs of Gustave Jaulmes and Victor Menu, like those of Boisgegrain himself, stayed confined to a rather conventional style with a heavy classical influence, whose lack of sparkle is ill served by dull, lifeless colour prints that have lost much of their appeal.

The real renaissance began shortly afterwards, under the influence of those who became known as the *coloristes*, because of their break with Art Nouveau and their close association with Fauvism. Many of the *coloriste* designers were also painters, and they were enthusiastically inspired by the brilliant use of colour in Bakst's sets for the Ballets Russes, which had been a great pre-war success. So it was farewell to anaemic mauves and reds, dreary sea-greens and insipid washed-out blues, and especially to the palette of muted pastels, lacking in contrast and accent. All of these were pushed aside in favour of the brilliance of ruby, orange, royal blue, buttercup yellow and all of the colours of the Mediterranean, straight from the brushes of Matisse, Derain and Braque (see Séguy, *Primavera*, ills 11–12).

This movement rapidly spread among young French designers and made its great breakthrough between 1911 and 1912. Colour was not, of course, the only aspect which altered fundamentally. Form too was re-evaluated and moved towards more sophisticated, even stylized designs (Iribe, ill. 4; Süe, ill. 6) or was adapted into supple interpretations that were either authentically or deliberately naïve in style (Atelier Martine, ills 20–22, 34–36; Dufy, ills 3, 25–28).

These innovations, which in retrospect appear experimental or even deliberately provocative, were made possible by manufacturing processes which involved a high level of traditional craftsmanship, allowing textiles to be produced in small quantities. For example, Follot, Groult and Mare (ills 2, 9, 13, 17) chose silk for their rich lampas designs, since its incomparable lustre alone could magnify their daring use of colour. The firms of Lamy & Gautier and Tassinari-Chatel still had handlooms, whose set-up costs could be paid for by modest orders. Other young designers turned eagerly to printing, since the engraving of a few pear-wood blocks could produce a wide variety of effects; there were colour variations and trial runs, limited editions, and textiles made to order. The entire output of the Atelier Martine was of this kind, as was the range known as 'Toiles de Tournon', made by Bianchini-Férier from designs by Raoul Dufy based on his woodcut illustrations for Apollinaire's *Bestiaire* (ills 25–28, 41). The same is also true of the so-called 'patriotic' fabrics (ills 37–38), occasional populatist productions made after 1916 and intended to raise civilian morale by praising the arms and victories of the Allied forces.

When war broke out, this creative exuberance was put on hold for over four years. However, from 1919, the whole movement took off again with a remarkable energy, proving that, as far as designers were concerned, the tragic events of history had merely forced a long break in their experiments and work. So there was no discontinuity in style between 1914 and 1919, as we can see in the work of the Atelier Martine and Louis Süe, who first worked with Palyart (ills 6–7), and then later with André Mare at the Compagnie des Arts Français (ills 16, 19).

The years immediately before and after the war, from 1910 to 1920, were the start of a period of intense creativity for Art Deco. With their gleeful bunches of palms and peonies and their brilliant firework display of uninhibited colours, the pioneers laid down the outlines of the new style of textiles that was to burgeon over the next decade.

1. Georges BARBIER. 'The Sparrow Girl', *Gazette du Bon Ton*. 1912. ▶

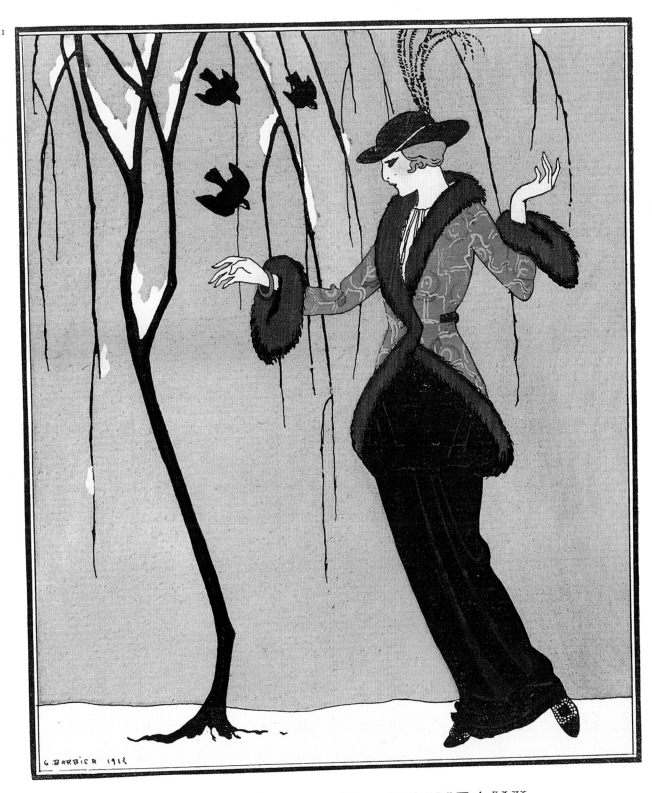

LA BELLE AUX MOINEAUX

Robe de Visite de Paquin

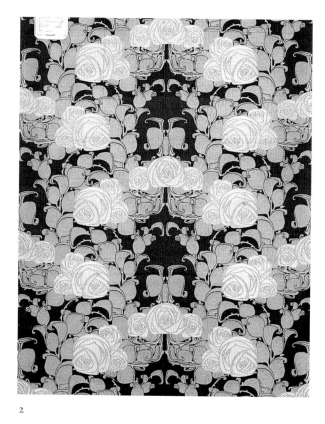

2

4

3

2. Paul FOLLOT. Roses. 1911.

3. Raoul DUFY. Roses and leaves with elephants. 1912.

4. Paul IRIBE. Floral all-over. 1911.

5. Georges BARBIER. 'White crêpe-de-Chine dress', *Journal des Dames et des Modes*, pl. 39. 1912.

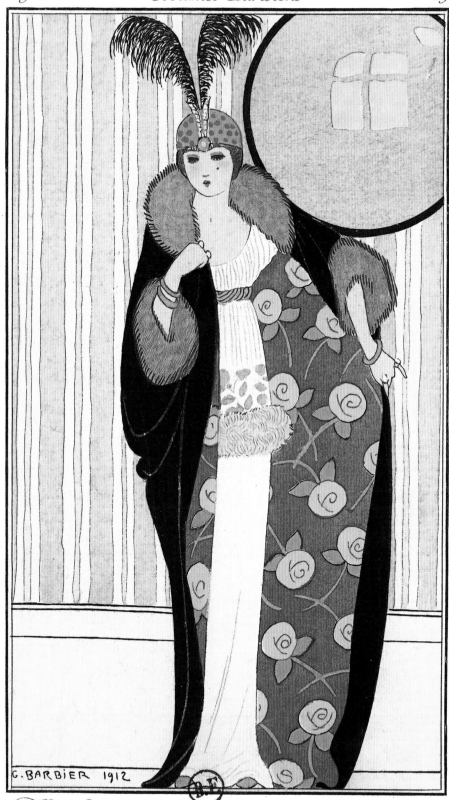

Robe de crêpe de Chine blanc garnie de renard
Manteau de loutre et skunks

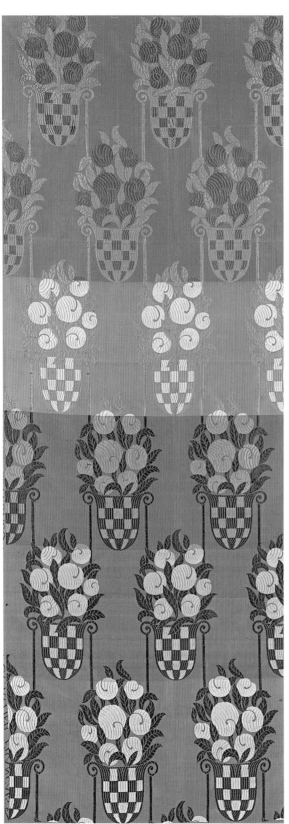

6. Louis SÜE and Jacques
PALYART. Colourways
for a lampas. 1913.

7. Louis SÜE and Jacques
PALYART. Display stand at
the Salon d'Automne, 1913.

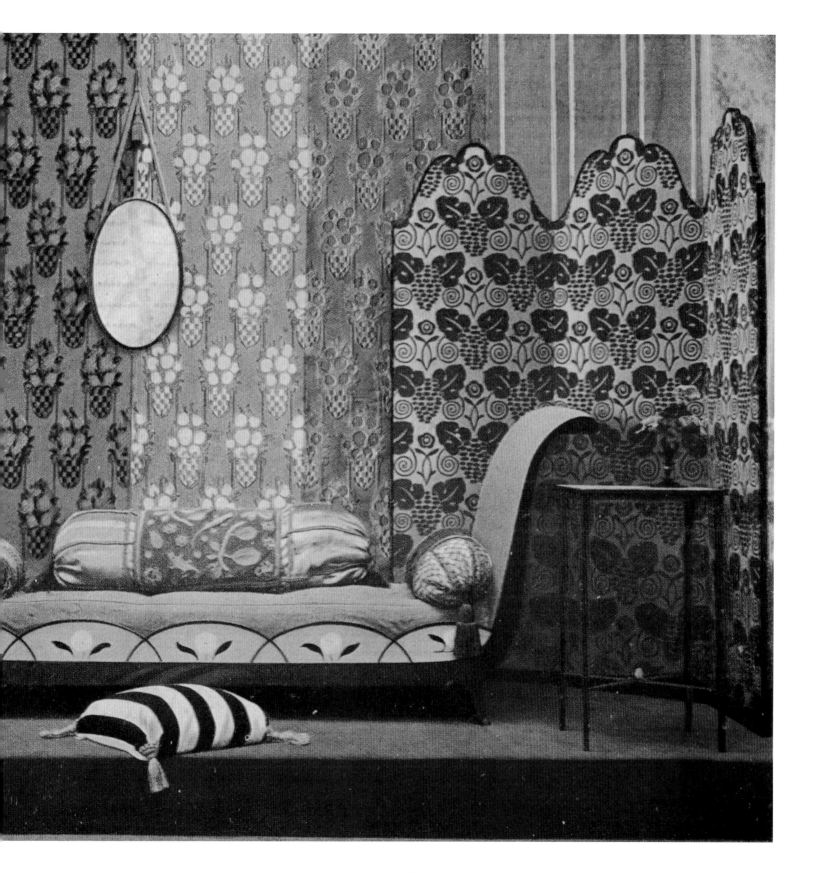

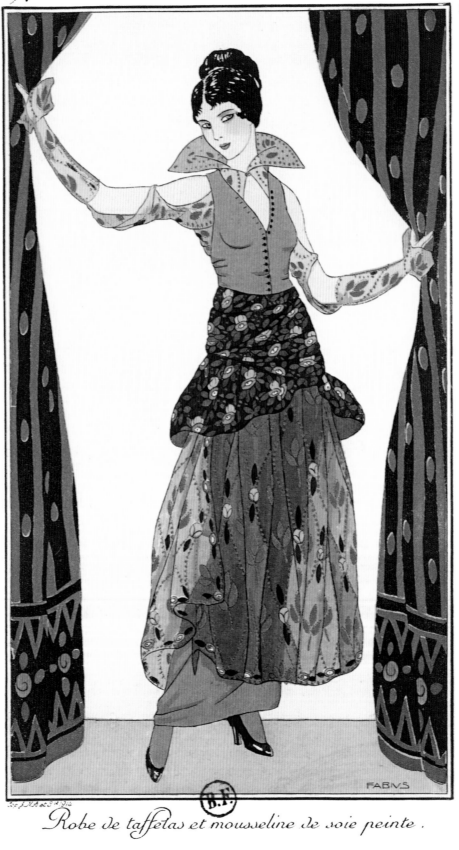

Robe de taffetas et mousseline de soie peinte.

8. FABIUS.
'Painted silk chiffon
and taffeta dress'.
*Journal des Dames
et des Modes,*
pl. 184. 1914.

9

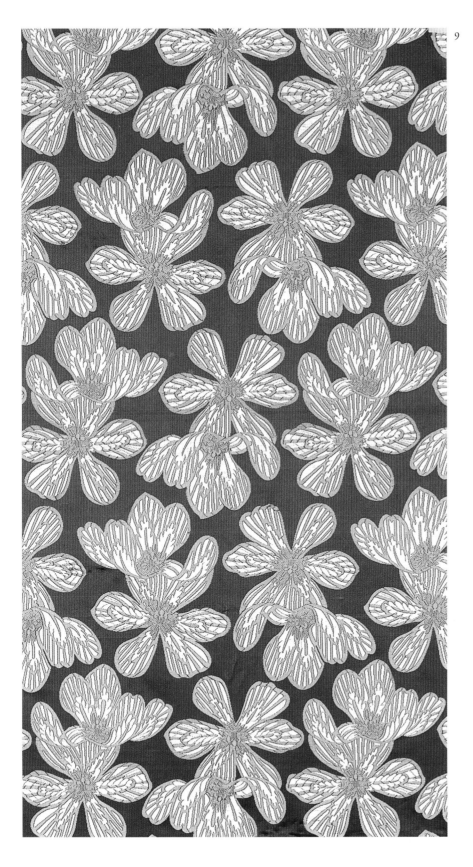

10

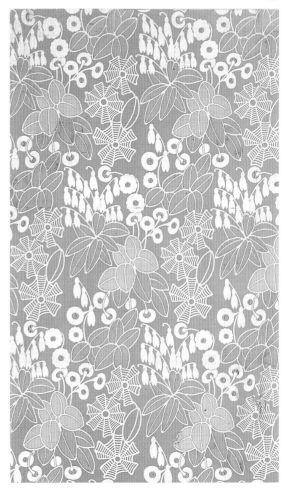

9. André GROULT. Floral motif. 1913.

10. Jacques KLEIN. Floral and vegetal motif. 1920.

11. Emile-Alain SEGUY. *Primavera,* pl. 5. 1913.

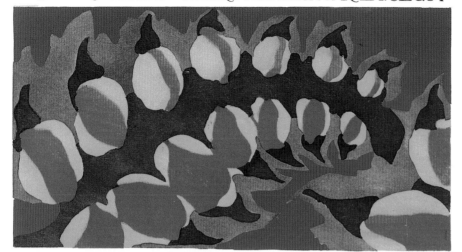

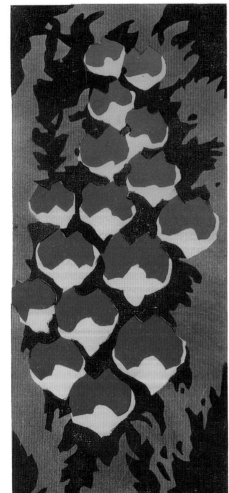

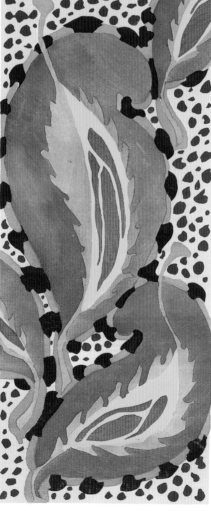

11

5

A.CALAVAS
ÉDITEUR PARIS

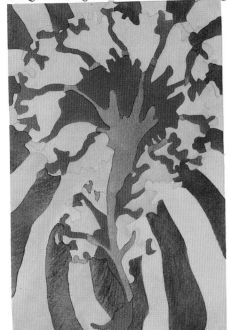

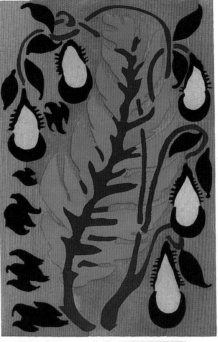

PRIMAVERA·DESSINS & COLORIS NOUVEAUX PAR E.A. SEGUY

12

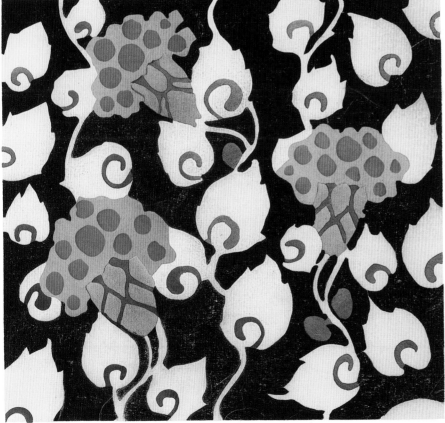

17

A.CALAVAS
ÉDITEUR PARIS

12. Emile-Alain SEGUY. *Primavera,* pl. 17. 1913.

Overleaf:

13. André MARE. Stylized floral motif.
1912–13.

14. Paul VERA. 'Deities of the Countryside'. 1919–20.

14

15

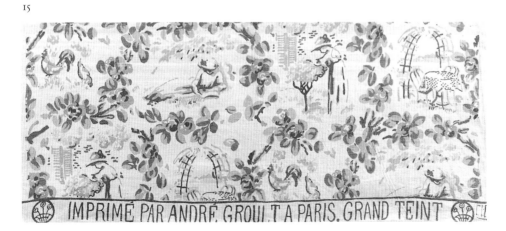

IMPRIMÉ PAR ANDRÉ. GROUI.T A PARIS. GRAND TEINT

15. Albert ANDRÉ. Country scene with figures. 1911.

16. Louis SÜE and André MARE. ►
Bunches of peonies. 1919–20.

26

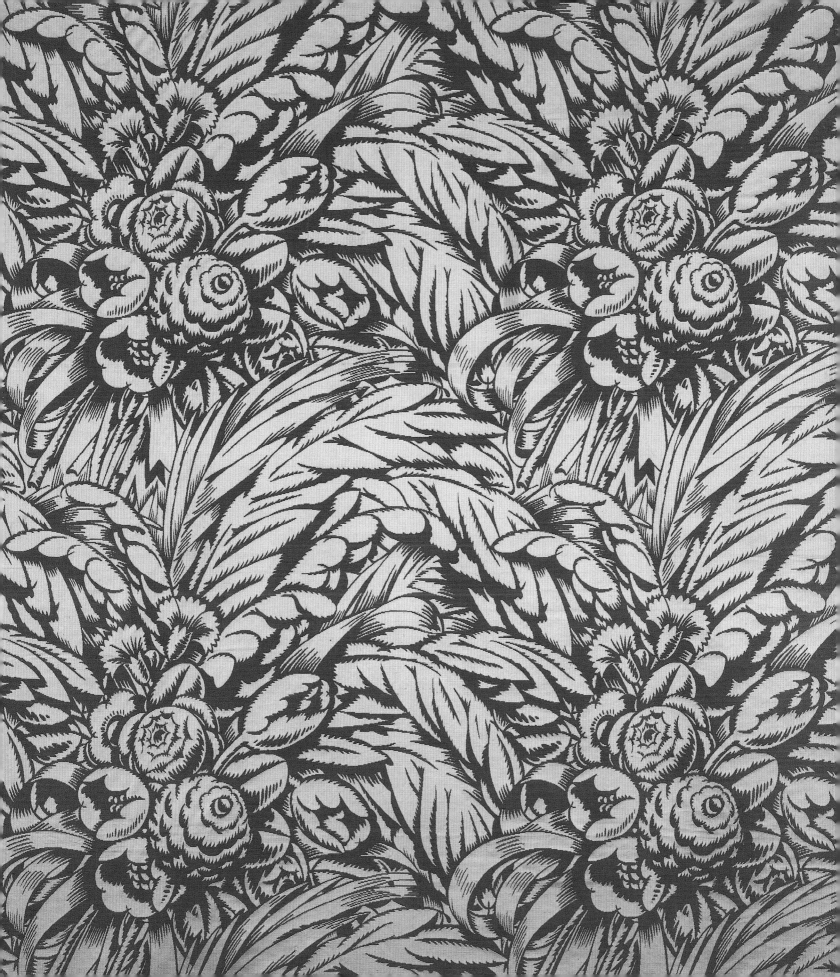

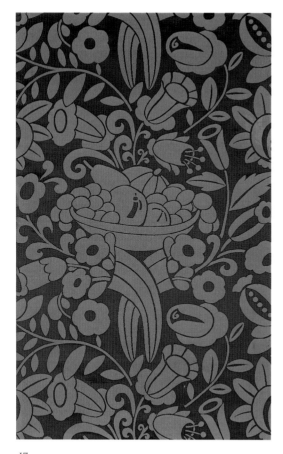

17

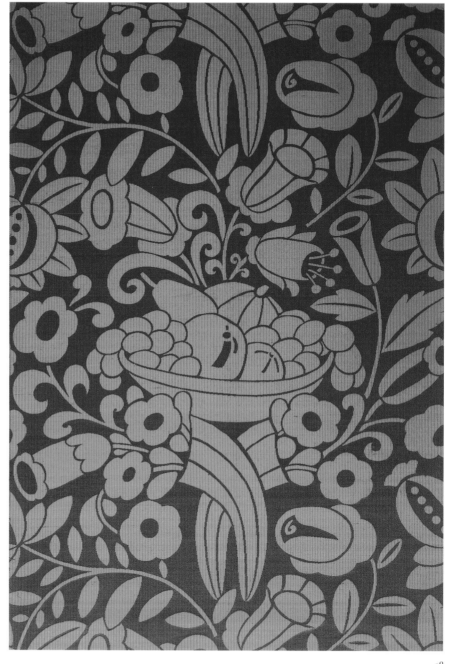

18

17, 18. André MARE. 'Abundance'. 1913 and 1919.

19. Louis SÜE and André MARE. 'Corpus Christi'. 1919–20. ▶

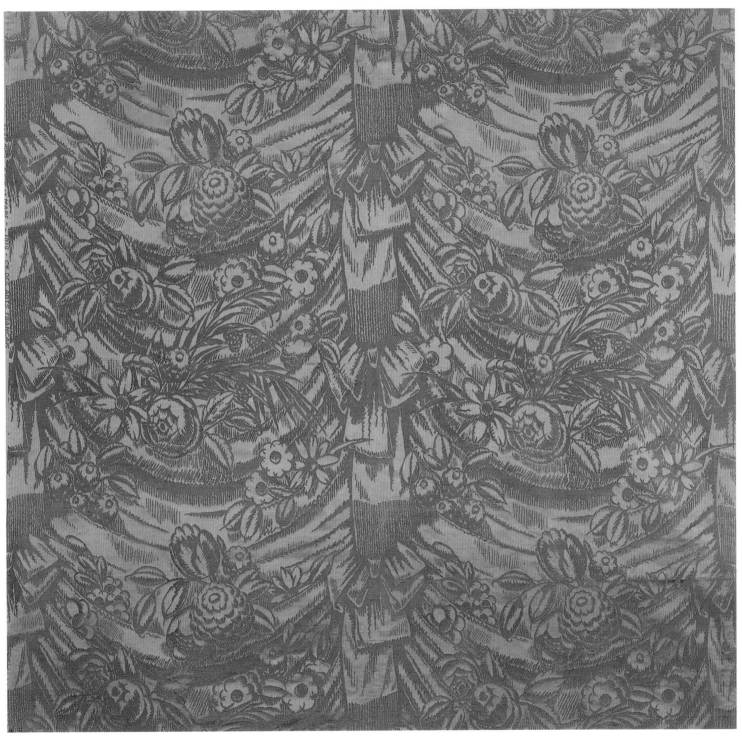

19

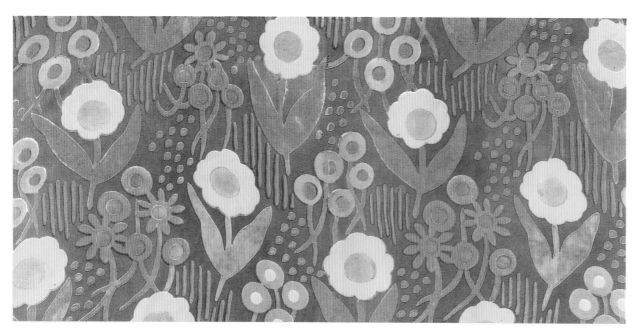

20

20, 21. Atelier MARTINE. Small floral motif. 1918–19. 22. Atelier MARTINE. Small floral motif. 1918–19. ►

21

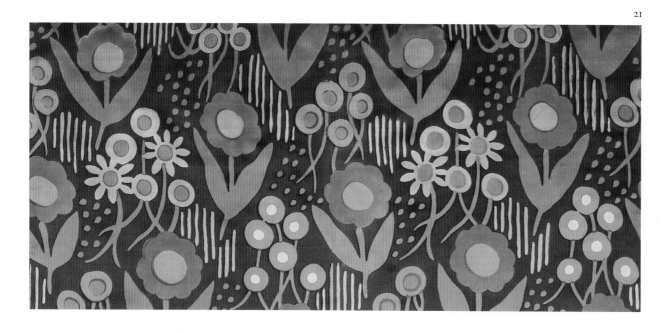

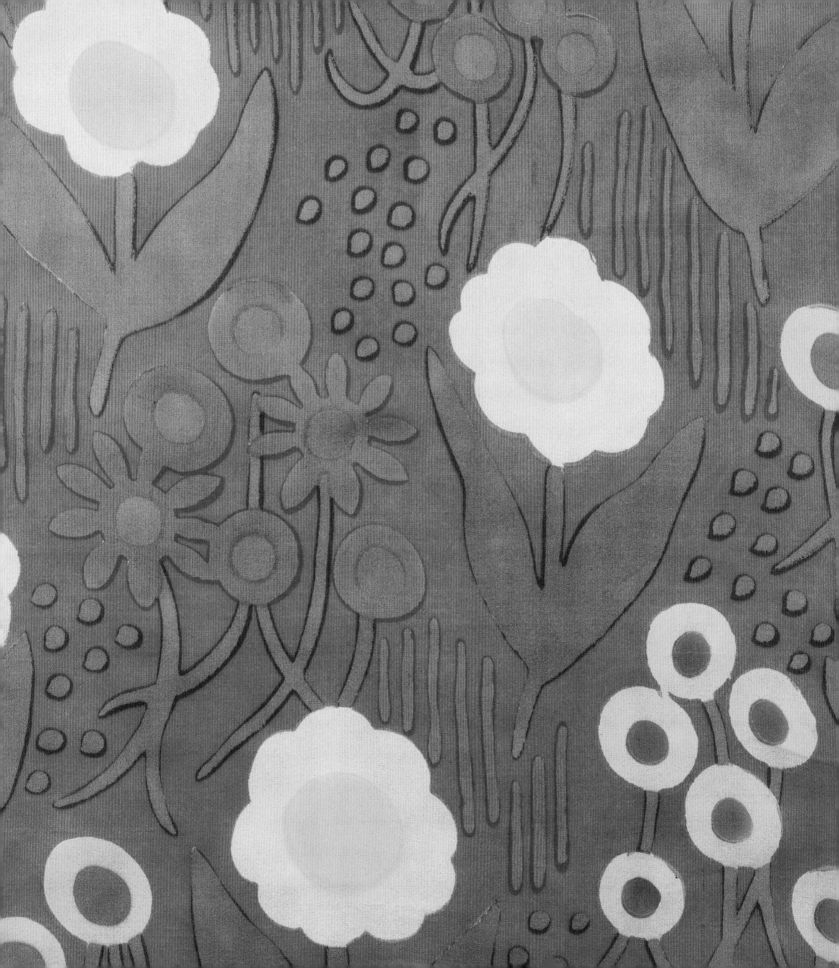

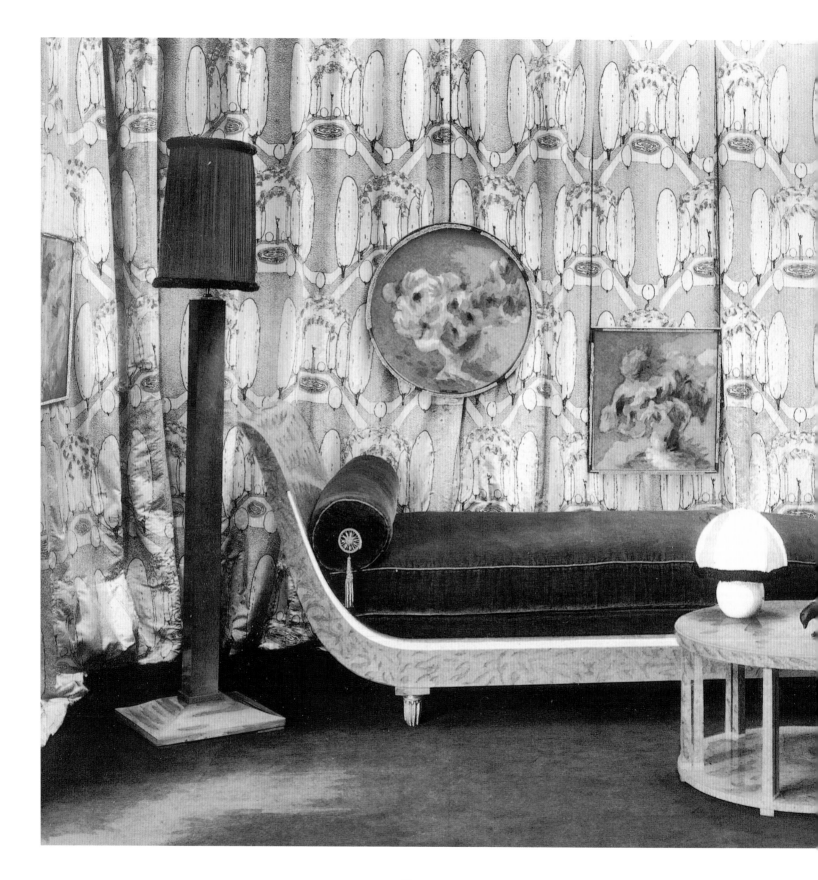

23. Jacques-Emile RUHLMANN. Young lady's bedroom decorated with 'The Park'. *Les Arts de la Maison.* 1924.

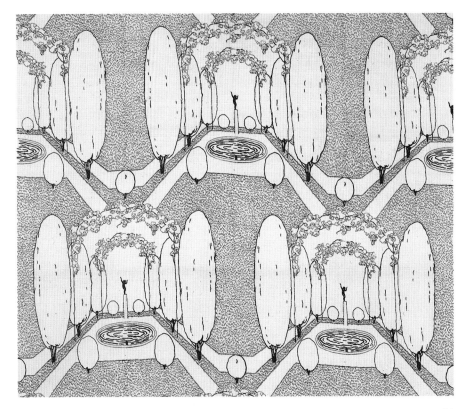

24

24. Jacques-Emile RUHLMANN. 'The Park'. 1920.

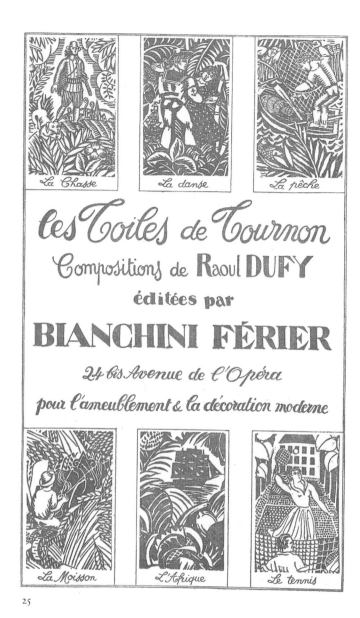

25

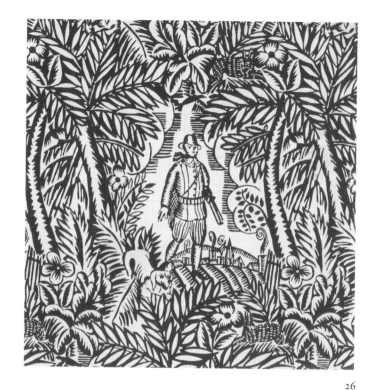

26

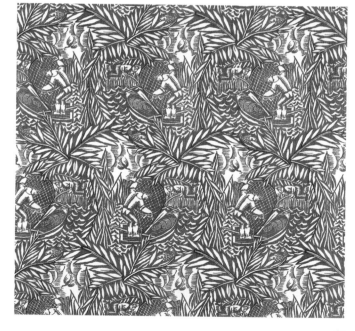

27

25. Raoul DUFY. Advertisement for the 'Toiles de Tournon' range. 1925.

26. Raoul DUFY. 'Hunting'. 1918.

27. Raoul DUFY. 'Fishing'. 1918.

28. Raoul DUFY. 'Tennis'. 1919–20. ▶

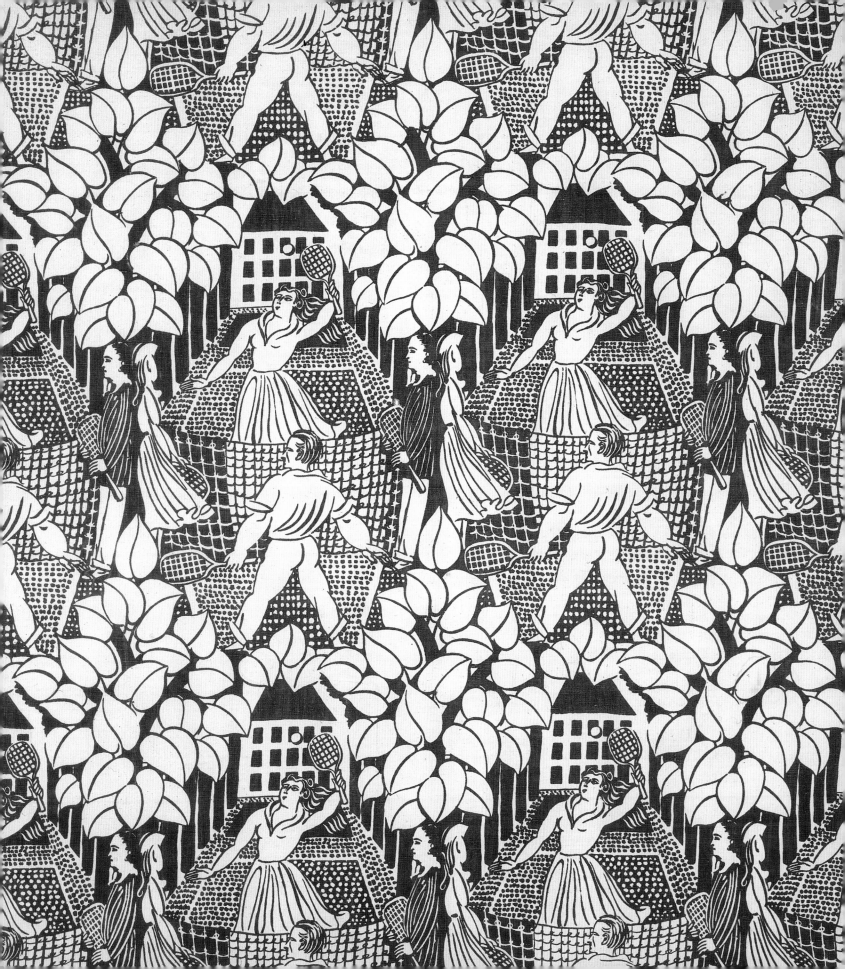

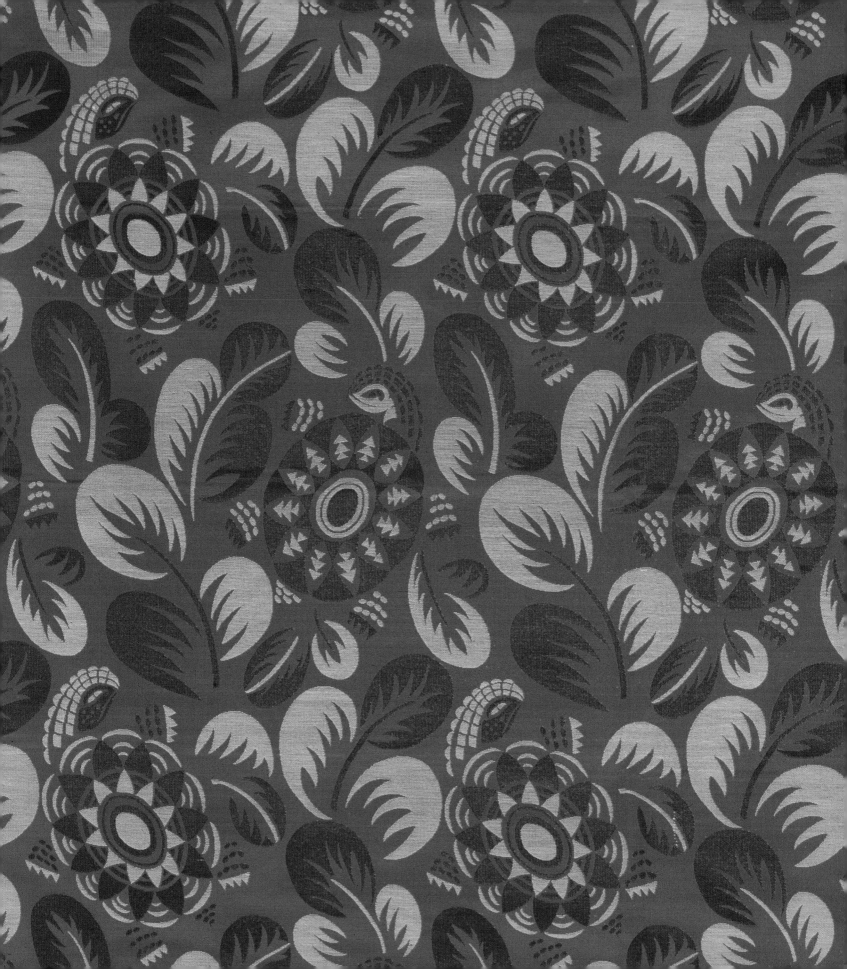

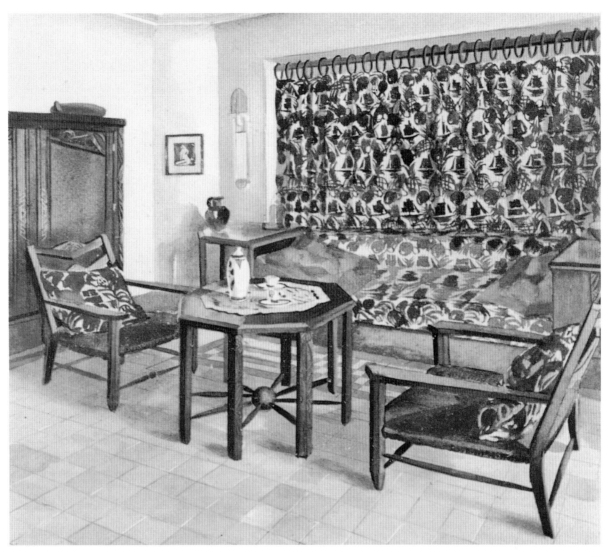

30

◄ 29. Raoul DUFY. Tortoise motif. 1920. 30. GOYENECHE. Decorative scheme featuring 'Africa' by Raoul Dufy. 1925.

LA GAIETÉ DES INTÉRIEURS

C'est au dix-huitième siècle que nous sommes redevables de la gaieté des intérieurs. On transforma alors les pompeux appartements du règne de Louis XIV ; les meubles plus petits, plus commodes surtout, remplacèrent les solennels fauteuils carrés ; les chaises légères et les fauteuils en cabriolet se groupèrent heureusement suivant les caprices de la conversation, et les murs s'égayèrent de ces délicieuses tentures en toiles des Indes : avec elles toute une floraison fantastique envahit la maison.

Pour la femme d'aujourd'hui qui eût aimé vivre au temps de ces joyeuses " turqueries ", tentures et meubles se revêteront de ces dessins naïfs, de ces fantaisies vieillottes qui charmèrent les contemporaines de Jean-Jacques ; c'est pour elle que PRIMAVERA composa ces toiles charmantes : ne dénotent-elles pas, chez celle qui en pare sa demeure, une âme délicate, un esprit d'artiste qui sait apprécier le prix d'un détail, la recherche d'un effet ?

Et comme elles méritent bien leur vieux nom de " Toiles d'Été ", ces modernes merveilles qui apportent au cœur de l'hiver la gaieté et le rayonnement du soleil !

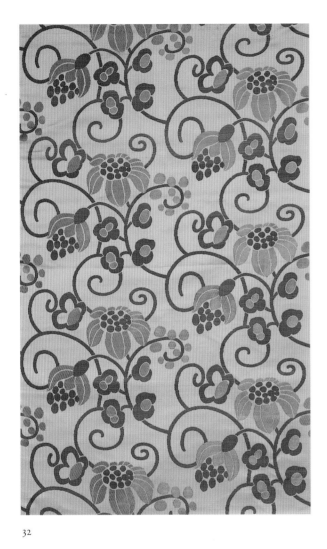

32

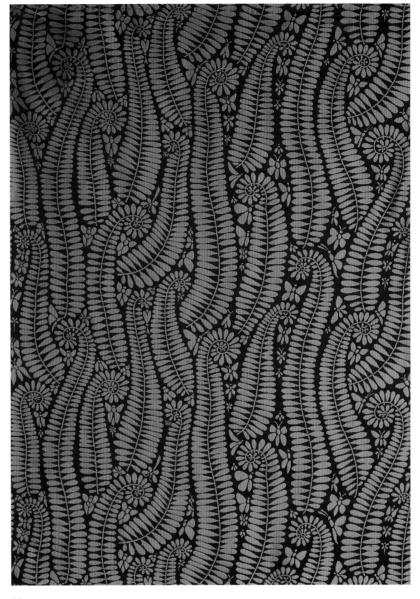

33

32. Fernand NATHAN. Tendril motif. 1914.

33. André GROULT. Fern motif. 1913.

◄ 31. Atelier PRIMAVERA. 'Advice from a Lady of Fashion'. 1920–21.

◄ 34. Atelier MARTINE. 'Wallflowers'.
Printed velvet. 1923.

35. Atelier MARTINE. Anemones.
c. 1920.

36. Atelier MARTINE. Nasturtium, tulip
and cornflower motif. 1920–25.

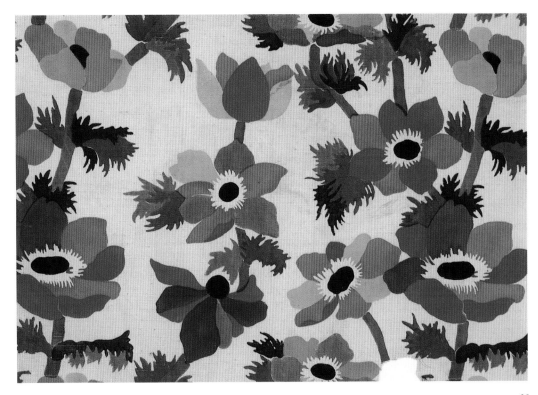

35

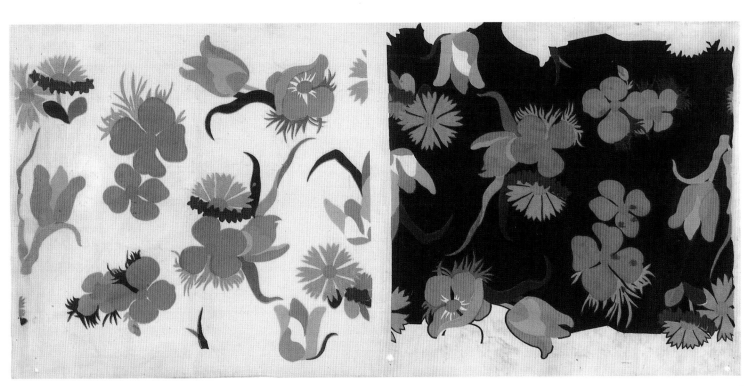

36

37

37, 38. ANONYMOUS. Patriotic motifs. 1917–18.

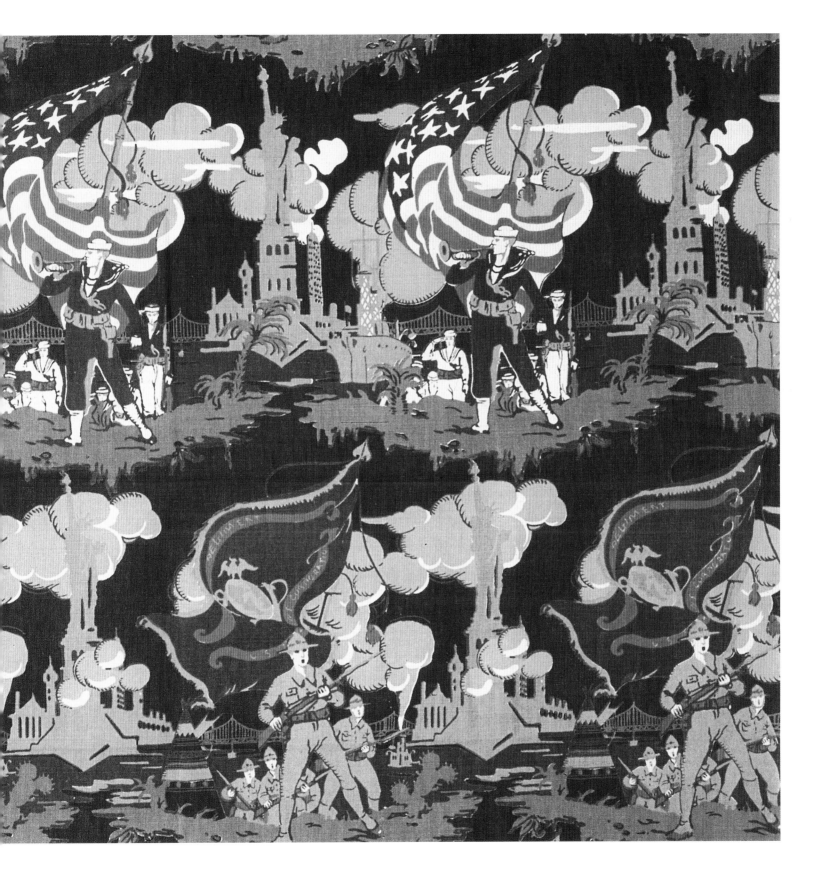

39. ANONYMOUS. Floral pattern. 1920.

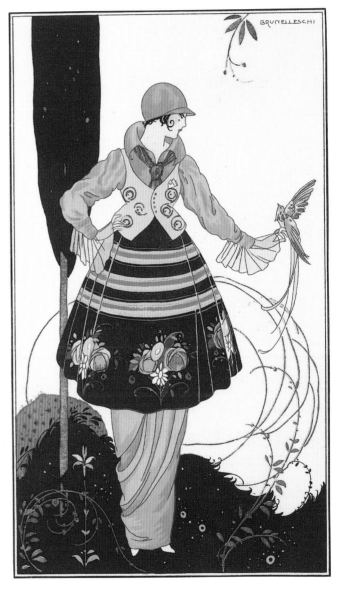

40

40. Umberto BRUNELLESCHI. Coloured woodcut,
Journal des Dames et des Modes. 1914.

FLORAL ART DECO (1919–31)

Supported by the need for reconstruction, the furnishing industry resumed business quickly after the Armistice had been signed; the commissions of the Comité Technique des Arts Appliqués had been actively preparing for this moment from 1916 on. Decorative artists immediately started work as before and, for the first post-war Salon d'Automne in November 1919, slumped back almost to a man into the gilded rut of luxury productions, which did not sit easily with the preoccupations of a France that lay in ruins.

Nevertheless, these luxurious creations did function as a stimulus to textile production, supporting more basic needs, and a rapid increase in productivity meant that fabric prices began to fall, allowing more democratic demands to be satisfied. At all levels of quality, patterns and colours spontaneously picked up the reins of pre-war audacity. The new style was now not only accepted and widespread, but it also had established itself throughout the profession, among pattern designers, art teachers, silk mills and department stores.

The stylized floral approach was dominant for several years as the formal stereotype of surface decoration and fabrics. Hand in hand, designers and manufacturers now worshipped at the altar of this new god. While floral patterns have always been an important part of textile decoration, the stylized flowers that followed on from the 'Iribe rose' and Groult's floral basketwork patterns now began to exhibit quite a different formal approach to fabric design, one that can be seen as characteristic of this decade. A rapid overview shows that, not counting copies of old patterns, floral designs accounted for over half the fabric designs of this period, whatever their origin, material, technique, purpose or price. It should also be noted that this stylization of flowers which, in about 1920, could be seen as a simple reduction of complex forms for decorative purposes, relying essentially on curved lines (Atelier Martine, Süe, Mare, Palyart) and Dufy's arabesques, gradually became more and more geometric, employing new ornamental forms in which straight lines became increasingly dominant (Benedictus, D.I.M., Martin). This new language not only triumphed, it even became overpowering, so

that the 1925 exhibition of decorative arts not only proclaimed the supremacy of floral Art Deco but also showed that time had come for change.

While the influence of the young generation of *coloristes* was a key factor in the exuberant expansion of this new decorative style (Süe, Mare and Groult, ills 9, 13, 17–18), some of the older decorative artists, coming from Art Nouveau, also played an important role. The decorative pattern books of Séguy (ills 11, 12, 128, 268, 285) and Benedictus (ills 46–55, 213, 248) laid out the archetypes of this style and their designs set its rules.

The most prolific contributor to this field was Raoul Dufy, who in ten years supplied over a thousand patterns to his publisher in Lyons (ills 41–44, 57, 60–63, 120, 121), bearing witness not just to the teeming variety of his talents, but also to his desire to 'give the art of textile decoration the valuable gift of [his] love of pure colour and arabesques.' (Dufy, 'Les tissus imprimés', in *Amour de l'Art*, May 1920). Others joining this school showed both skill and originality, such as Robert Bonfils (ills 58, 59, 64–67, 215, 258), Michel Dubost, creative director of Ducharne (ills 68, 85, 89, 90), and Yvonne Clarinval, whose 'Four Elements' range (ills 71–73) combined an inspired vision with an extraordinarily accomplished stylistic skill. Many others took up the design vocabulary of this new language, often for commercial reasons, until it began to grow hackneyed. They sometimes did so with great success, as is the case of some of the floral prints by anonymous designers in the Mulhouse museum; the wealth of imagination, the sharpness of the patterns and the power of the colours have such visual impact that the cloth has a dreamlike quality (ills 80, 152, 188).

Fortunately, the proliferation of stylized flowers drawn with ruler and compass was tempered by a fashion, promoted by Dufy, for genre scenes reminiscent of the traditional Toiles de Jouy (ills 28, 43, 44), which depicted images of contemporary life. These are often charming, but their mannered elegance now seems outdated (Lorenzi, ills 82, 83; Mahias, ill. 81). A clearly identifiable and complex vein of exoticism was also mined in a similar way, creating some very unusual idyllic scenes in designs

including Charles Dufresne's 'Voyage' (ill. 76), and Beaumont's 'Garden of Eden' (ill. 87). This thread of inspiration, which bore little resemblance to the reality portrayed in the Colonial Exhibitions of the day (Marseilles, 1922; Paris, 1931), was also happily combined with the floral trend to produce luxurious tropical jungles (Bonfils, 'Africa', 'The Oasis', ills 58, 67; Benedictus, ill. 53), filled with elephants, parrots or monkeys, often chosen for their allegorical meaning as well as their graphic interest (ills 59, 79, 86, 97, 99).

Great designers not only turned their talents to creating fabrics for mass production (Maurice Dufrene, ill. 106), but also for wealthy customers, sometimes sowing the seeds of future innovations, as with Ruhlmann's ribbon brocade (ill. 93). While most geometric designs still remained anchored in real life (stylized flowers, leaves, flames or cushions), some designs by painters (Marcoussis, 1923, ill. 112) and fashion designers (Coudurier, Fructus & Descher, 1923, ill. 143; Marguerite Pangon's batiks, 1924, ills 107–109) were based solely around colour combinations and geometric shapes. In the years that followed, these exceptions were to become the rule.

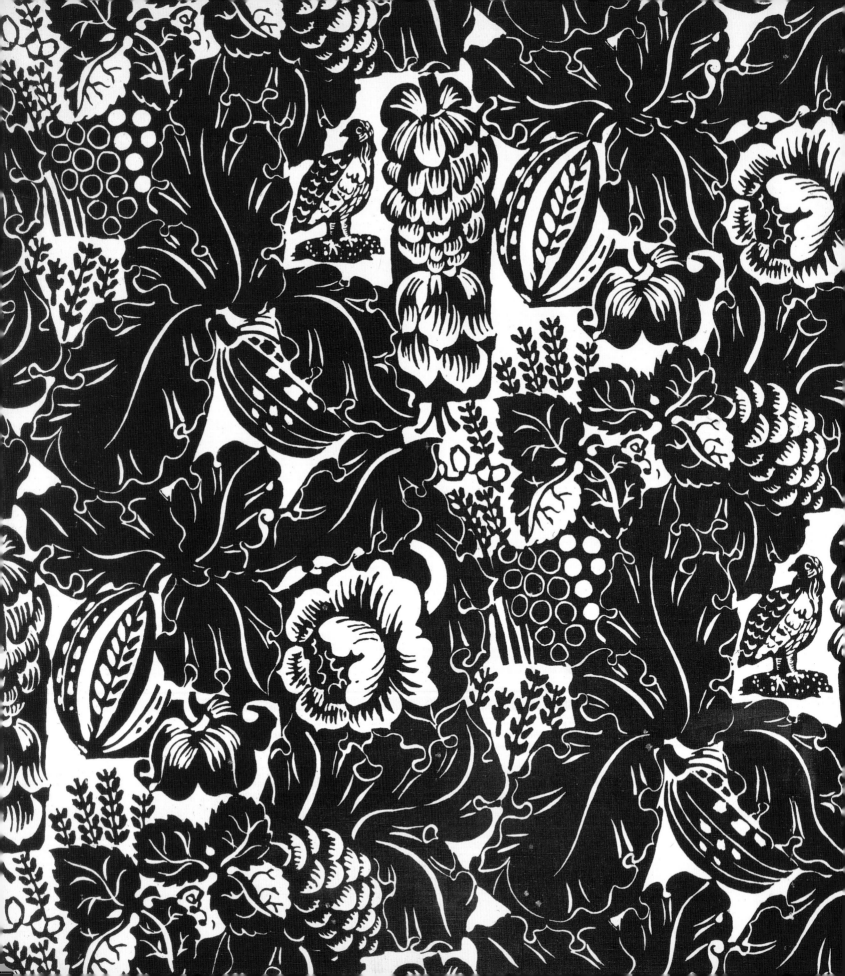

42

42. Advertisement for Bianchini-Férier fabrics,
Mobilier et Décoration, 1929.

◄ 41. Raoul DUFY. Indienne with partridge motif. 1926–28.

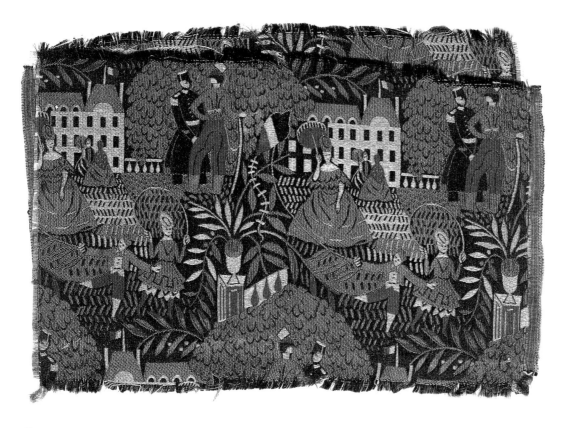

43

44. Raoul DUFY. 'Bagatelle' or 'Le Pré Catelan'. 1919. ▶

43. Raoul DUFY. 'Les Tuileries'. 1920–21.

45. Paul POIRET. Dressing gown made from the fabric 'Bagatelle' by Raoul DUFY.

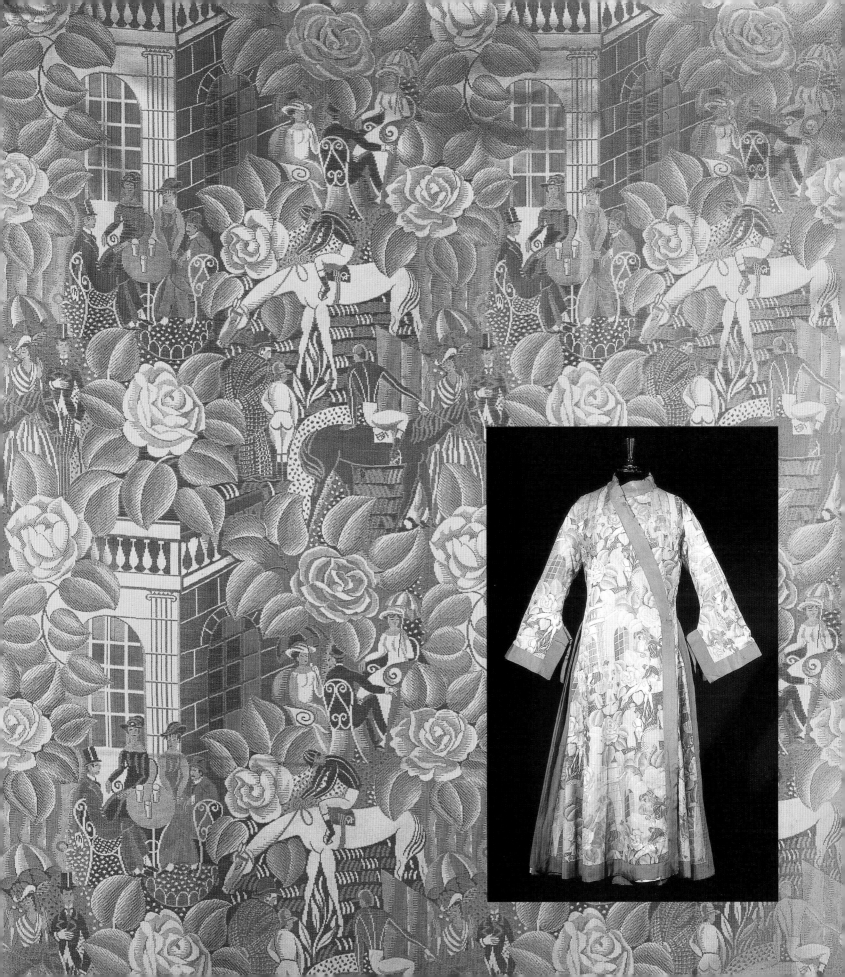

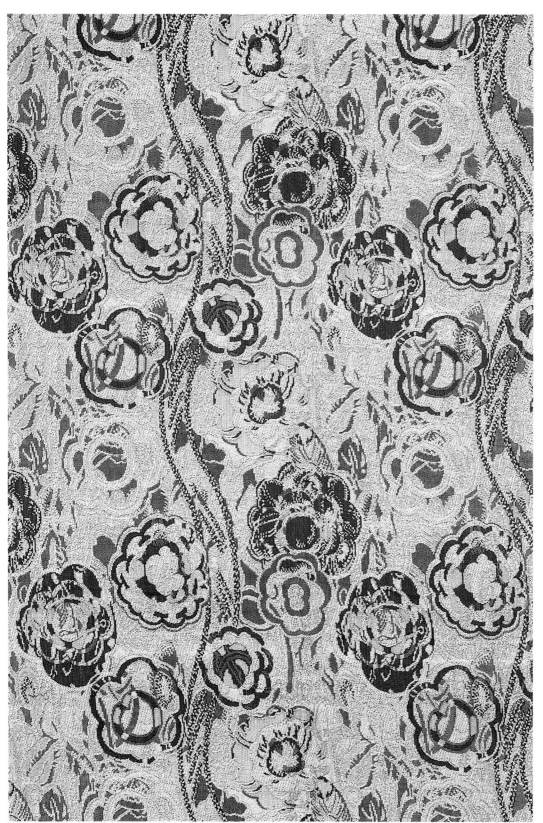

46

46. Edouard BENEDICTUS.
'China'. 1924.

47. Edouard BENEDICTUS.
Variations, pl. 13. 1923.

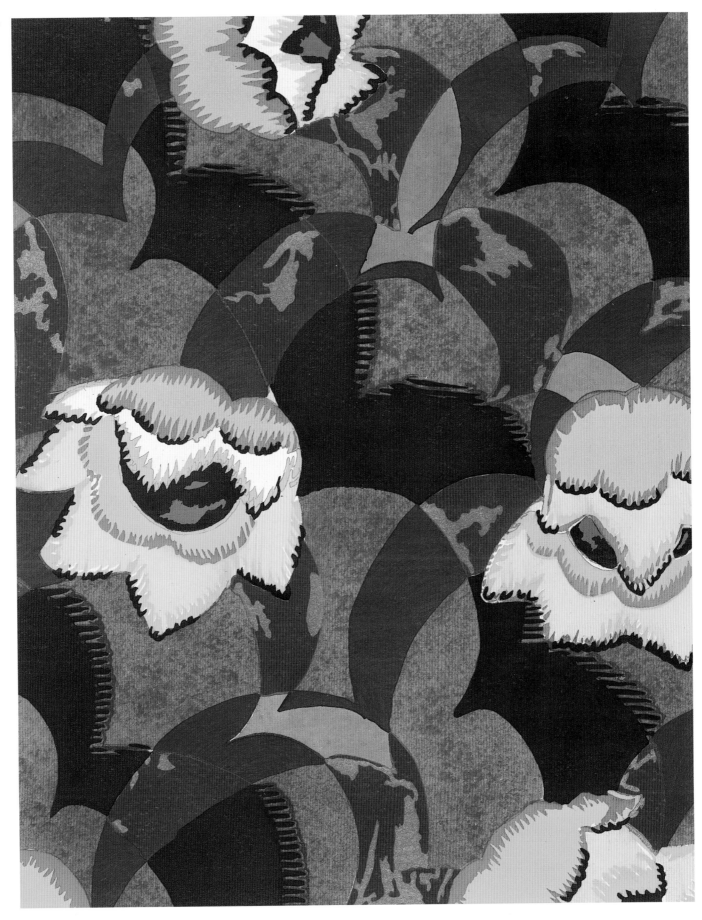

48

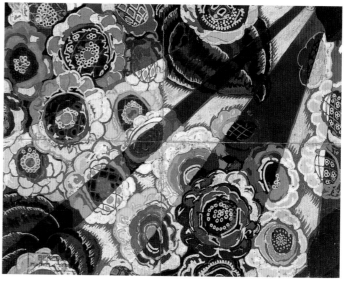

50

49

51

48. Edouard BENEDICTUS. 'Leaves', gouache fabric design. 1923.

49. Edouard BENEDICTUS. 'Leaves'. 1924.

50. Edouard BENEDICTUS. 'Cineraria', gouache fabric design. 1923–24.

51. Edouard BENEDICTUS. 'Cineraria'. 1924.

52. Edouard BENEDICTUS. 'Fountains'. 1925. ▶

53

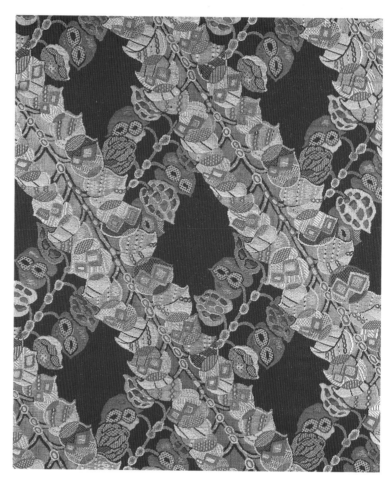

54

53. Edouard BENEDICTUS. 'Golden Fruits'. 1924–25.

54. Edouard BENEDICTUS. 'Trellis'. 1924–25.

55. Edouard BENEDICTUS. 'Athena'. 1924–25. ▶

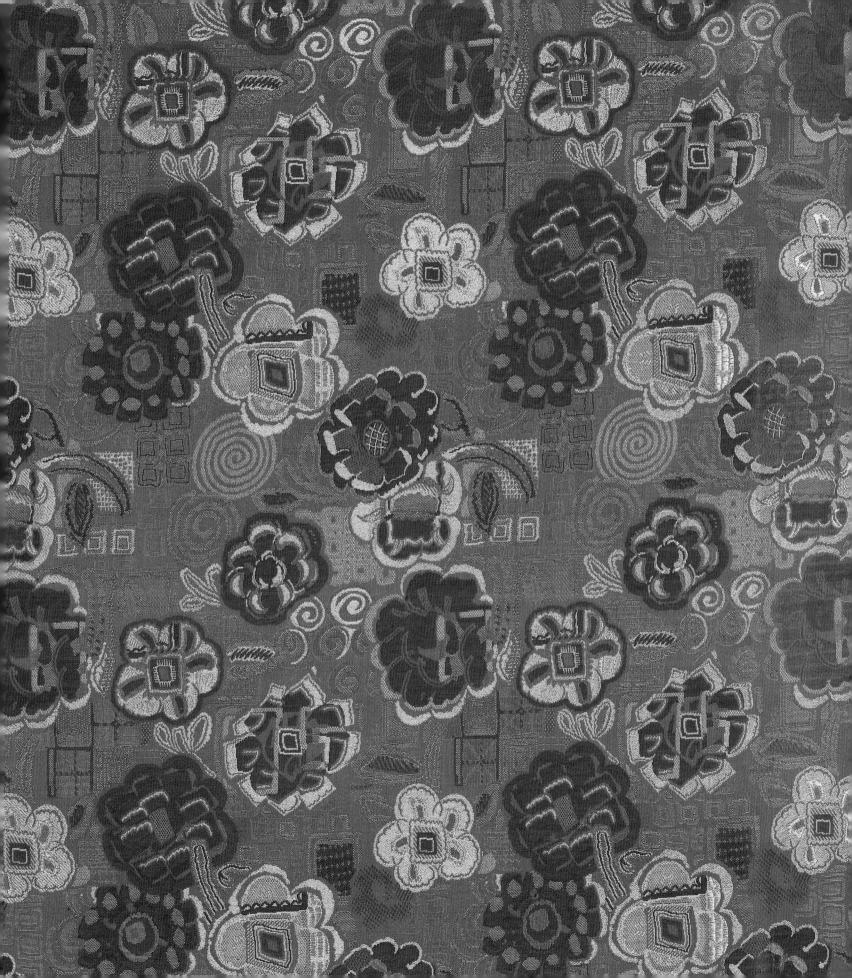

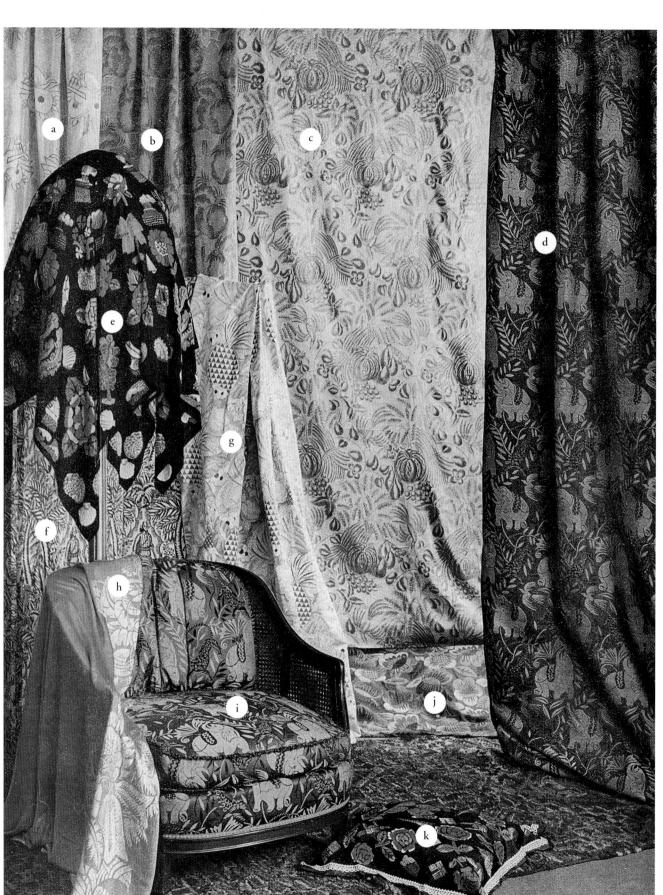

56. BIANCHINI-FÉRIER, display of furnishing fabrics
Larousse Ménager, 1926.

a. Robert BONFILS, 'Venice'.

b. Unknown.

c. Raoul DUFY, 'Fruits of Europe', Toile de Tournon.

d. Raoul DUFY, 'Jungle' (see ills 57 and 60).

e. Raoul DUFY, 'Flowers and Boats'.

f. Raoul DUFY, 'Hunting', Toile de Tournon.

g. Charles MARTIN, 'Pineapples' (see ill. 117).

h. Unknown.

i. Chair upholstered with 'The Jungle' by Raoul DUFY.

j. Raoul DUFY, Floral pattern.

k. Cushion covered with the foulard design
'Monuments of Paris' by Raoul DUFY.

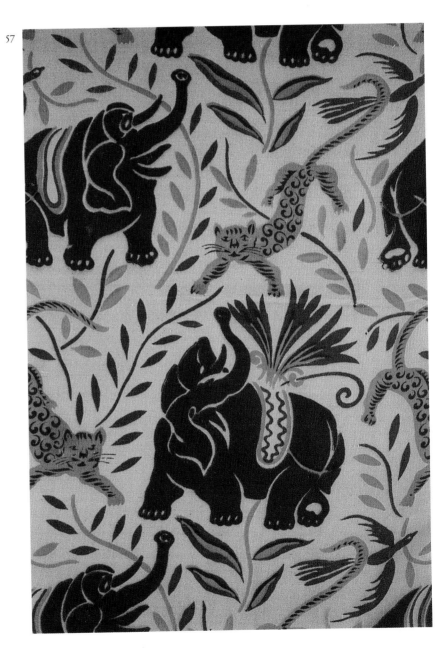

57

57. Raoul DUFY. 'Jungle'. 1922.

58

59

58. Robert BONFILS. 'Oasis'. 1926.

59. Robert BONFILS. Elephant heads.
1925–30.

60. Raoul DUFY. 'Jungle'. 1922. ▶

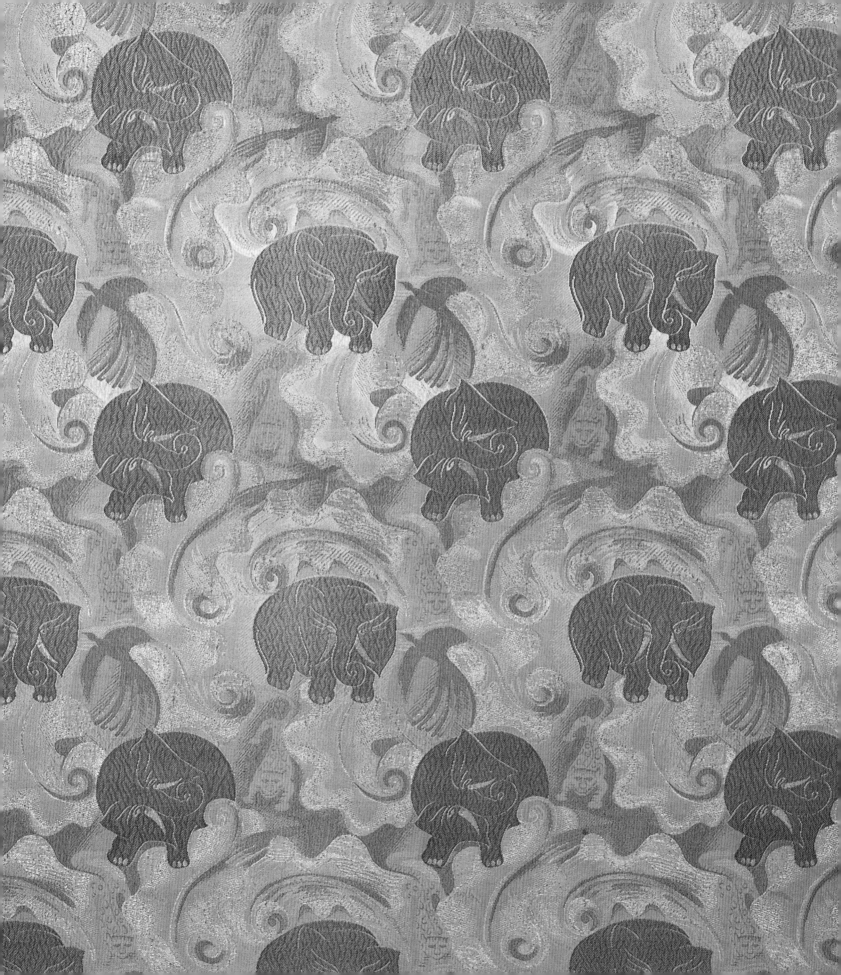

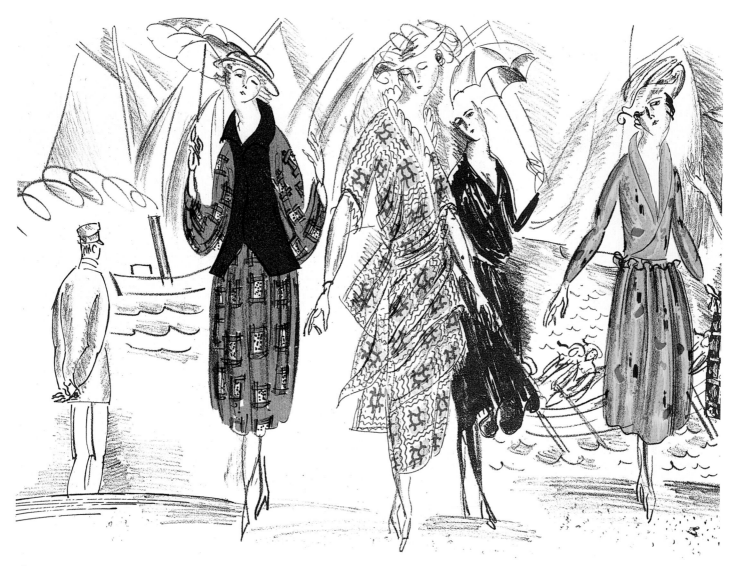

61a

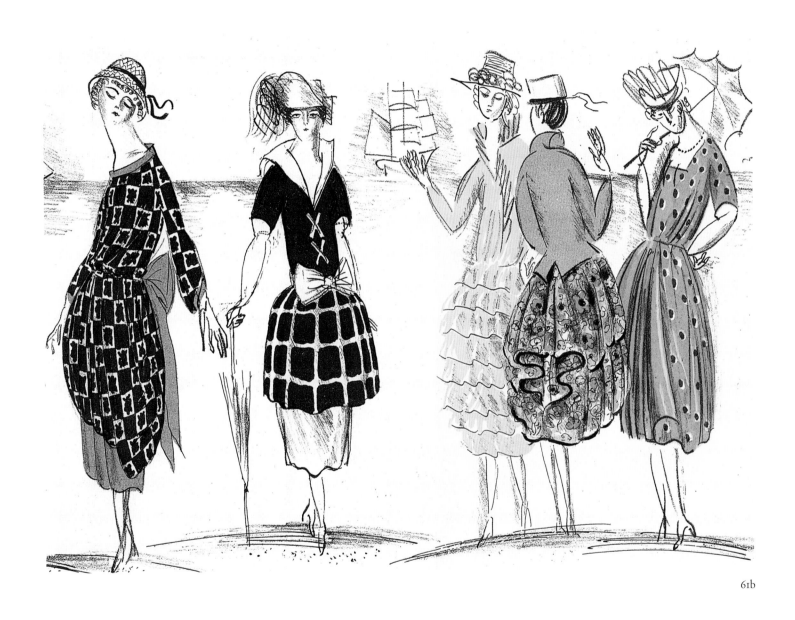

61b

61. Raoul DUFY. 'Dresses for Summer 1920'. Plates 21–24, *Gazette du Bon Ton,* 1920, vol. IV.

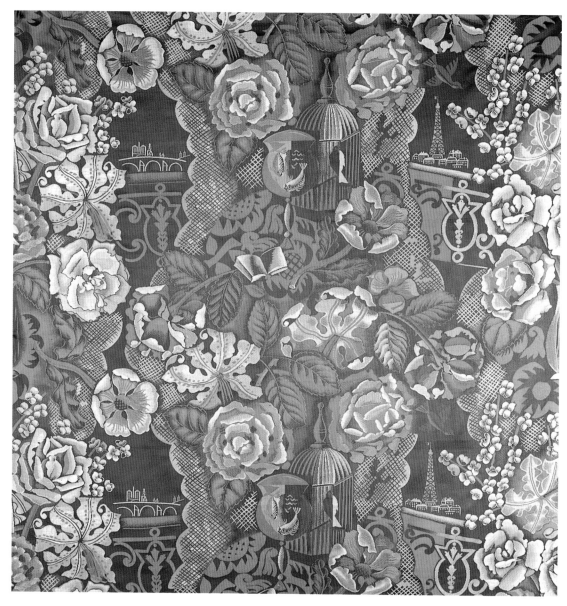

62

62. Raoul DUFY. 'Paris'. 1923.

63. Raoul DUFY. 'Paris'. 1923. ▶

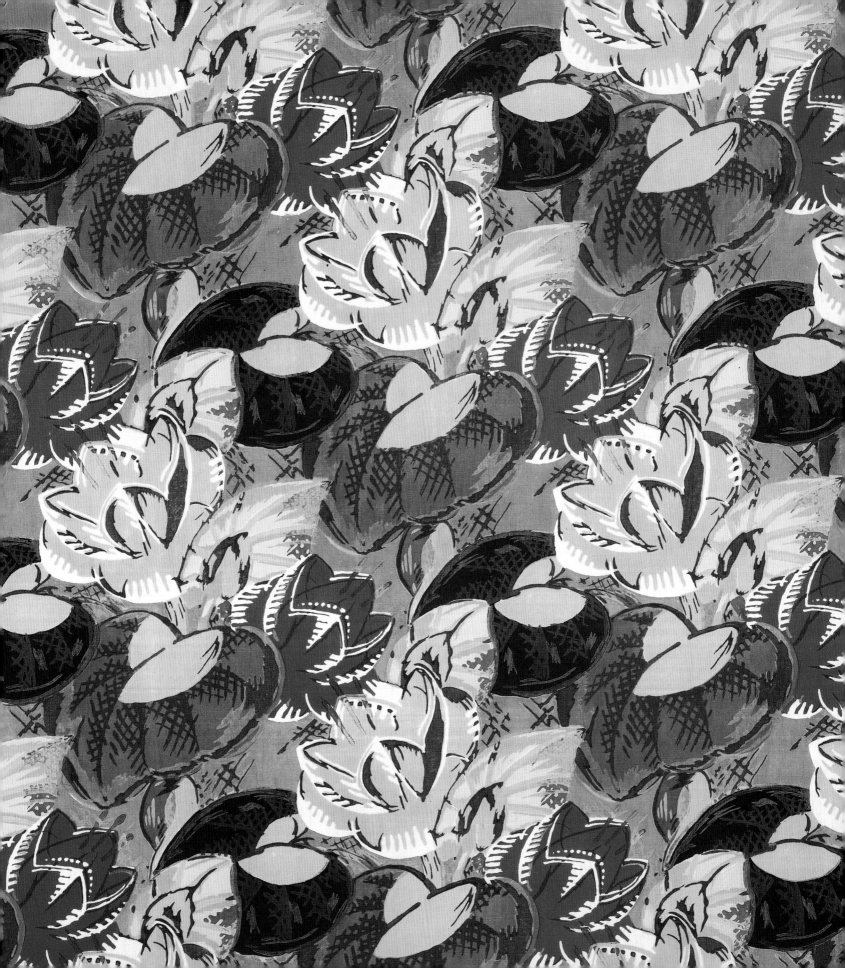

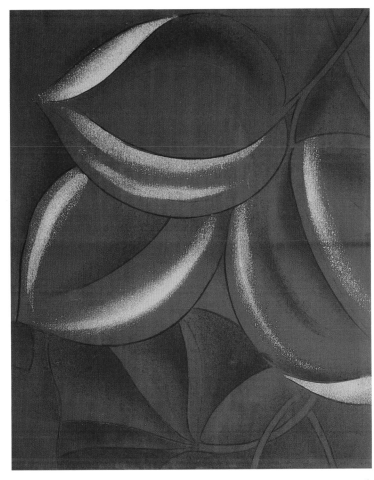

65

66

65 and 66. Attr. Robert BONFILS. Fabric
design with leaf motif, in two colourways. 1931.

Opposite:

64. Robert BONFILS. 'Anemones'. 1926–27.

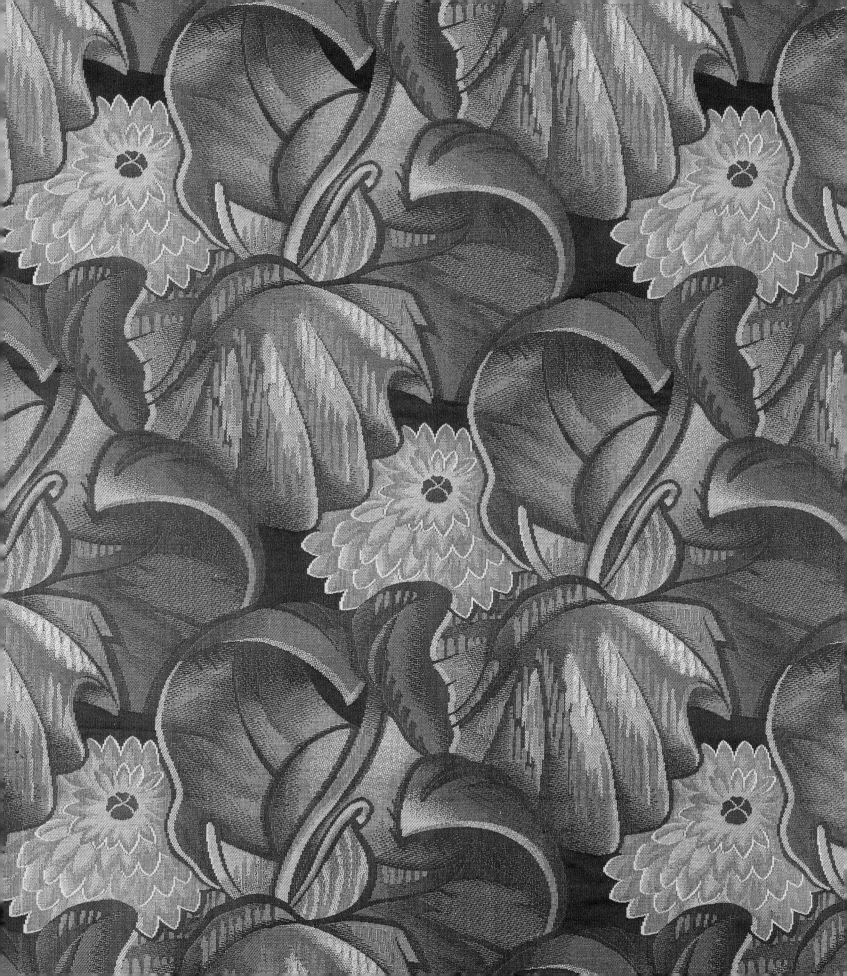

68

◄ 67. Robert BONFILS. 'Africa'. 1922–23. 68. Michel DUBOST. Stylized tropical fruits. 1924–25.

69. ANONYMOUS. Water plants.
Winter 1922.

70. Georges LEPAPE. 'Belle
Impéria', *Gazette du Bon Ton*, 1912.

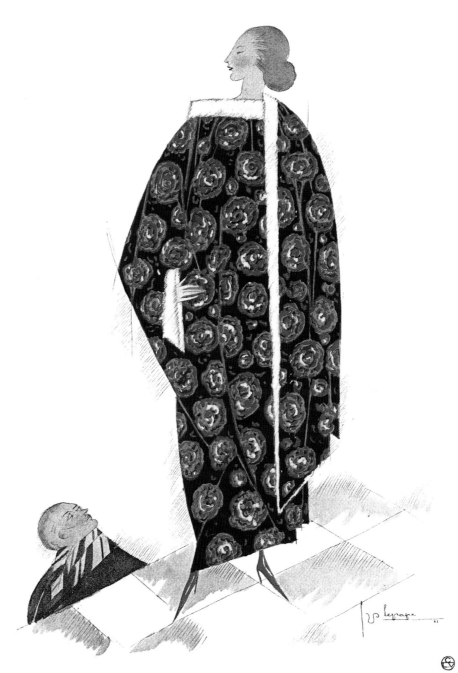

BELLE IMPÉRIA

MANTEAU DU SOIR, EN VELOURS DE BIANCHINI

71

72

71. Yvonne CLARINVAL. 'The Four Elements: Air'. 1923.

72. Yvonne CLARINVAL. 'The Four Elements: Water'. 1923.

73. Yvonne CLARINVAL. 'The Four Elements: Earth'. 1923. ▶

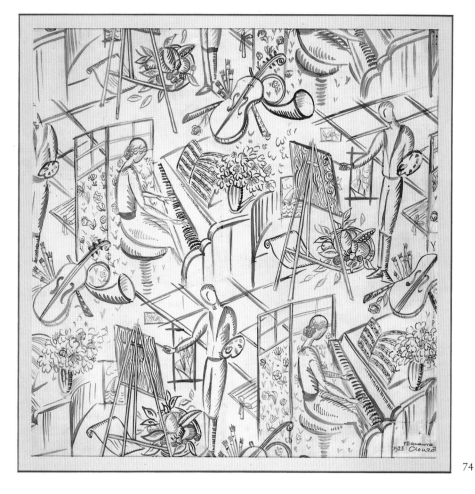

74

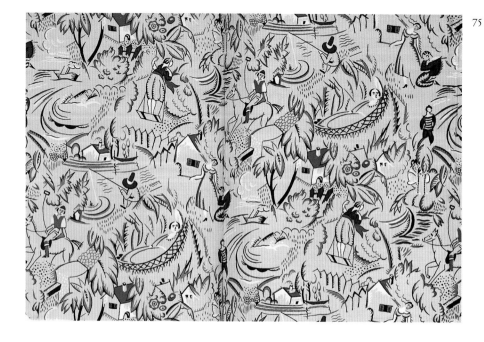

75

74. Marianne CLOUZOT. Music and painting; gouache fabric design. 1923.

75. ANONYMOUS. Summer. 1924.

76. Charles DUFRESNE. 'Voyage'. 1919–20. ▶

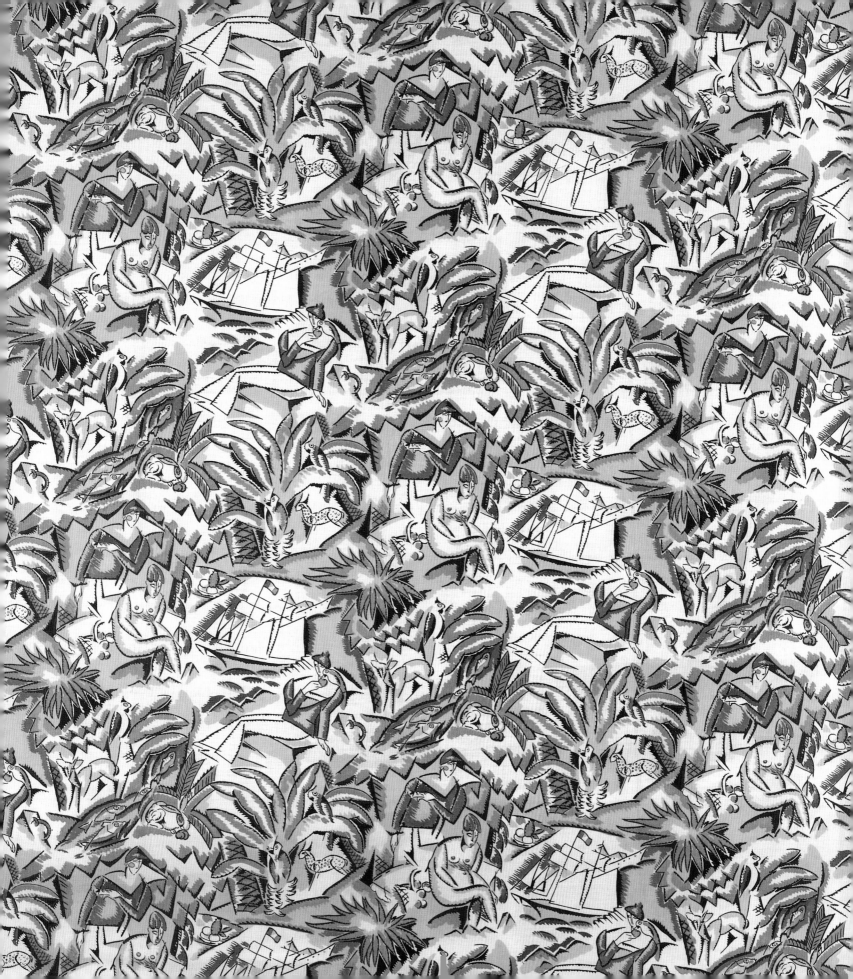

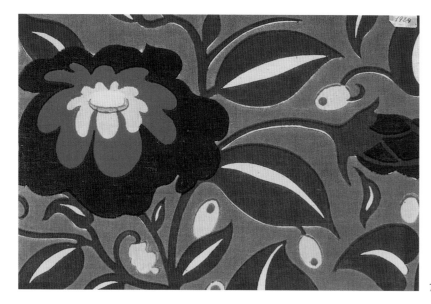

77

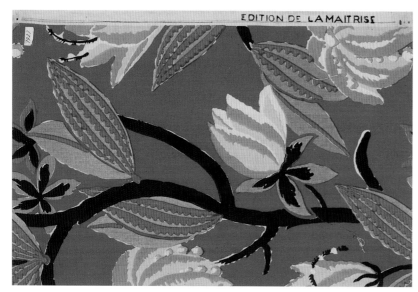

78

79

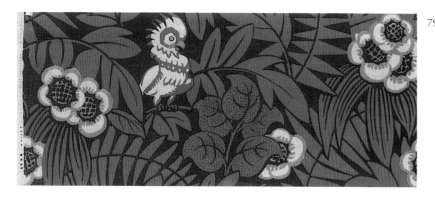

77. Maurice CROZET. Flower and leaves. 1924.

78. La MAÎTRISE. Branch of magnolia blossom. 1927.

79. Jean-Gabriel DARAGNÈS. 'Macaws'. 1921.

80. ANONYMOUS. Branch with stylized leaves and flowers. 1928. ▶

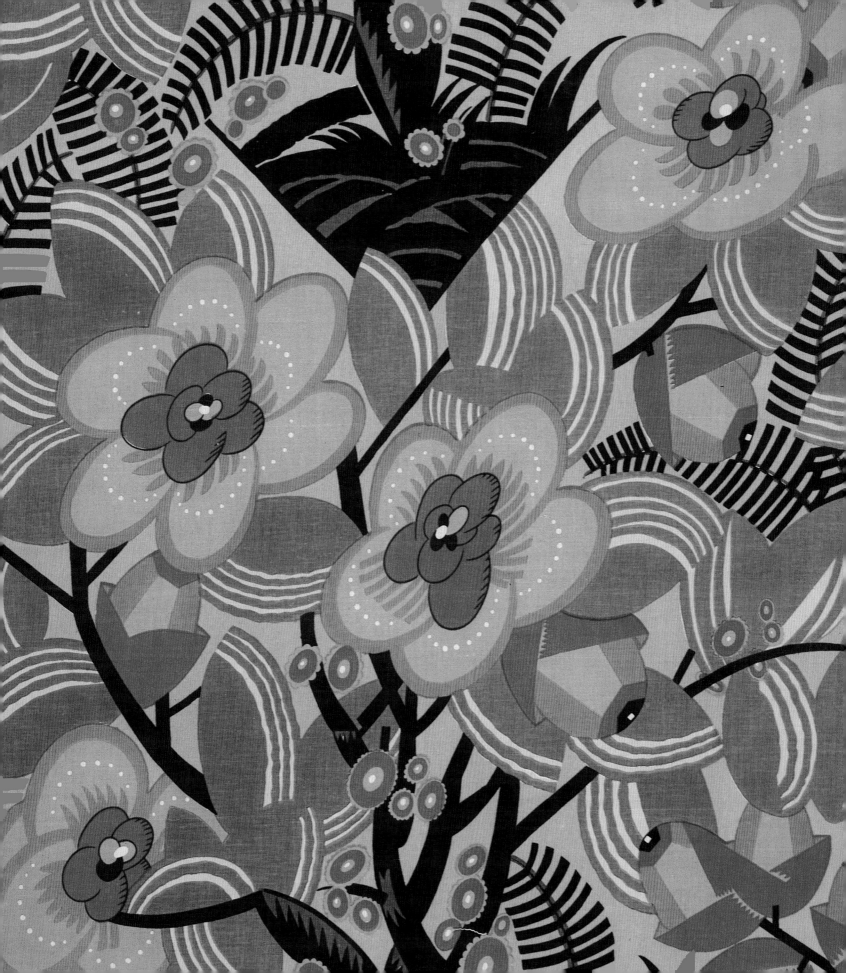

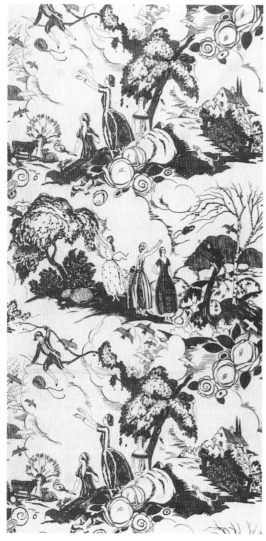

81

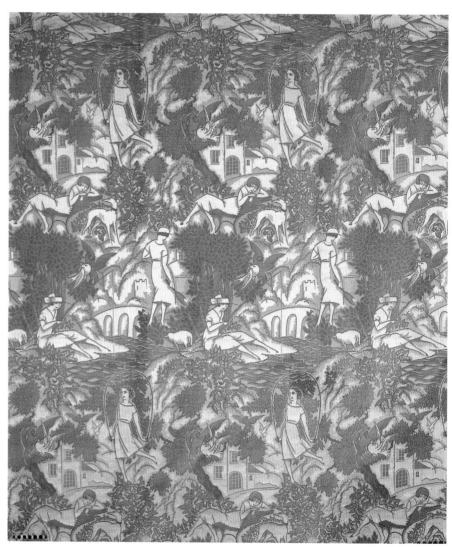

82

81. Robert MAHIAS. 'My Hat Has Blown Away'. 1923.

82. Alberto LORENZI. 'On Holiday'. 1921–22.

83. Alberto LORENZI. 'A Walk in the Park'. 1921–22. ▶

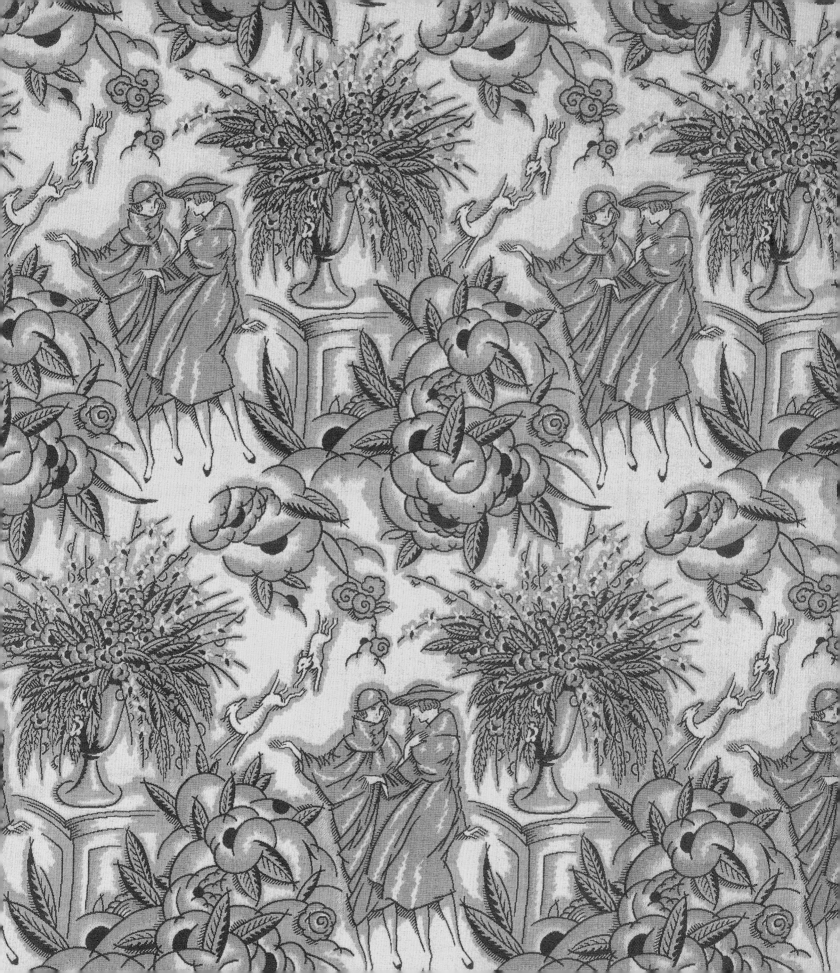

84

84. Georges BARBIER. 'The Wind', *Falbalas et fanfreluches,* 1926.

85. Michel DUBOST. 'Forest Full of Birds'. 1925–30. ▶

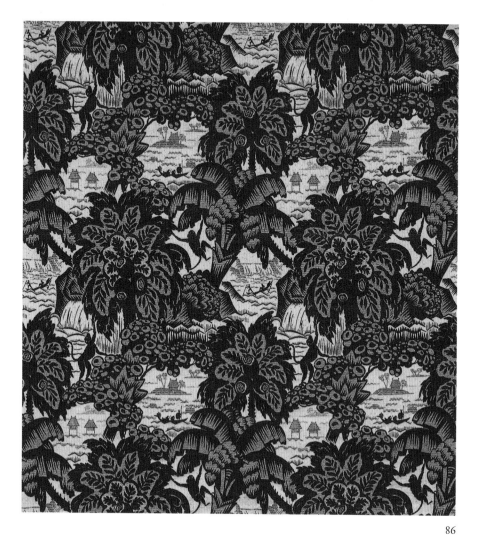

87

86

88

86. Jean BEAUMONT. 'Rainforest'. 1924–25.

87. Jean BEAUMONT. 'The Garden of Eden'. 1924–25.

88. Jean BEAUMONT. Tapestry cover for an armchair by Jules Leleu. 1929.

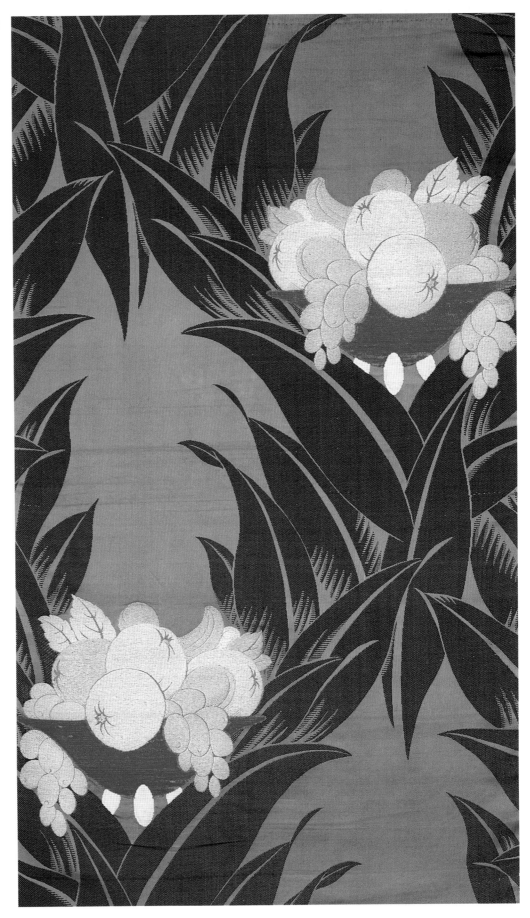

89. Michel DUBOST. 'The Bowl'. 1919–20.

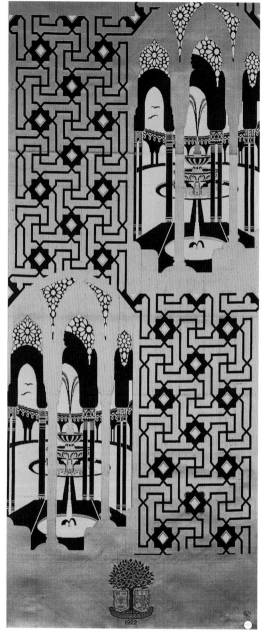

90

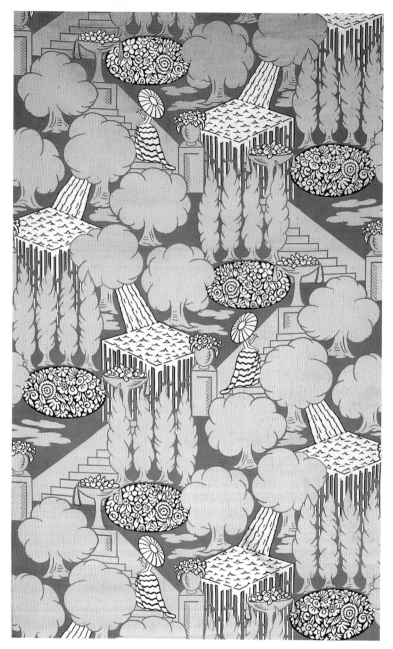

91

90. Michel DUBOST. 'The Lion Court'. 1922.

91. Ms LARBITRAY. 'Rain'. 1924.

92. Henri STEPHANY. Pigeons with urns and flowers. 1925–26.

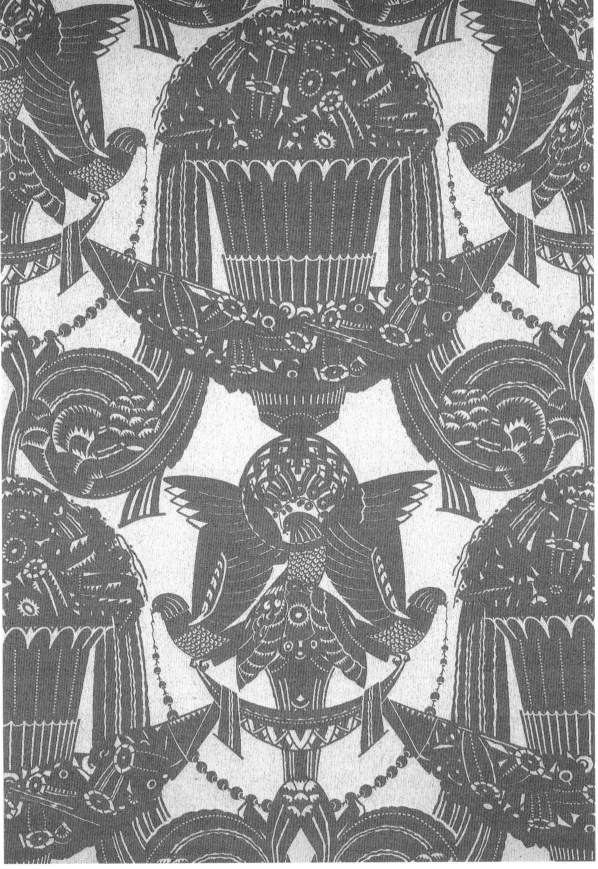

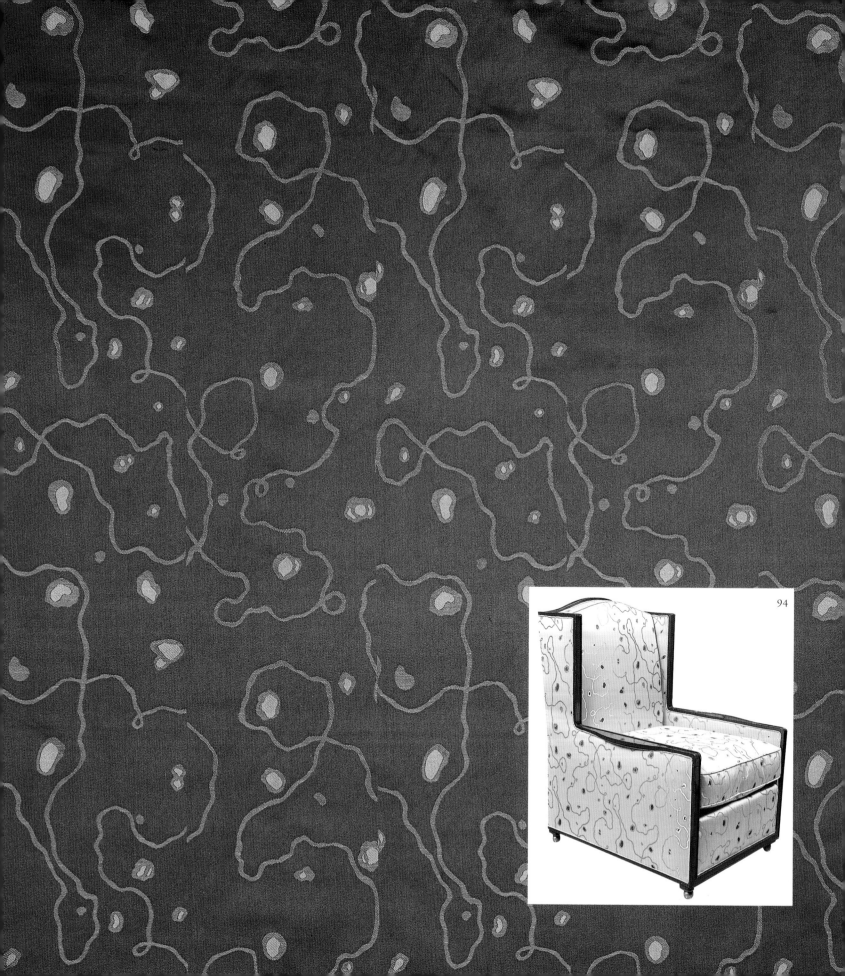

94

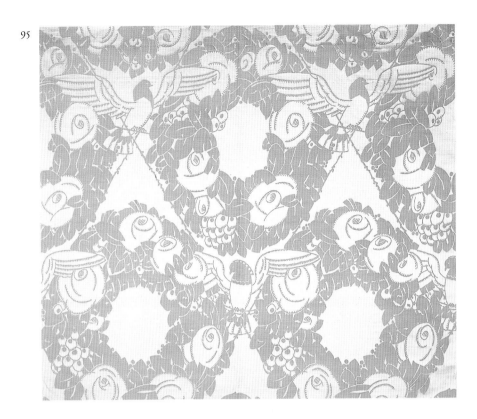

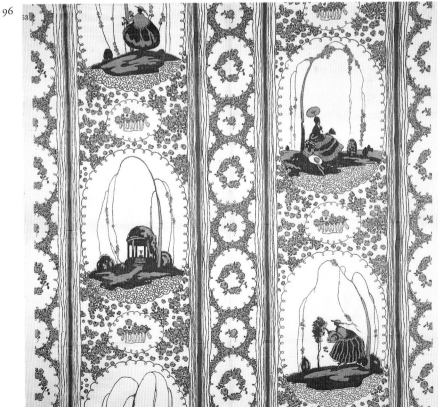

95. Henri STEPHANY. Pigeons with urns and flowers. 1925.

96. Atelier RUHLMANN. Floral pattern with narrative scenes. 1920–25.

◀ 93. Jacques-Emile RUHLMANN. Ribbon brocade. 1922–23.

94. Jacques-Emile RUHLMANN. Armchair covered with ribbon brocade. 1922–23.

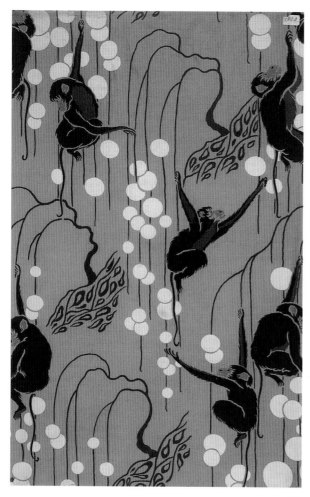

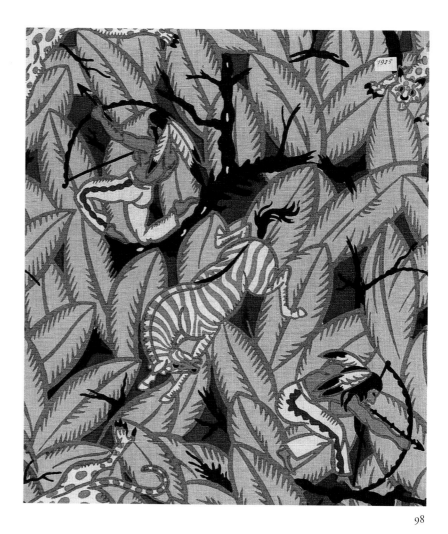

97

98

97. ANONYMOUS. Chimpanzees. 1922.

98. ANONYMOUS. All-over with foliage, Native
American with bow, zebra and panther. 1925.

99. Germaine LABAYE. Chimpanzees and tropical
vegetation. 1925.

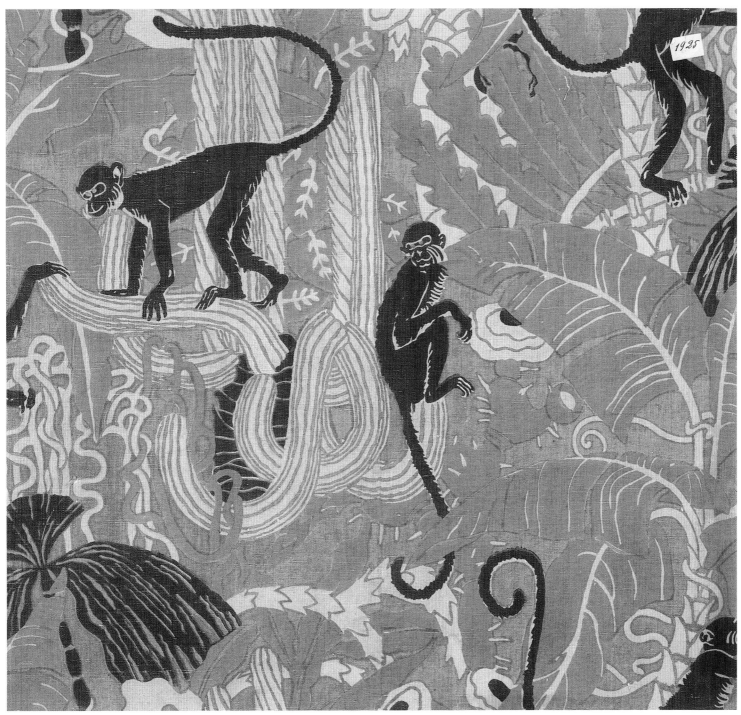

99

100

101

100. ANONYMOUS. Figurative motif with stylized trees, house and viaduct. 1923.

101. ANONYMOUS. Composition with pendants and rosettes. 1923.

102. ANONYMOUS. Highly formalized floral motif. 1924.

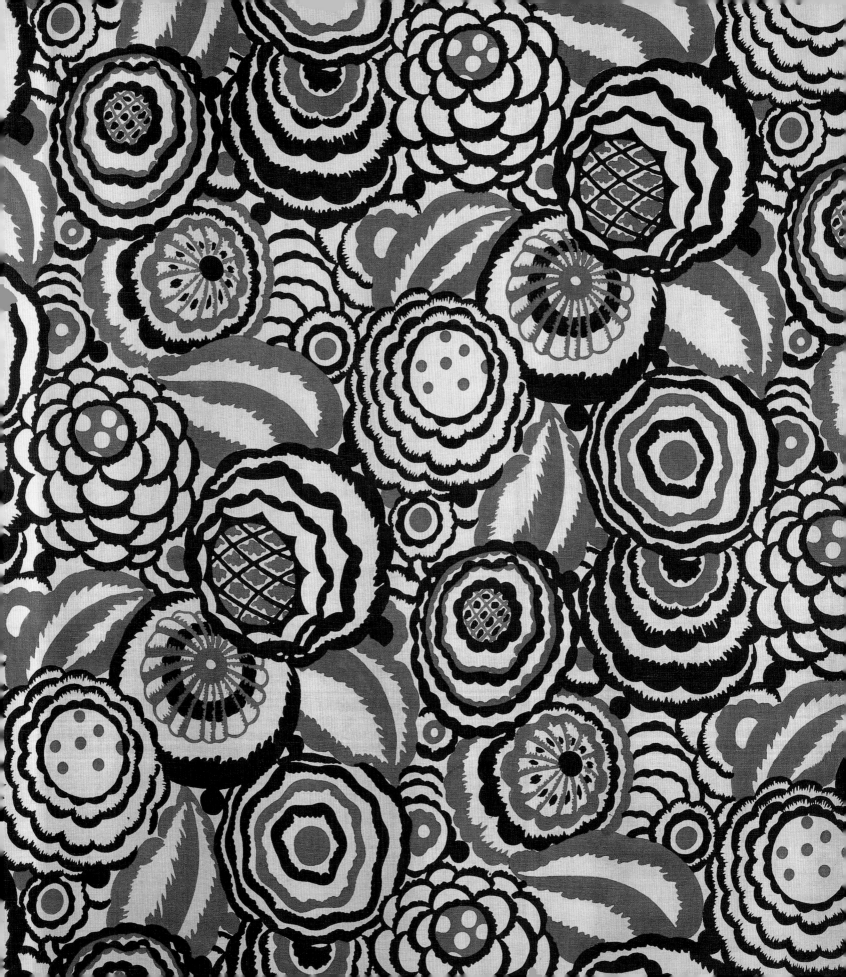

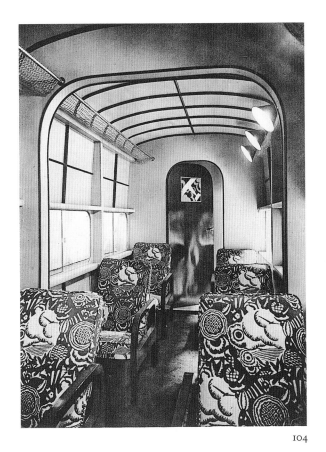

104

105

Martine. Bianchini. Martine. Bianchini. Dim. Martine.

TOILES IMPRIMÉES POUR L'AMEUBLEMENT.

MODÈLES ÉDITÉS PAR LES MAISONS MARTINE, BIANCHINI-FERRIER ET DIM.

104. D.I.M. Aeroplane cabin decorated for the Farman company. 1925.

105. Display of modern furnishing fabrics. *Larousse Ménager*, 1926.

◄ 103. D.I.M. 'Floréal'. 1920–25.

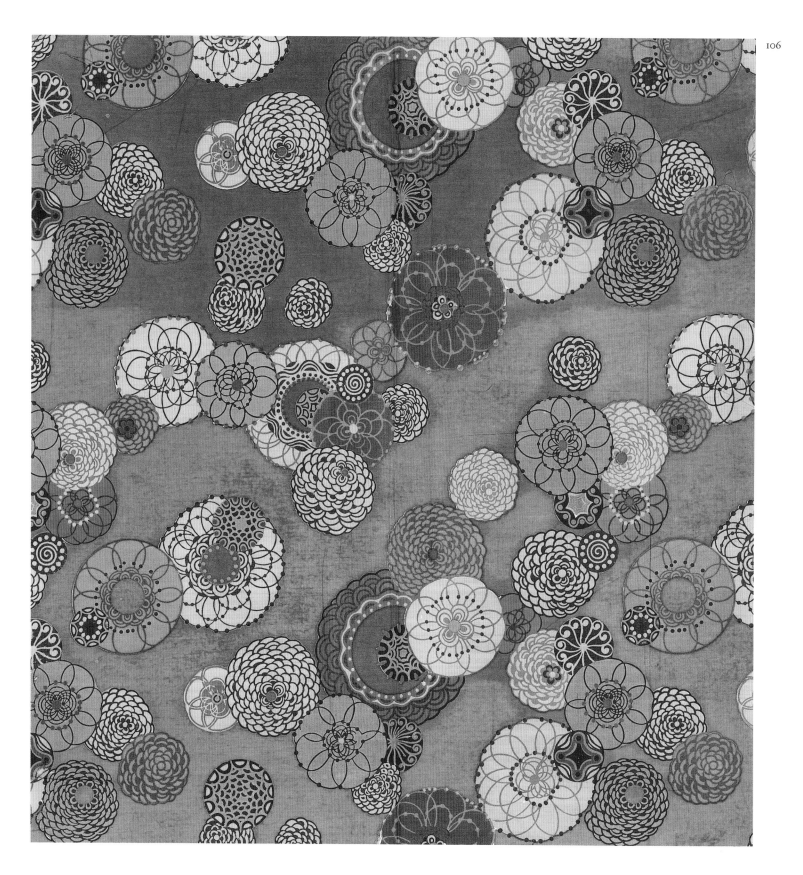

107

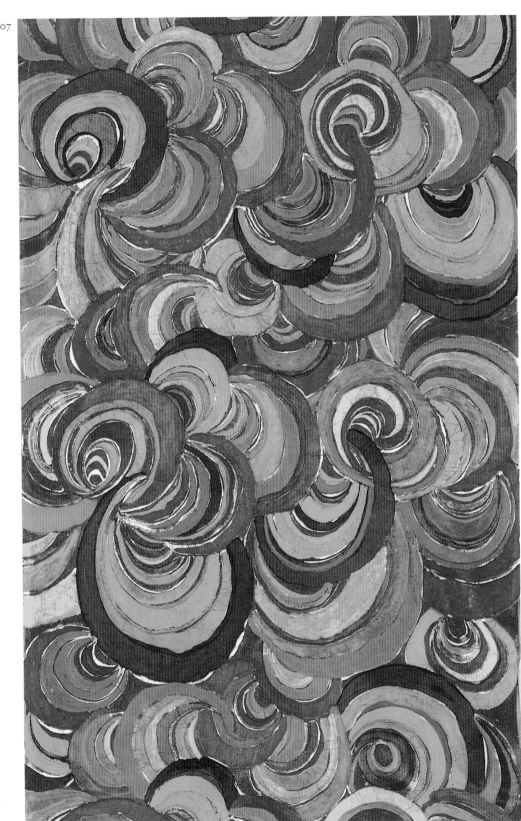

◄ 106. Maurice DUFRENE. Floral motif.
1919–20.

107. Marguerite PANGON.
Design on velvet for a coat, *Les Batiks de
Madame Pangon,* pl. 3, 1925.

108

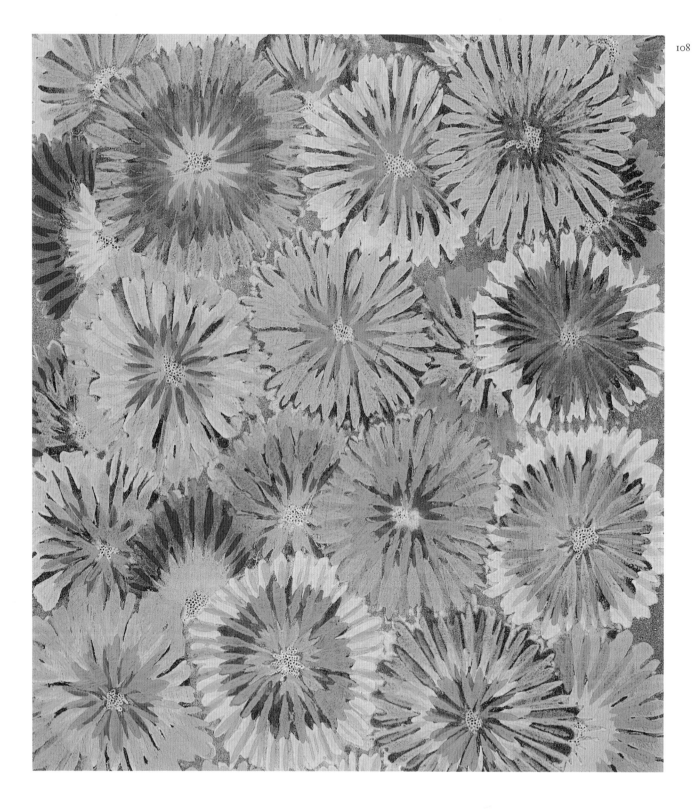

108. Marguerite PANGON. Chiffon scarf, *Les Batiks de Madame Pangon,* pl. 13, 1925.

109. Marguerite PANGON. Upholstery velvet, *Les Batiks de* ►
Madame Pangon, pl. 22, 1925.

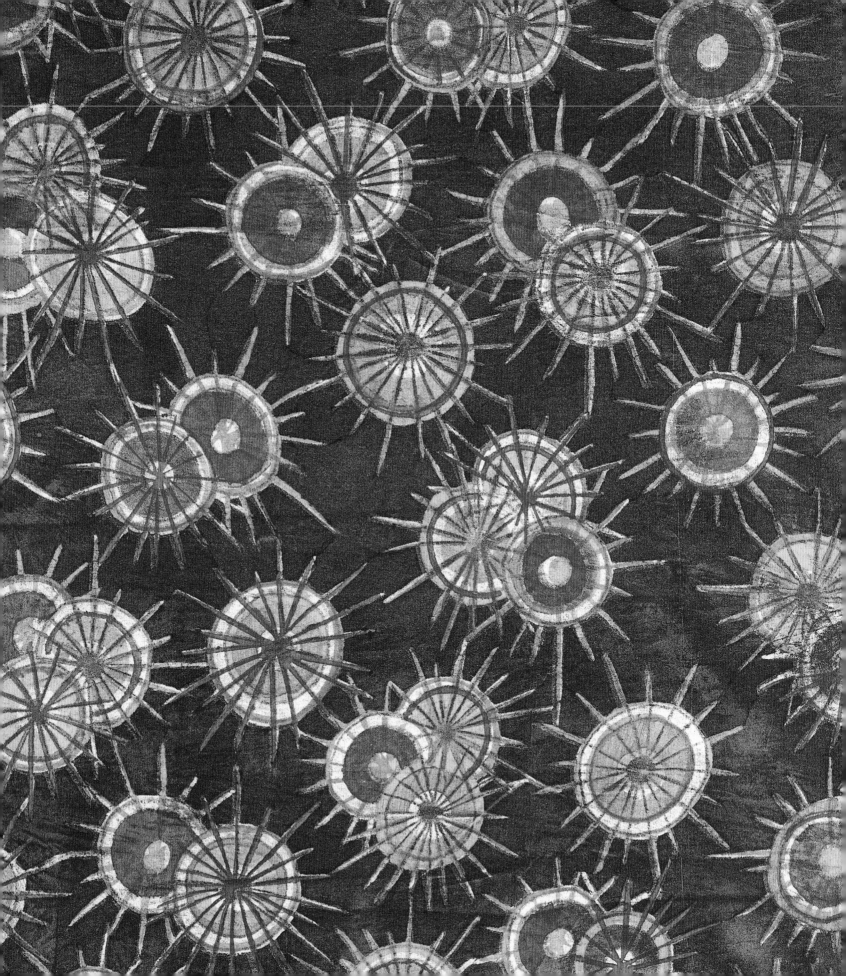

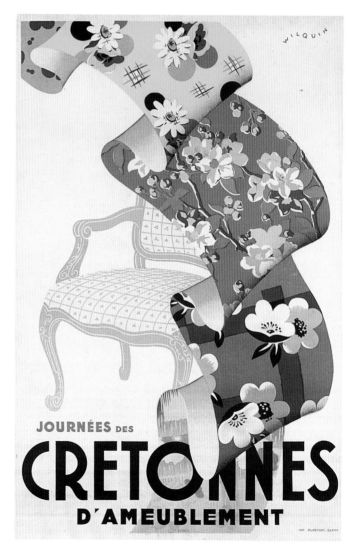

110. STUDIUM LOUVRE. *L'Art décoratif moderne aux Grands Magasins du Louvre*, 1925.

111. André WILQUIN. Advertising poster for cretonne furnishing fabrics. 1930–35.

112. La MAÎTRISE. *Tapis, Rideaux, Ameublement,* ►
catalogue for the Galeries Lafayette, 1923.

MAISON VENDANT LE MEILLEUR MARCHÉ
DE TOUT PARIS

"porteuses d'eau"
01-346
tapisserie : bleu et or
or et noir, noir et fuschia
largeur 128/130
prix le mètre : 17.90

"fusées"
01-348
damas de Brochard
noir et or, violet et or
bleu et or, vert et or
fuschia et or
largeur 128/130,
prix le mètre 49

"puzzle
02-1028
cretonne imprimée
pour tentures et
rideaux, larg 78/80
prix le mètre 3.75

"picassine"
02-1030
dessin de Marcoussis
toile métis imprimée
fonds : bleu, rouge
mauve, jaune, vert
largeur 128/130
prix le mètre 25.

"les deux pigeons"
02-1029
toile de coton imprimée
fonds : vert, rubis, noir
bleu, blanc
largeur 75/80
prix le mètre 7.50

"coquillages"
01-347
damas : bleu et violet
rouge et or, bleu et or
largeur 128/130
prix le mètre 49.

"fougères"
01-349
damas de Maurice Dufrène
bleu et or, pourpre et bleu
bleu et rouge, gris et rose
largeur 128/130,
prix le mètre 29.

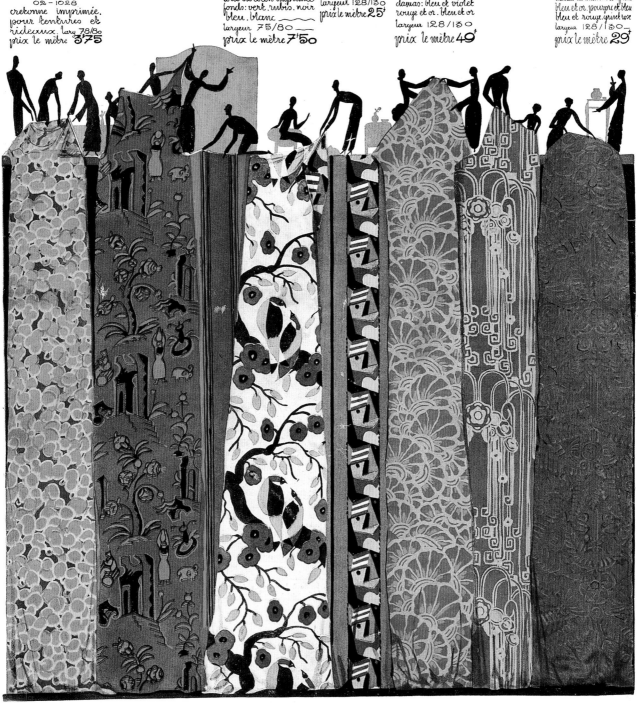

02-1028	01-346	02-1029	02-1030	01-347	01-348	01-349
3.75	17.90	7.50	25. »	49. »	49. »	29. »

113

114

Arch. phot. de la PLANÈTE.

CHAMBRE ET SALON
composés et exécutés par *MARTINE.*

113. Atelier MARTINE. Decorative
scheme for the barge *Amours.* 1925.

114. Atelier MARTINE. Decorative
scheme for the barge *Amours.* 1925.

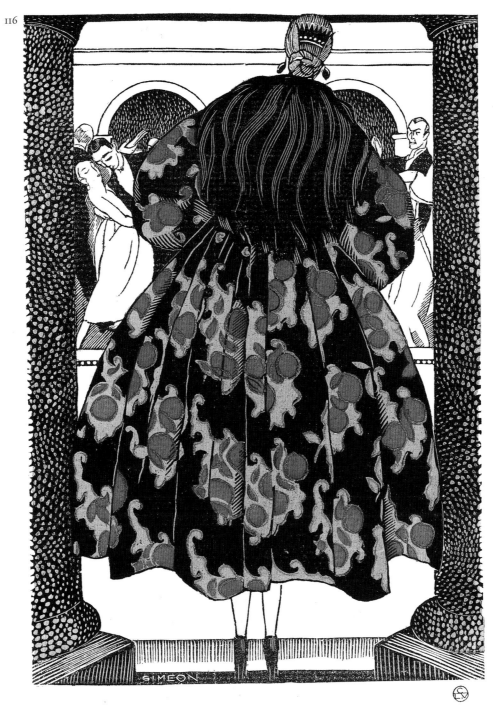

LE PLAISIR A LA MODE

MANTEAU DU SOIR, EN TISSU DE BIANCHINI

◄ 115. Attr. Raoul DUFY.
Clover-leaf pattern. *c.* 1930.

116. SIMÉON. 'Le Plaisir à la Mode', *Gazette du Bon Ton*, no. 1, pl. 3, 1921.

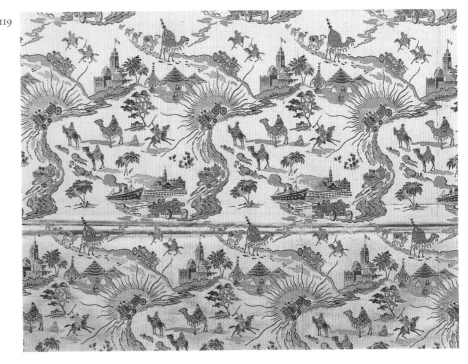

118. ANONYMOUS (attr. Raoul DUFY). Fabric design with large roses in rows and columns. *c.* 1925.

119. ANONYMOUS. 'La Croisière Noire'. 1924–25.

◄ 117. Charles MARTIN. 'Pineapples'. 1922–23.

120. Raoul DUFY. Tiger lilies, fabric design. *c.* 1925.

121. Raoul DUFY. Bluebells, fabric design. *c.* 1925. ▶

122

123

124

122, 123, 124. Frédéric ROBIDA. Fabric designs. 1925–30.

125

126

125. ANONYMOUS. Stylized floral pattern.
Summer 1923.

126. ANONYMOUS. Arabesques and
cornucopias. 1924–25.

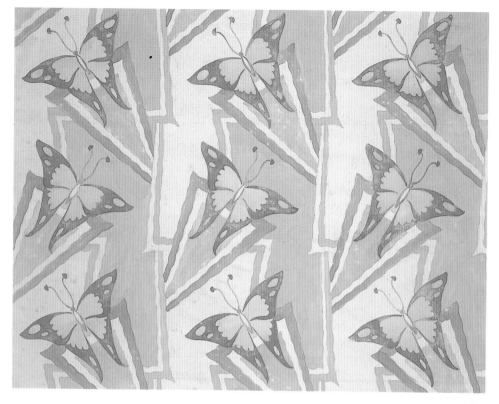

127

128

127. Frédéric ROBIDA. Fabric design. 1925–30.

128. Emile-Alain SEGUY.
'Roses and Butterflies'. 1926.

129. Attr. Emile-Alain SEGUY. ►
Butterflies on stylized roses. 1926.

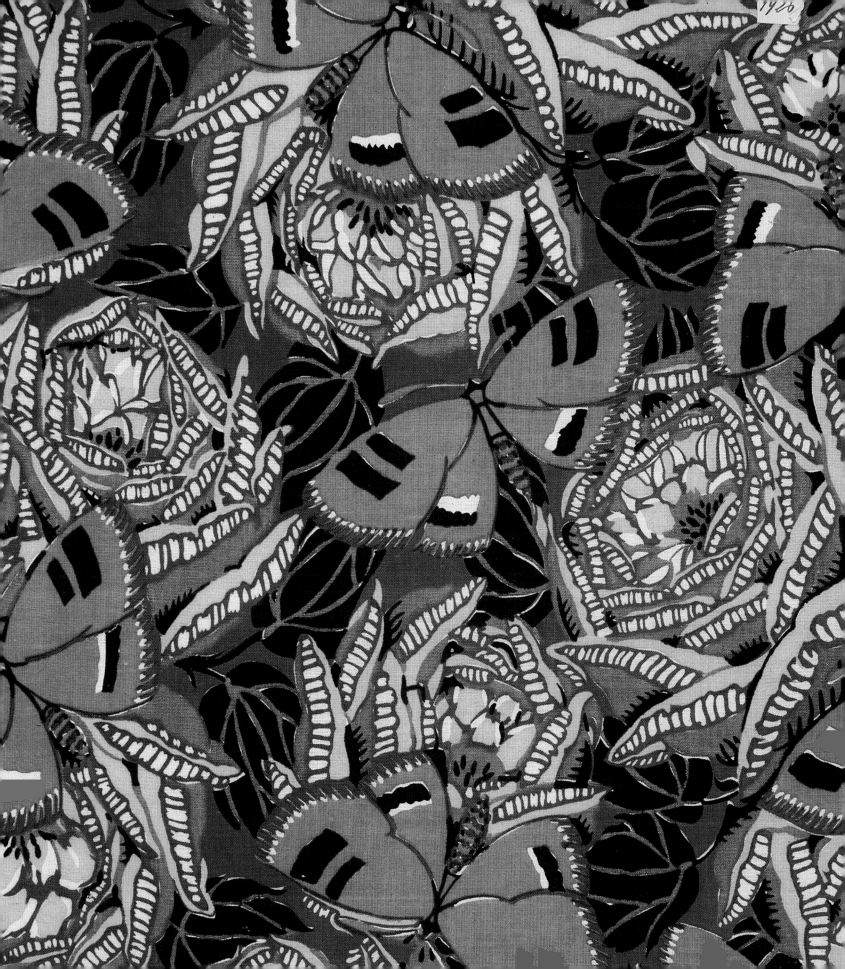

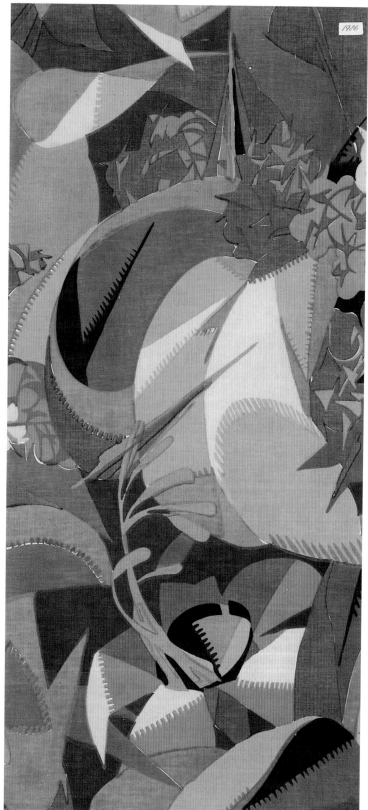

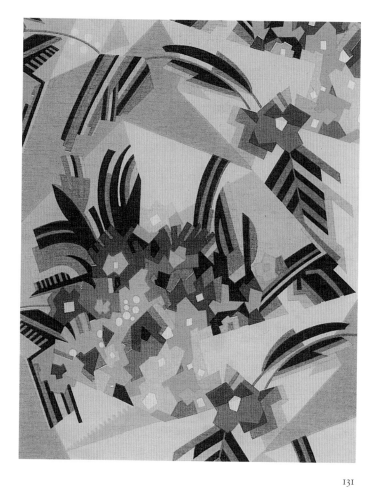

131

130. ANONYMOUS. Floral motif
on geometric ground. 1926.

131. ANONYMOUS. Floral bouquet
on geometric ground. 1930.

130

132. ANONYMOUS. Bowl of fruit. 1929.

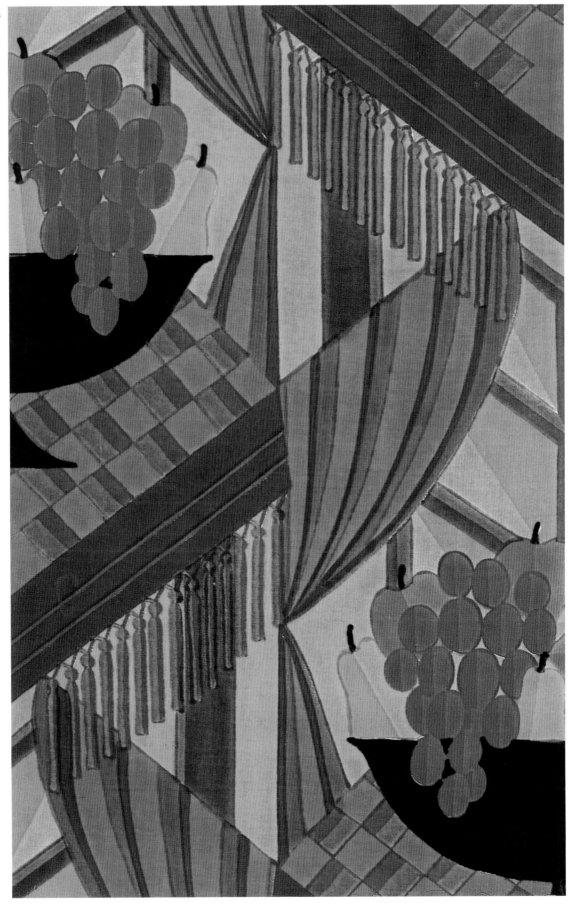

134

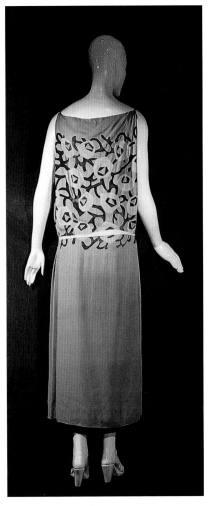

135

134 and 135. Madeleine VIONNET.
Dress with appliqué bodice and
detail. Winter 1921–22.

Opposite:

133. ANONYMOUS. Stylized
flowers. 1926.

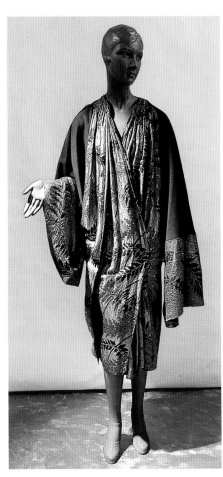

137

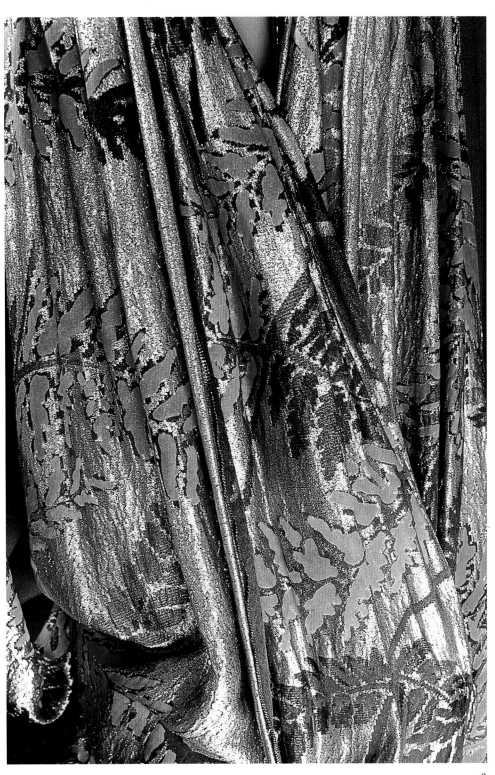

137. CALLOT Sisters. Evening coat. *c.* 1925.

138. ANONYMOUS. Fabric used for the
coat shown above. *c.* 1925.

138

◄ 136. ANONYMOUS. Geometric floral bouquet. 1925.

139

139, 140. ANONYMOUS. Pattern of stylized flowers and leaves. 1926.

140

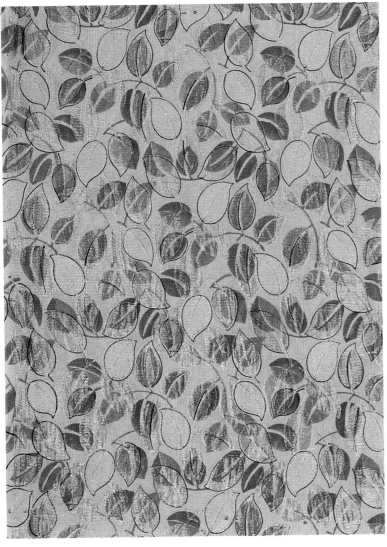

141

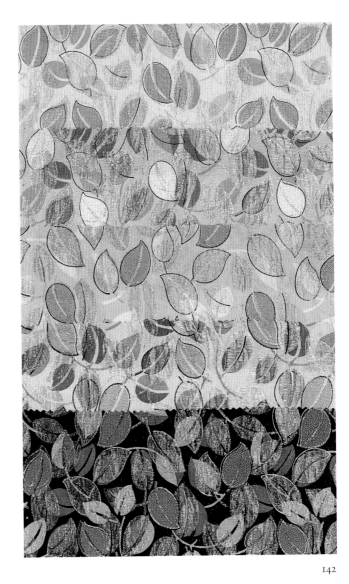

142

141, 142. ANONYMOUS. 'Crêpe gauze'. 1931.

143. ANONYMOUS. Geometric composition with overlapping squares
of stylized decoration. Summer 1923.

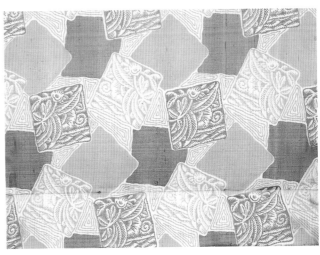

143

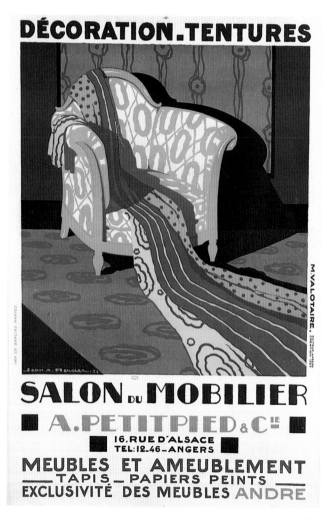

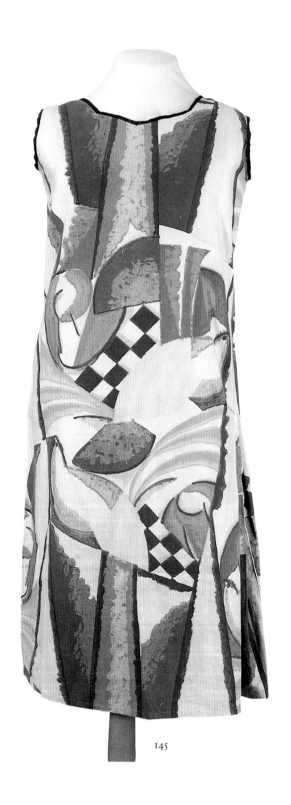

144. Jean MERCIER. Advertisement for a furnishing store. 1924.

145. Lina DE ANDRADA. Furnishing fabric made into a dress. *c.* 1925.

SALLE COMMUNE. Albert Guénot
en collaboration avec René Prou.
édités par " Pomone ".

146

146. René PROU and Albert GUENOT. Decorative scheme for the Atelier Pomone. 1929.

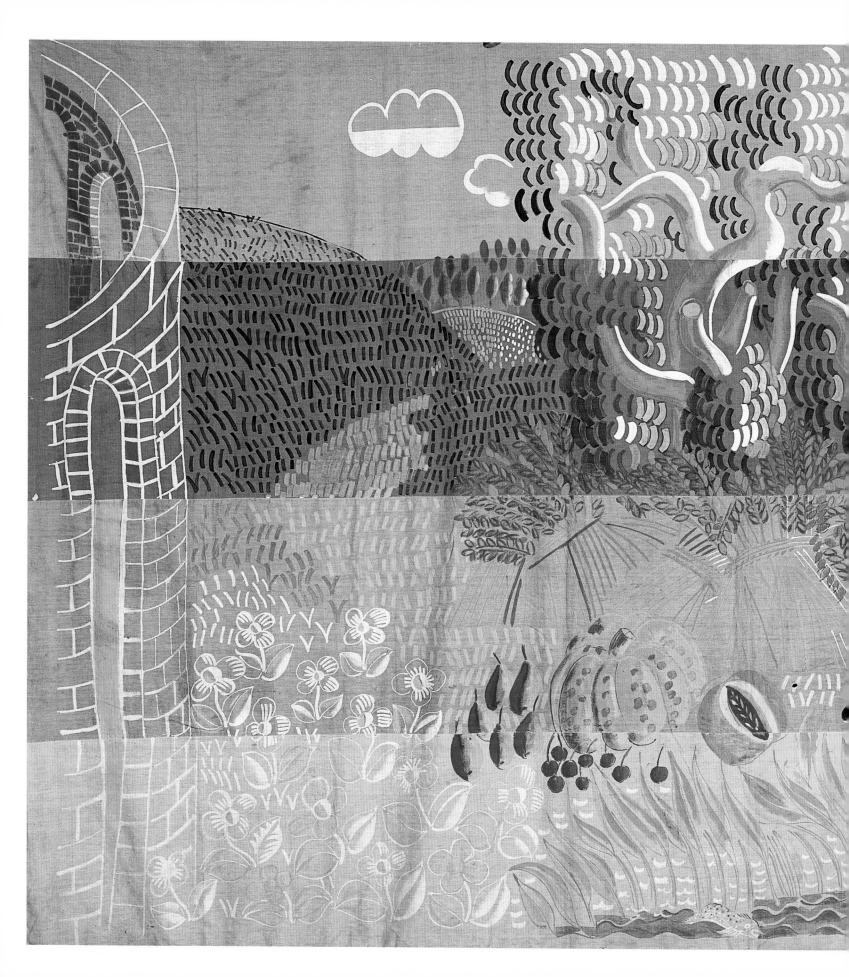

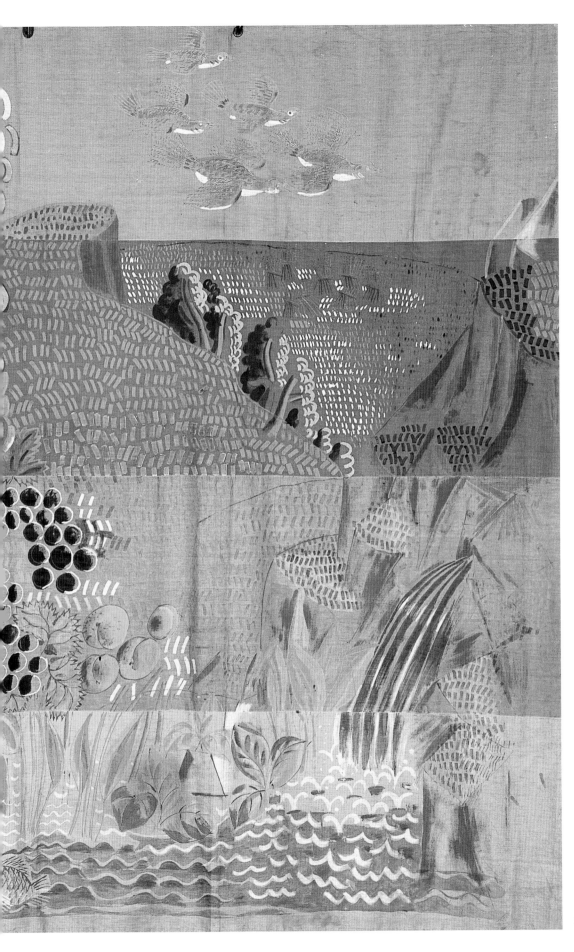

147. Raoul DUFY. 'Aqueduct',
wall hanging. 1925.

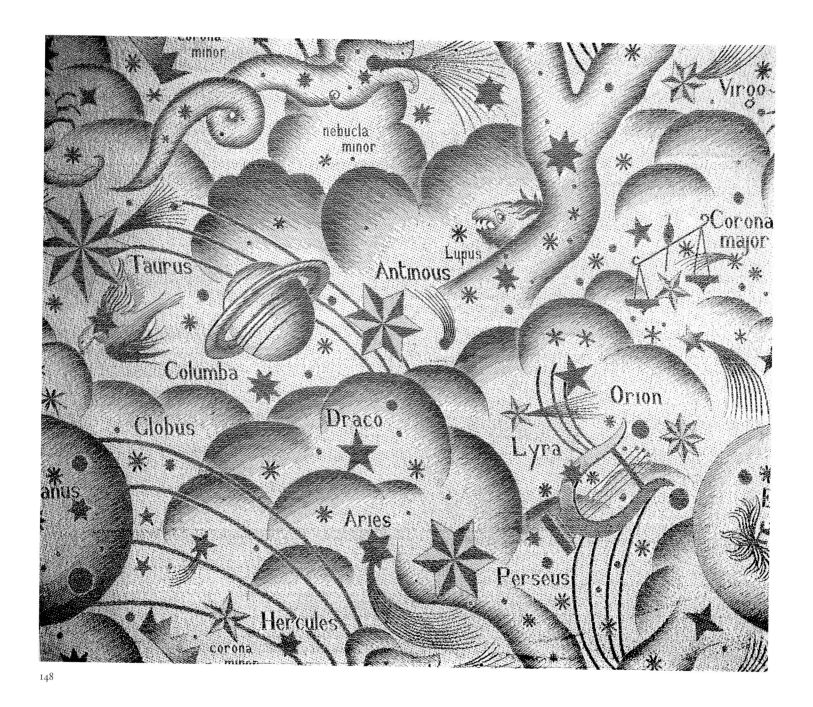

148

149. RODIER. Composition with starfish and shells. 1928.

150. RODIER. Composition with crescent moons, stars and clouds. 1928.

148. RODIER. Constellations. 1928.

151. RODIER. 'Sailing Ships'. 1927.

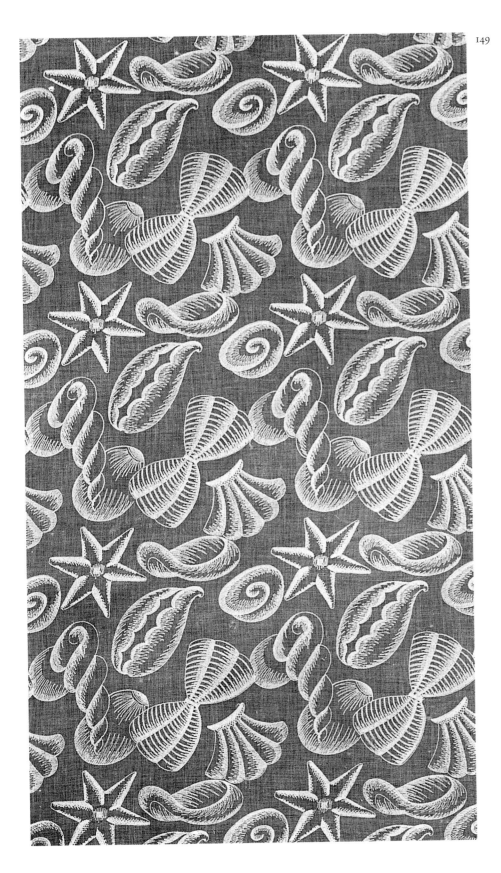

149

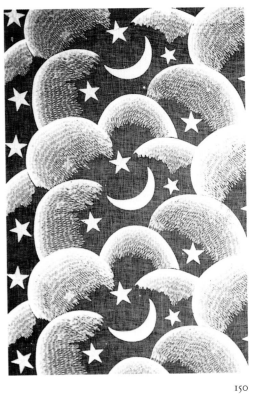

150

151

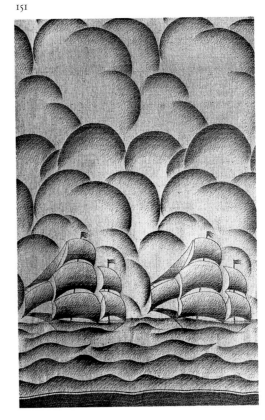

MODERNISM AND GEOMETRY (1923–36)

Geometric designs made their first discreet appearance in France in around 1923–24, but within a few years reached such heights of popularity that they totally supplanted floral decoration. One of the primary reasons for this was in-built: by interpreting, stylizing and transforming flowers and leaves into geometric shapes, designers found themselves concentrating purely on line, on the combinations of lines that formed shapes, and therefore on abstractions, in which a motif can no longer discerned even as a pretext. These developments were hastened by Cubists and other painters who were openly calling for abstract art. Secondly, France became increasingly influenced by geometric designs from abroad; firstly the Wiener Werkstätte, which had grown to prominence through the 1925 Paris International Exhibition, and later the Bauhaus, whose teachings were being propagated by young working architects. Finally, the Functionalist school, which was still a small minority in 1925 (Mallet-Stevens, Herbst, Chareau and Jourdain were its only representatives at the Paris exhibition, along with Le Corbusier), attracted many recruits and became more and more influential, leading to the foundation of the U.A.M. (Union des Artistes Modernes) in 1930. Functionalism was opposed to ornamentation, so it is easy to understand why the days of the flower were numbered; more so because the theorists behind the movement were architects who taught that the square and ruler were its basic tools.

In 1925, Sonia Delaunay had just turned forty, and was exhibiting her new multicoloured silk prints at her 'Boutique Simultanée' on the Pont Alexandre III. Their highly stylized polychrome forms contained no obvious flowers (or almost none: see ill. 158), and the patterns were made up of the most basic shapes – squares, rectangles, triangles – with a simplicity that was considered both shocking and remarkable. The same goes for the apparently uniform blocks of colour, without shading or variation (ills 159–186). This was the breakthrough of the new international style which, three years later, Sonia Delaunay displayed in a book published by Charles Moreau, devoted to the latest textiles. She was a pioneer of the new painterly style, in which fashion fabrics were covered in careful combinations of different colours in ingenious primary shapes ('They contain geometric shapes because these simple and flexible elements seemed a convenient way to lay out the colours whose combinations are in fact the real objective of this research, but geometric shapes are not characteristic of our art, since the positioning of the colours could also quite easily be done using complex forms, such as flowers...' (Sonia Delaunay, 'L'influence de la peinture sur l'art vestimentaire', a lecture given at the Sorbonne, 27 January 27). However, Sonia Delaunay was not as isolated as the retrospective emphasis laid on her might make us think. Some illustrations in this section from the same period show that other avant-garde artists and manufacturers used the same approaches, and even the same formal and chromatic techniques, in their fabric designs (Burkhalter, ill. 206, 1924; Bianchini, ill. 249, 1925; Studium, ill. 110, 1925; Primavera, ill. 204, 1926). This proves that this stylistic sea change in textile design was a truly collective phenomenon, the result of far-reaching practical and cultural trends, and was not, as was the case in the fine arts, merely the result of the impact of a few strong personalities on followers engaged in similar formal experiments (such as Picasso and Braque in Cubism, or Matisse and Derain in Fauvism).

At the 1925 Paris exhibition, Chareau used woven fabrics by Hélène Henry as curtains for the windows of the library he designed for the 'French Embassy' stand. These clearly differ from Sonia Delaunay's prints in both colour and material, but they share the same inspiration and method, with parallel horizontal strips in subtle mauve monochromes. Henry (ills 216–230) created furnishing fabrics which were both rich, with their striking rayon and refined use of textures, and restrained, using highly simplified designs in subtle, closely harmonizing colours. Her work was in close harmony with decorative trends of the day and created a fertile synergy with modernists such as Chareau, Herbst, Mallet-Stevens and Sognot, who in turn were able to exploit the deceptively simple, even old-fashioned, appearance of these handwoven textiles to their own ends. Among the artists already discussed, Hélène Henry was the only

weaver, and used her own looms to produce textiles that she had previously designed and conceived, thus laying the foundations for a style of a textile art which was later developed by Anni Albers at the Bauhaus.

The geometric development of ornamental patterns certainly owed a great deal to both Delaunay and Henry, who worked together for some time at the U.A.M., and the major influence which their innovative textiles had on many of their colleagues accelerated a change that had already begun. Eric Bagge, a talented but still very conventional decorative artist in 1925, soon turned to geometric art and produced several magnificent collections of Art Deco prints for Bouix (ills 191–196) and machine-woven fabrics in a style reminiscent of Hélène Henry (ills 198–200). As for the Rodier brothers, who had until then remained firmly camped in the handwoven textiles used for the fashion designs in which they specialized, expanded their output to embrace furnishing fabrics and used the prolific talents which had earned them their reputation to gradually substitute geometric designs for the floral patterns that had previously dominated their work (ills 236, 237, 244–247). Many others became caught up in this new fashion, even some great floral illustrators, such as Bonfils who, in 1928, produced a design whose archetypal combination of straight lines and curves achieved lasting success (ills 214, 215). Even Verneuil, who influenced by Grasset had been one of the masters of Art Nouveau floral decoration, became a convert and in 1927 published a pattern book (*Kaléidoscope*; ills 209–211) of totally geometric designs, not dissimilar to those which the painter Georges Valmier brought out with the same publisher a few months later (ills 250–252), thus sealing his break with Cubism. The way in which these two artists, almost twenty years apart in age, took up geometric abstraction at the same time shows the sheer power of the stylistic currents that were sweeping over the decorative arts, and textile design in particular.

The silk industry in Lyons was reluctant to abandon floral decoration, which suits silk dresses so well, and so added little to this new trend, but printing workshops, which had turned only slowly to floral decoration, were eager to embrace pure geometric abstraction, since it makes poorer quality designs easier to disguise. This movement was intensified when the Depression set in, because their output, being suitable for use on furniture and relatively cheap, could still reach customers through department stores. While much of their work was mediocre, there were still some superb successes, particularly in around 1935, when great efforts were made to simulate woven textiles, using prints on textured cloth (ills 278, 279), weaving effects (ill. 277), or warp printing (ills 281).

However, floral decoration nonetheless survived for many years until after 1930, especially in prints, since the development of silk-screen printing allowed more colours to be used, exciting the designers who set their flowers off against ultra-geometric back grounds in creations that were stylistically hybrids, artificial and yet striking (ills 152–154, 188). At the same time, varied forms of disloyalty to the imperialism of geometric abstraction started to become rife, and fabric creation gave itself up to fantasy, with new themes associated with current events (Charles Lindbergh's Atlantic crossing in 1927; a 1925 car expedition through Africa, known as the 'Croisière Noire', ill. 119). With the coming of modernity, textiles both printed and woven, for furnishings and fashion, luxurious and cheap, became figurative and even narrative, turning into a true mirror of society. They created scenes, told stories, celebrated events. Genre scenes that had still been popular a year before fell out of favour, and were replaced by new illustrative themes praising technological progress – machines and aviation (ills 225, 257); or new trends – cigarettes and advertising (ills 190, 259); leisure activities such as cocktails or golf (ills 260, 263); and new social practices such as trips to the country and holidays (ills 75, 299, 306). Fabric design still dwelt in the natural world, but nature was magnified and idealized, dominated by stars and constellations (ills 148, 150, 258), seashells and waves (ills 149, 262, 310), and strange and exotic vegetation with parading toucans and colourful fruits (ills 189, 275), and flowers and leaves which are illuminated in Viennese fashion by parallels, dotted lines, zigzags and crosses (ills 270, 273).

152

153

152. ANONYMOUS. Three roses on a geometric ground. 1930.

153. ANONYMOUS. Geometric pattern with flower. 1929.

154

154. ANONYMOUS. Pots of flowers on a geometric ground. 1930.

155. ANONYMOUS. Geometric composition based on floral forms. 1929.

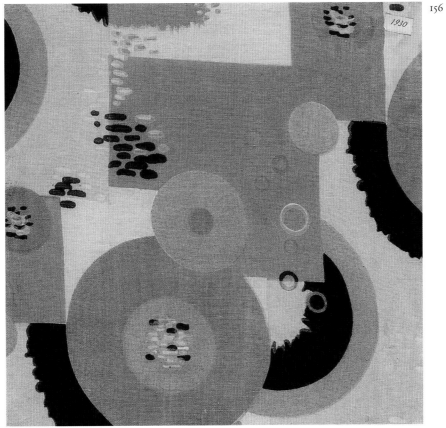

156. ANONYMOUS.
Geometric composition with
squares and circles. 1930.

157. ANONYMOUS.
Geometric composition. 1928.

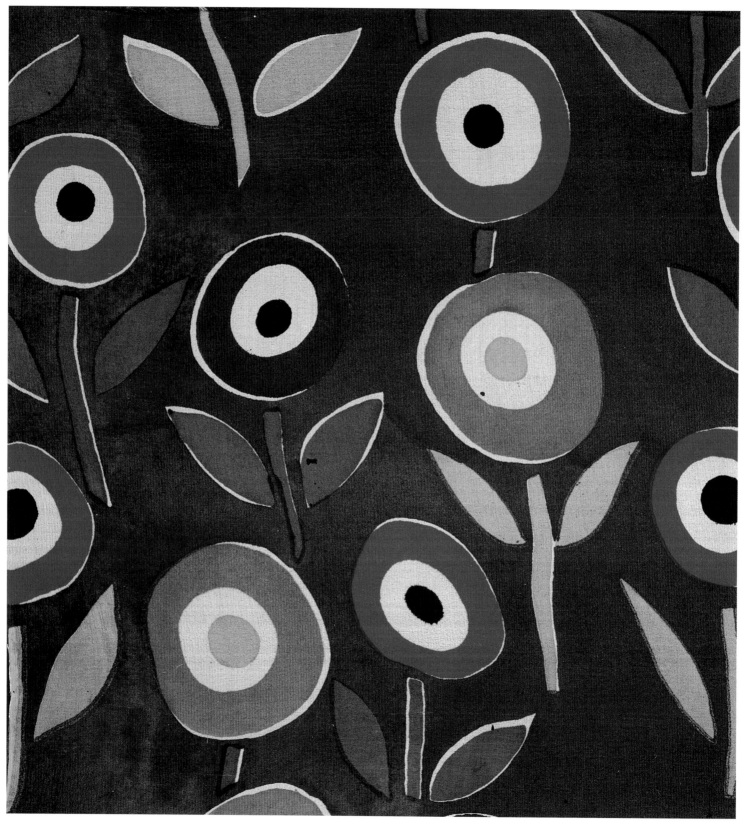

158

159

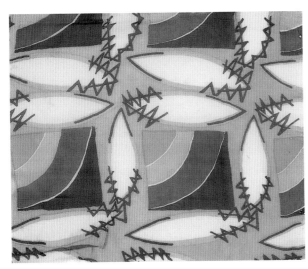

160

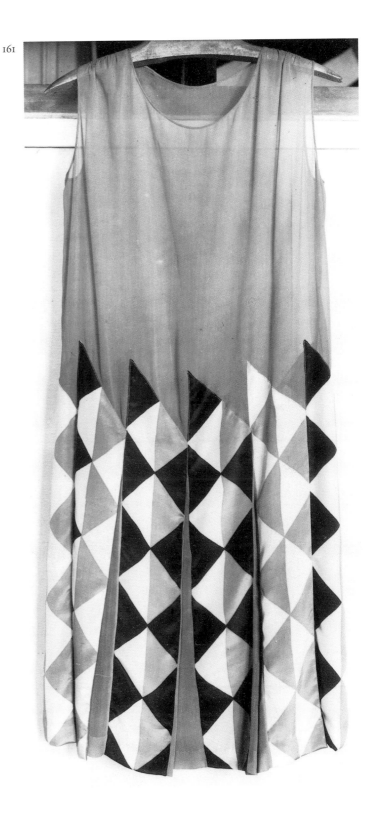

161

159. Sonia DELAUNAY. Parallel and right-angled stripes. 1925.

160. Sonia DELAUNAY. Geometric composition with squares and shuttle-shapes. 1924.

161. Sonia DELAUNAY. Dress made from printed crêpe de Chine. 1926.

158. Sonia DELAUNAY. Stylized floral pattern. 1923–24.

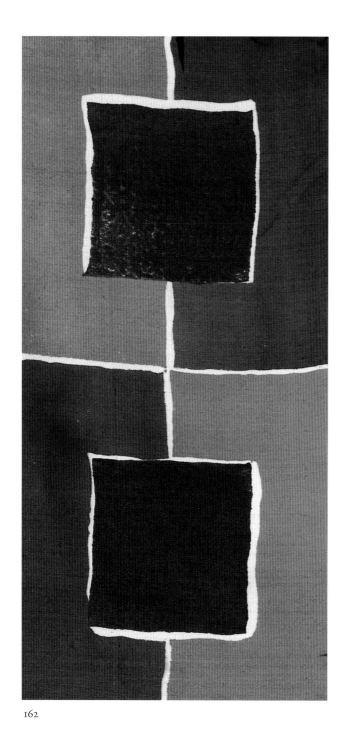

162

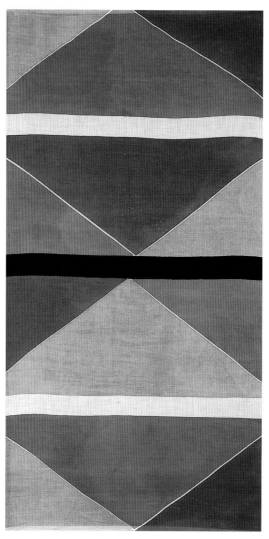

163

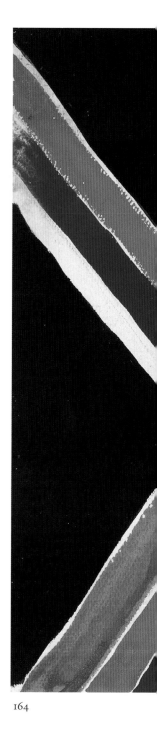

164

162. Sonia DELAUNAY. Geometric square motif. 1927.

163. Sonia DELAUNAY. Composition with divided lozenges, triangles and stripes. *c.* 1926.

164. Sonia DELAUNAY. Design for Simultaneous Fabric no. 186. 1926.

9134

L. Delaunay

déposé

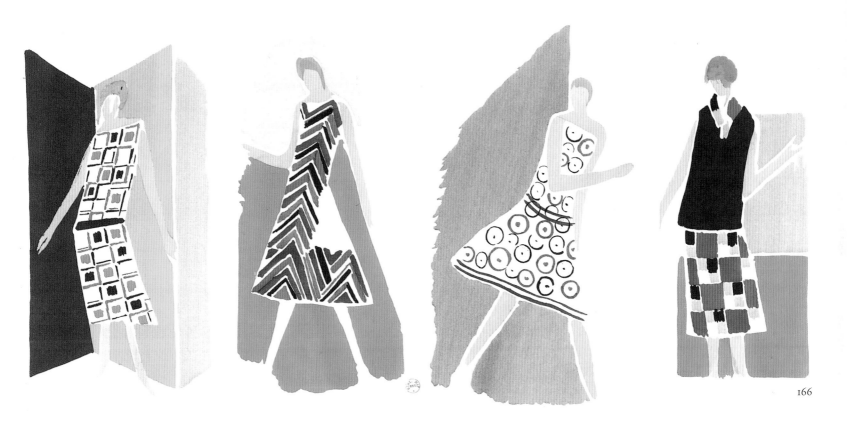

166

Sonia Delaunay

◄ 165. Sonia DELAUNAY. Design for Simultaneous
Fabric no. 34. August 1924.

166. Sonia DELAUNAY. *Ses Peintures, ses Objets, ses Tissus Simultanés, Ses Modes*, pl. 2. 1925.

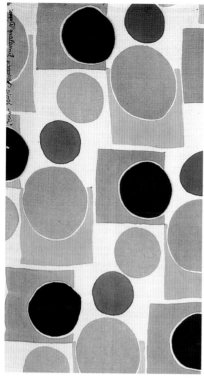

167

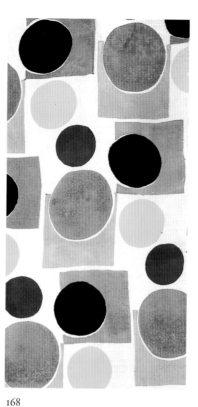

168

170

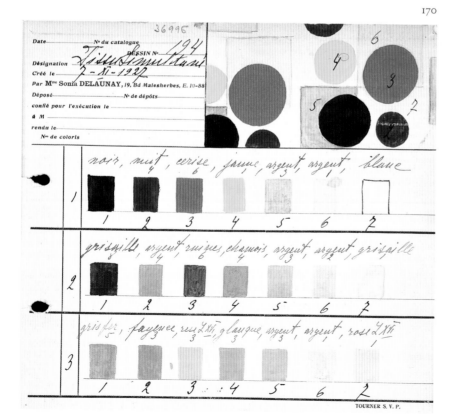

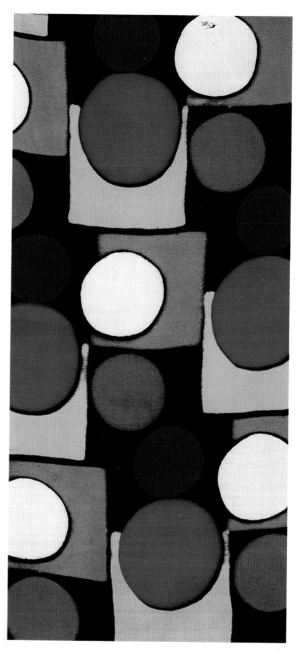

169

167, 168, 169. Sonia DELAUNAY. Multi-coloured circles on black and grey squares. 1927.

170. Sonia DELAUNAY. Colour chart for Simultaneous Fabric no. 194. 1927.

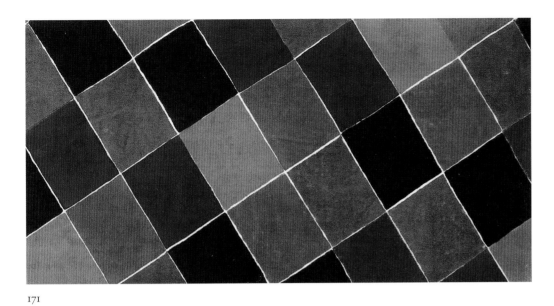

171

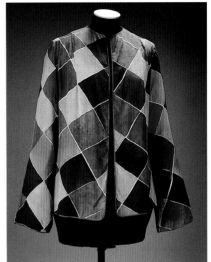

172

173

171. Sonia DELAUNAY. Harlequin check. 1926–27.

172. Sonia DELAUNAY. Jacket made from harlequin check fabric. 1928.

173. Sonia DELAUNAY. Colour chart for Simultaneous Fabric no. 189. 1927.

174. Sonia DELAUNAY. Overlapping scales. 1923–24.

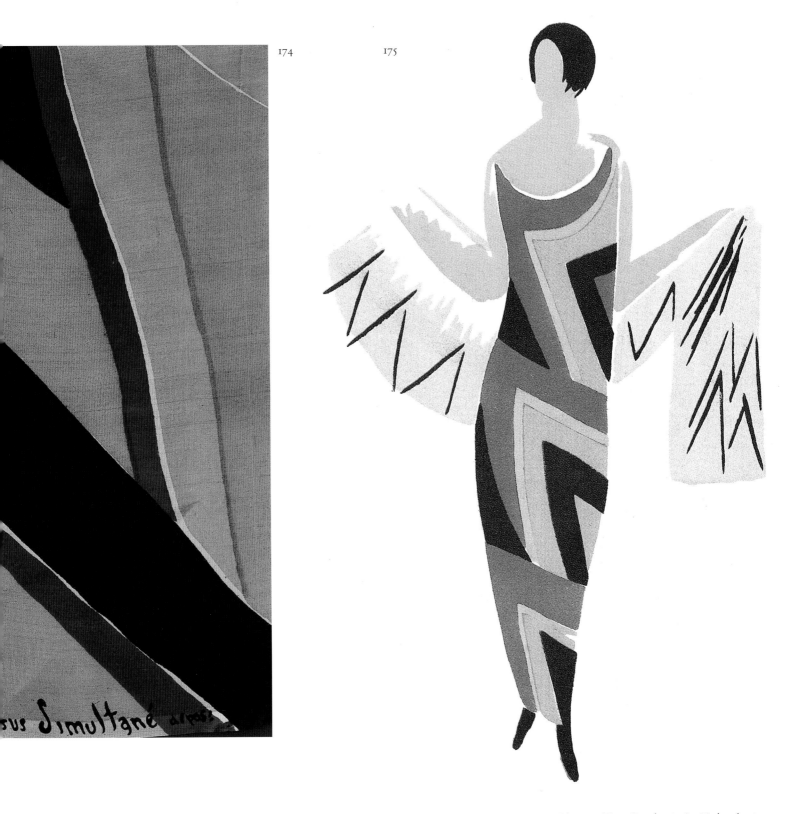

174 175

175. Sonia DELAUNAY. *Ses peintures, ses Objets, ses Tissus Simultanés, Ses Modes*, pl. 16. 1925.

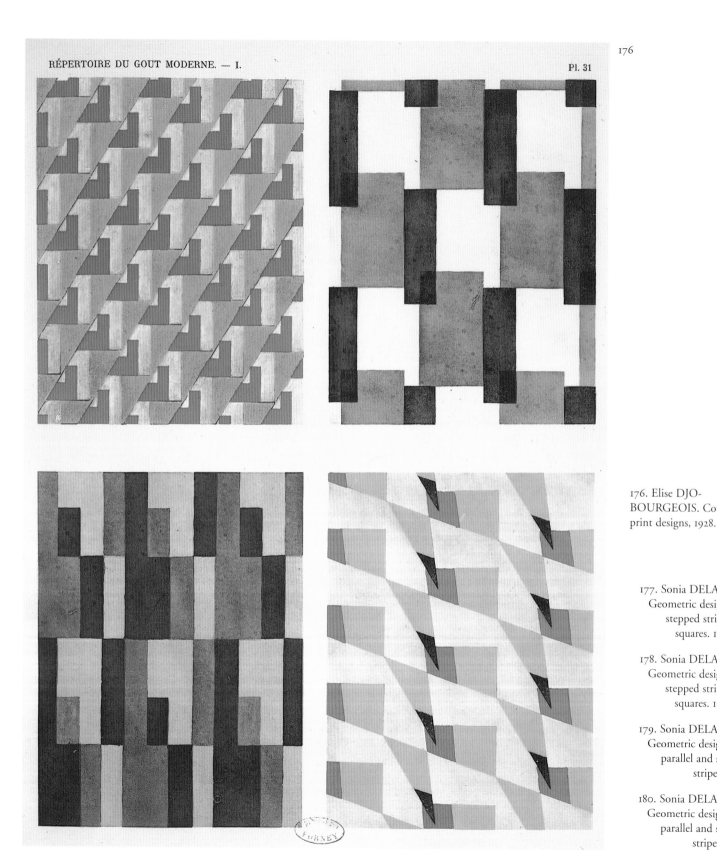

RÉPERTOIRE DU GOUT MODERNE. — I.

Pl. 31

176. Elise DJO-BOURGEOIS. Cotton print designs, 1928.

177. Sonia DELAUNAY. ▶ Geometric design with stepped stripes and squares. 1924–25.

178. Sonia DELAUNAY. Geometric design with stepped stripes and squares. 1924–25.

179. Sonia DELAUNAY. Geometric design with parallel and stepped stripes. 1924.

180. Sonia DELAUNAY. Geometric design with parallel and stepped stripes. 1926.

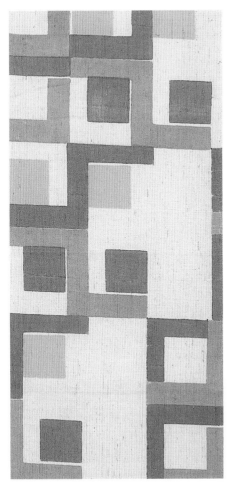
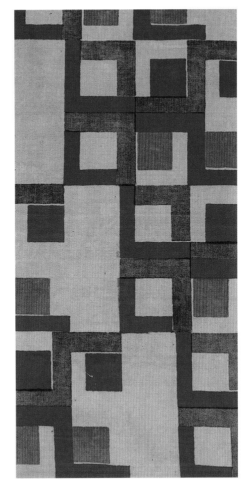
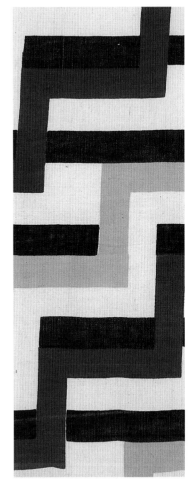

177

178

179

180

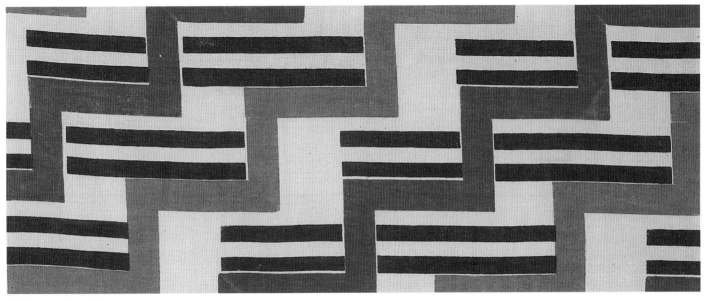

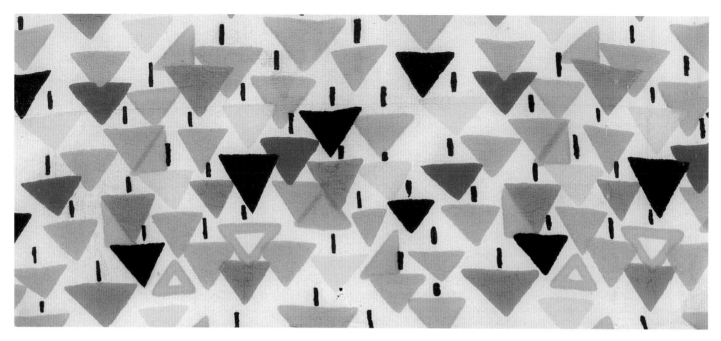

181

182

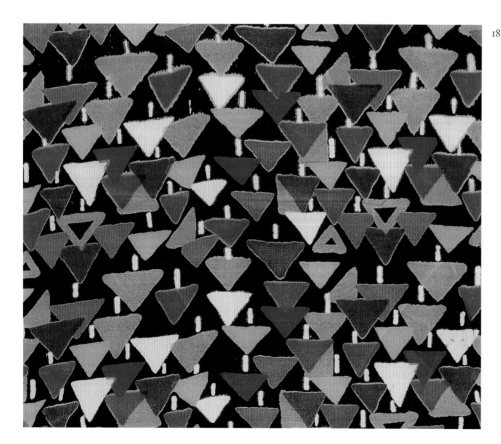

181, 182, 183, 184. Sonia DELAUNAY.
Directional motif with triangles and
vertical dashes. 1928.

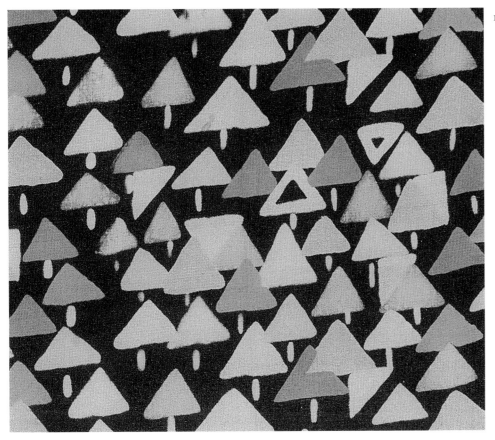
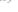

183

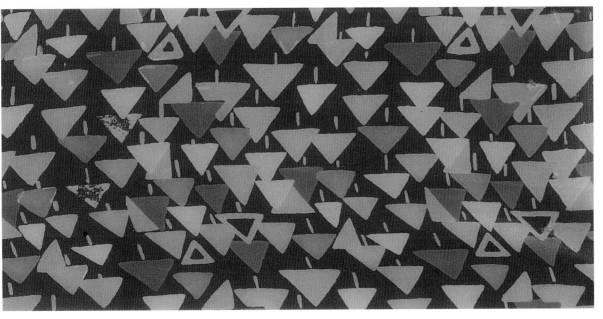

184

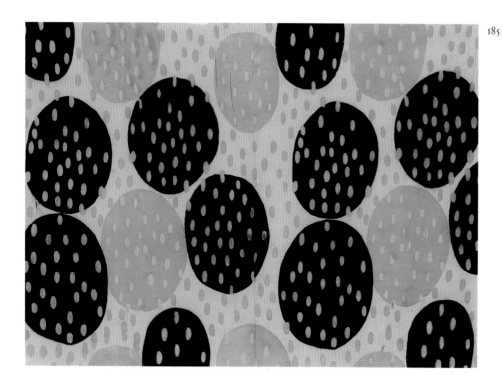

185

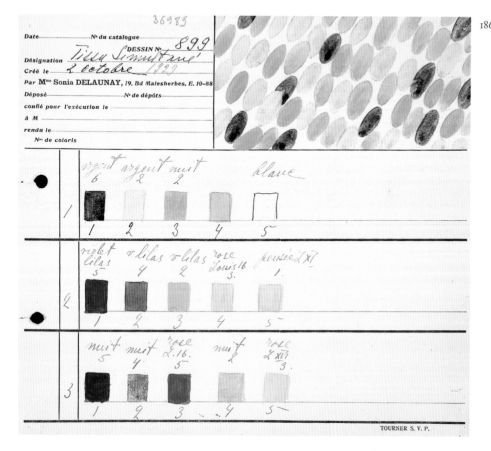

186

185. Sonia DELAUNAY. Large cellular motif with dots. 1928.

186. Sonia DELAUNAY. Colour chart for Simultaneous Fabric no. 899. 1927.

187. ANONYMOUS. Geometric composition with ground of squares and rectangles. 1925.

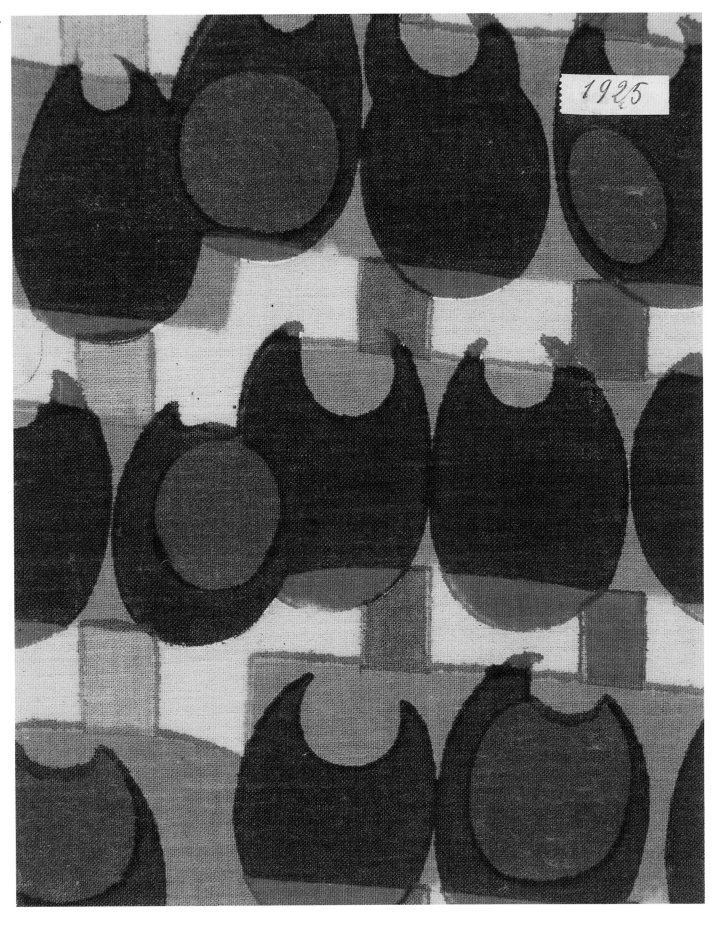

1925

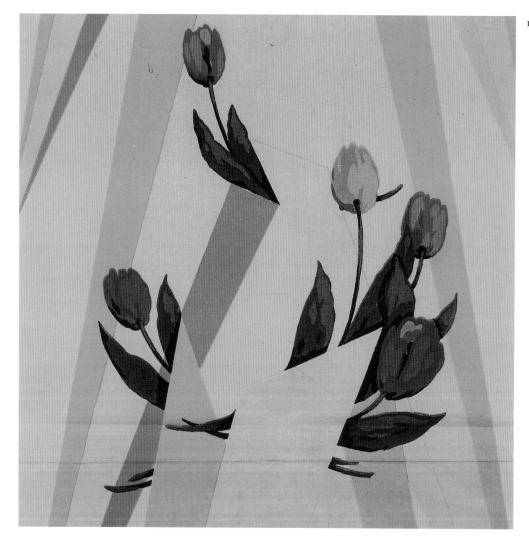

188

189. ANONYMOUS. All-over with lemons ▶
and leaves, fabric design. 1930.

Overleaf:

188. ANONYMOUS. Five tulips on a geometric ground. 1930.

190. ANONYMOUS. All-over with figures looking at posters. 1925–30.

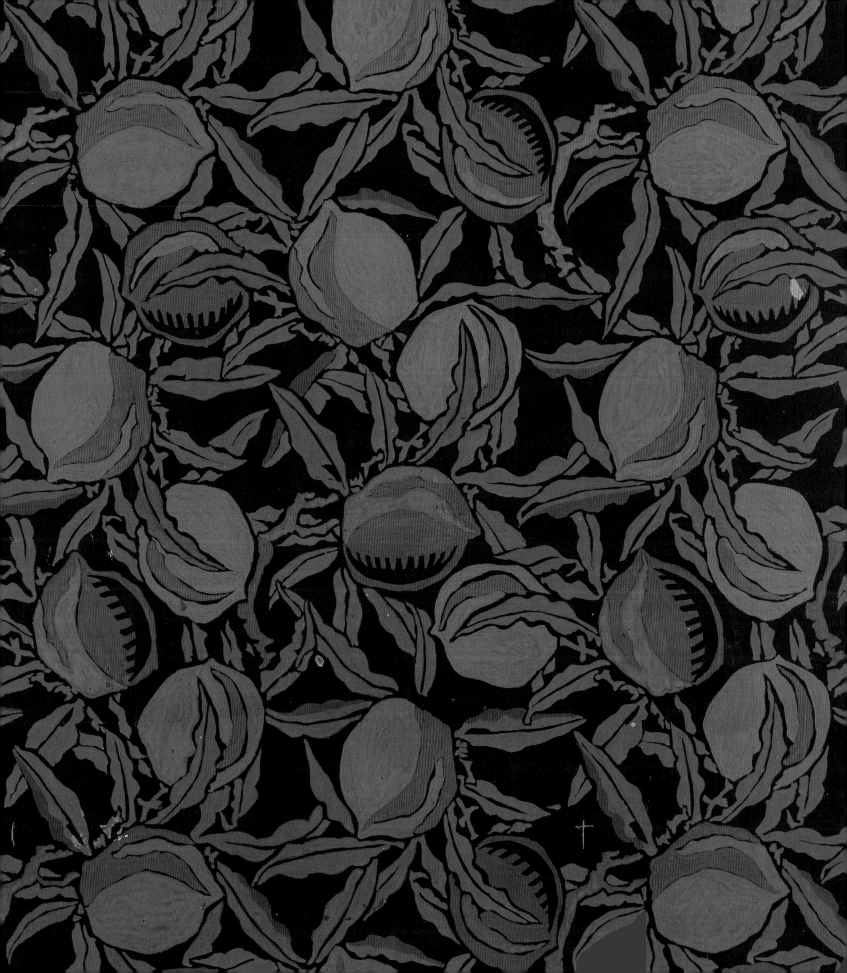

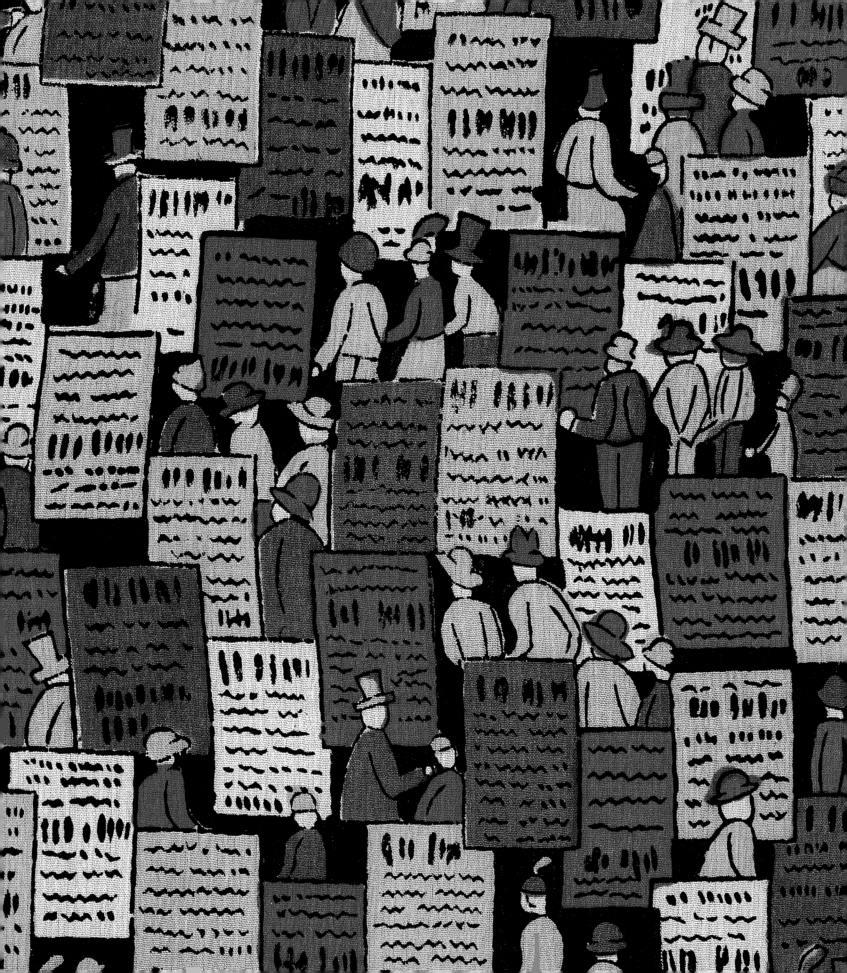

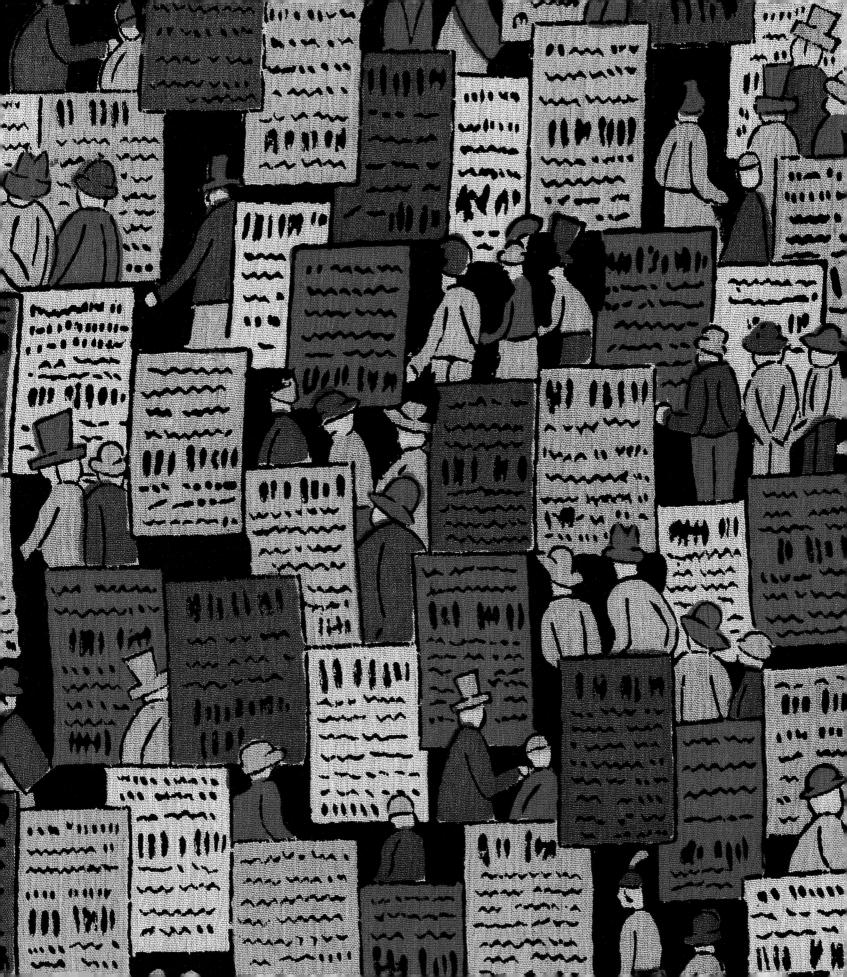

SENS UNIQUE

Pᵒⁿ 11.518 **Qualité 13**
Largeur 130 **Raccᵈ 0ᵐ82**

Pᵒⁿ 11.519 **Qualité 13**
Largeur 130 **Raccᵈ 0ᵐ82**

Pᵒⁿ 11.520 **Qualité 13**
Largeur 130 **Raccᵈ 0ᵐ82**

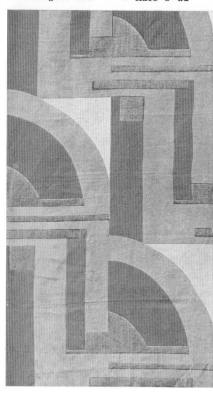
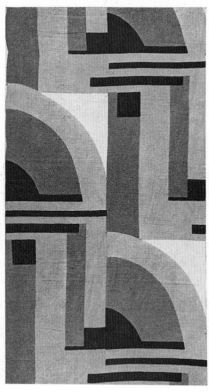
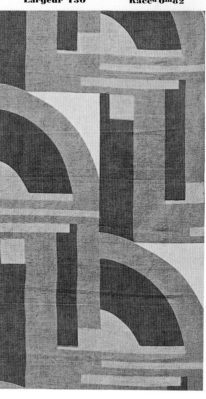

192

191

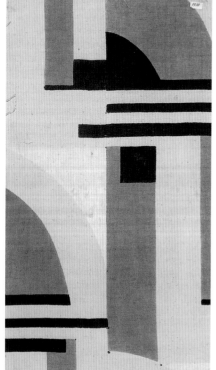

191. Eric BAGGE. 'One Way', from Lucien Bouix catalogue no. 41. 1927–28.

192. Eric BAGGE. 'One Way'. 1928.

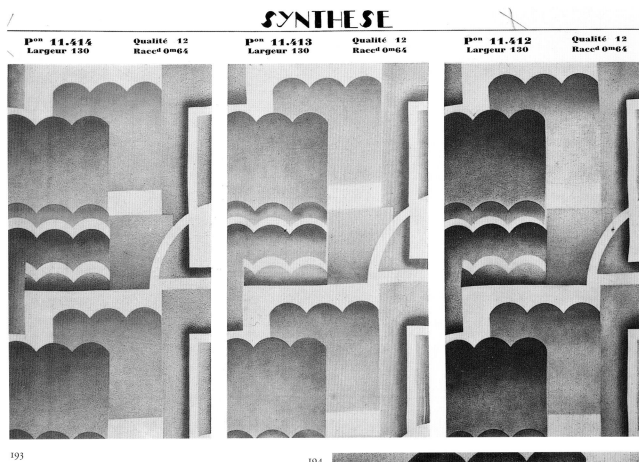

SYNTHESE

Pᵒⁿ **11.414** Qualité 12
Largeur 130 Racc⁴ 0ᵐ64

Pᵒⁿ **11.413** Qualité 12
Largeur 130 Racc⁴ 0ᵐ64

Pᵒⁿ **11.412** Qualité 12
Largeur 130 Racc⁴ 0ᵐ64

193

194

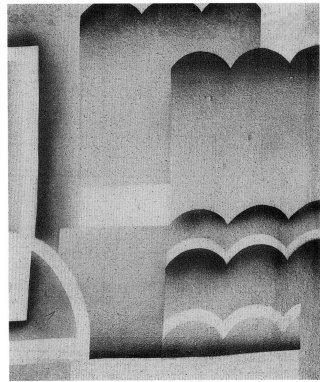

193. Eric BAGGE. 'Synthesis', from Lucien Bouix catalogue no. 41. 1927–28.

194. Eric BAGGE. 'Synthesis'. 1927–28.

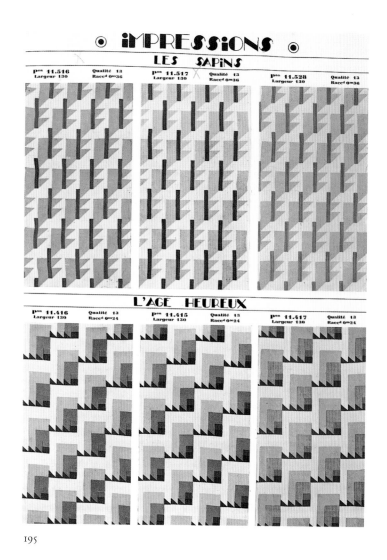

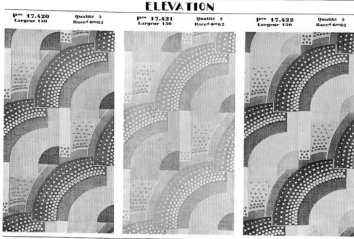

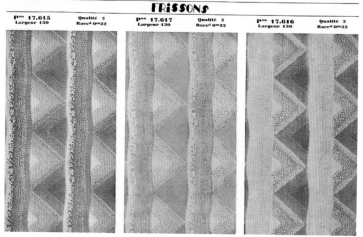

195

196

197

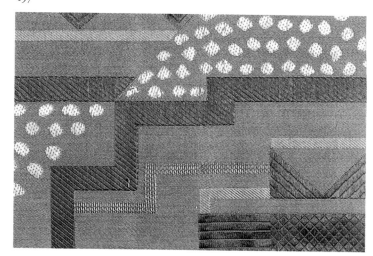

195. Eric BAGGE. 'Fir Trees' and 'L' Age Heureux',
from Lucien Bouix catalogue no. 41. 1927–28.

196. Eric BAGGE. 'Elevation' and 'Frissons',
from Lucien Bouix catalogue no. 41. 1927–28.

197. Eric BAGGE. Swatch from Lucien Bouix
catalogue no. 41. 1927–28.

Opposite:

198, 199, 200. Lucien BOUIX. Swatches from catalogue no. 43. 1928–29.

198

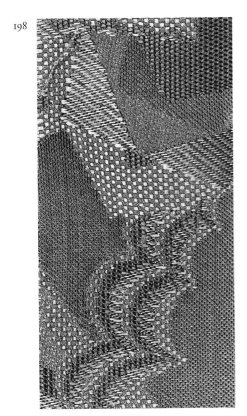

199

200

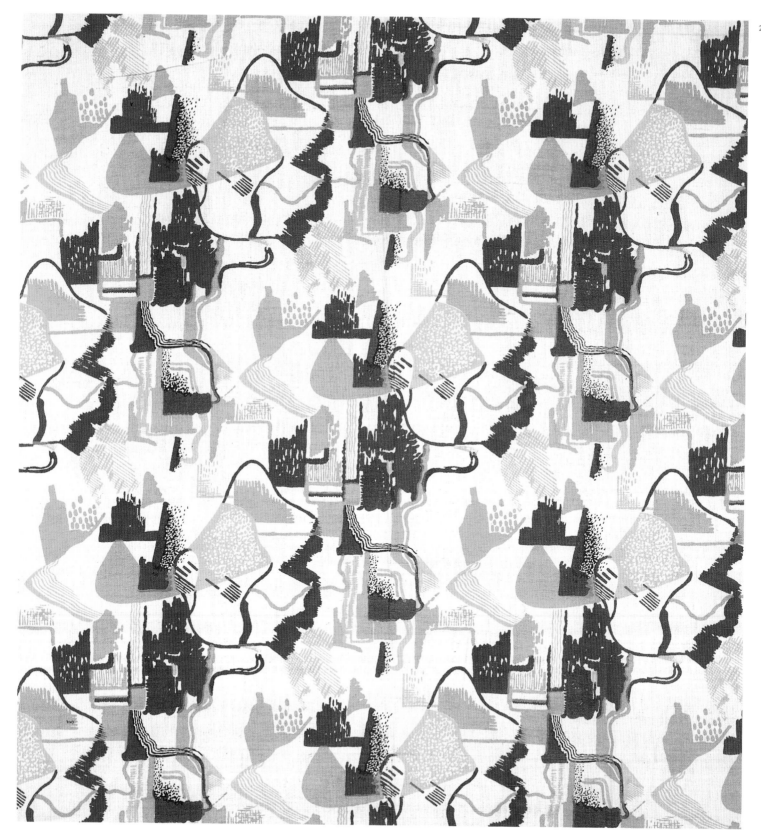

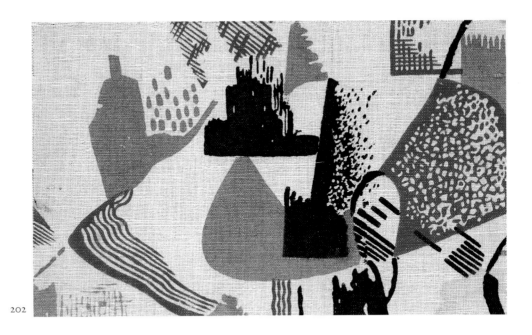

202

203

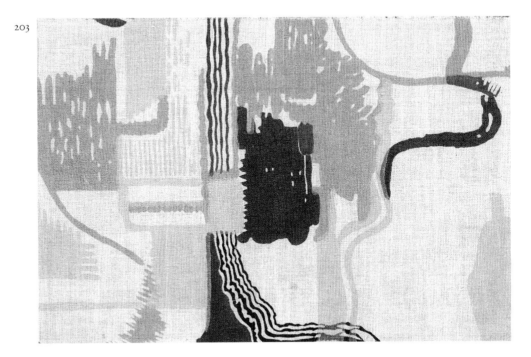

201. Jean BURKHALTER. Abstract pattern. 1929.

202, 203. Jean BURKHALTER. Colour variations for the fabric opposite. 1929.

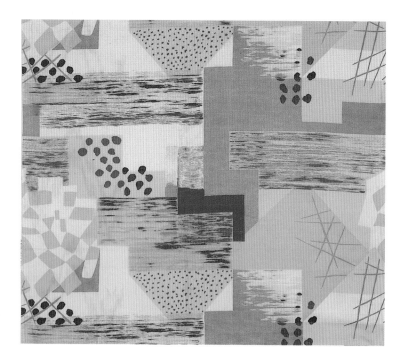

204

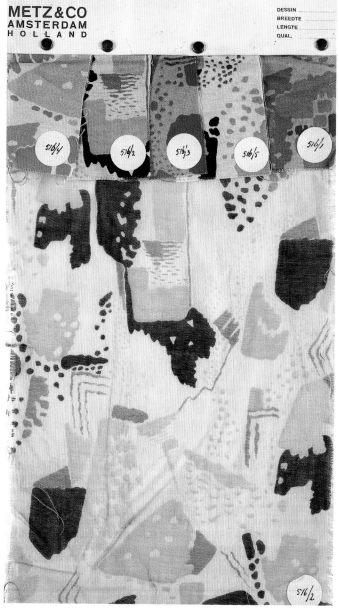

205

204. Atelier PRIMAVERA. Abstract pattern. 1926.

205. Jean BURKHALTER. Abstract pattern with range of colourways. 1928–30.

206. Jean BURKHALTER. Geometric ►
composition. 1924.

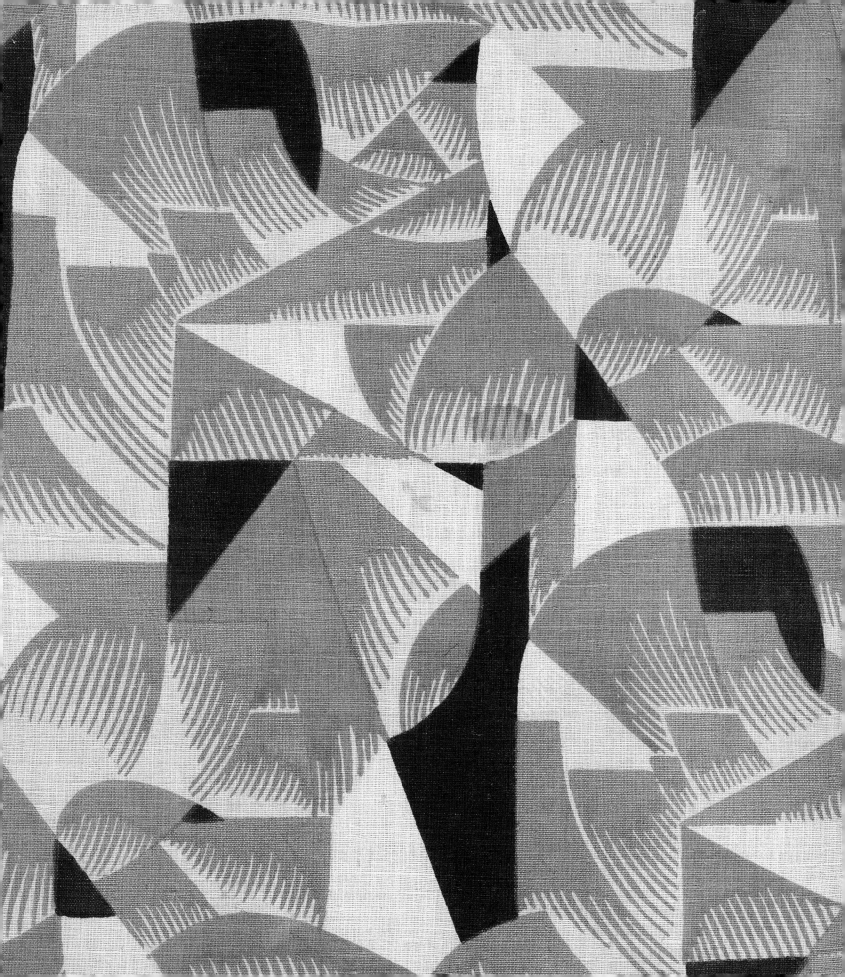

207

207. Adrien GARCELON. *Inspirations*, pl. 19. 1928.

208. Adrien GARCELON. *Inspirations*, pl. 8. 1928.

209 210

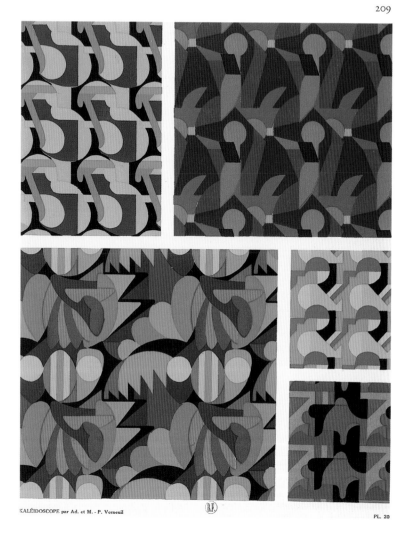

209. Maurice & Adam VERNEUIL. *Kaléidoscope*,
pl. 20. 1927.

210. Maurice & Adam VERNEUIL. *Kaléidoscope*,
pl. 5. 1927.

211. Maurice & Adam VERNEUIL. *Kaléidoscope*,
pl. 18. 1927.

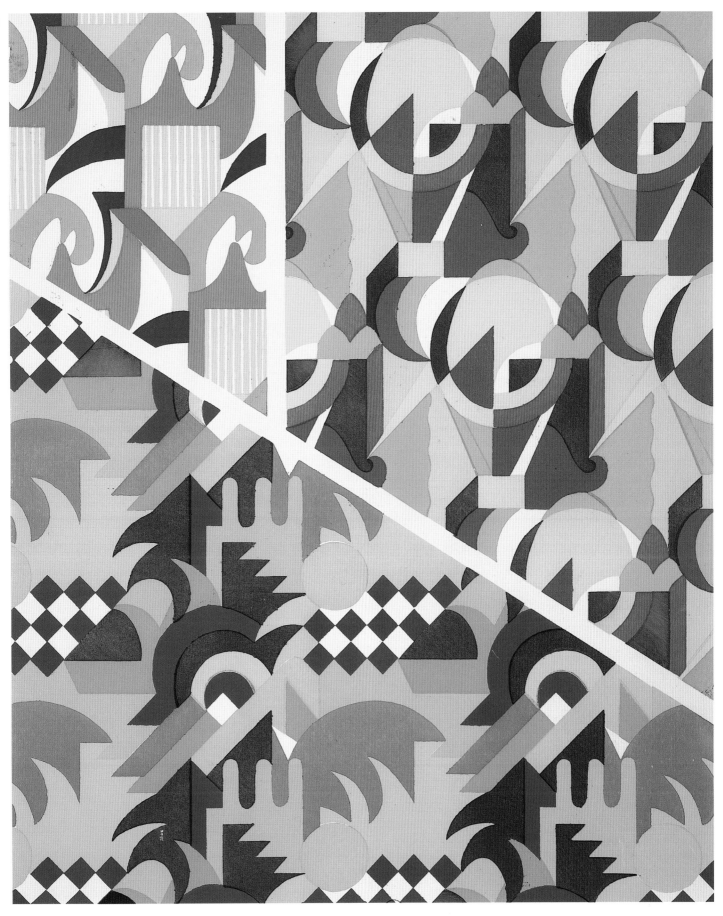

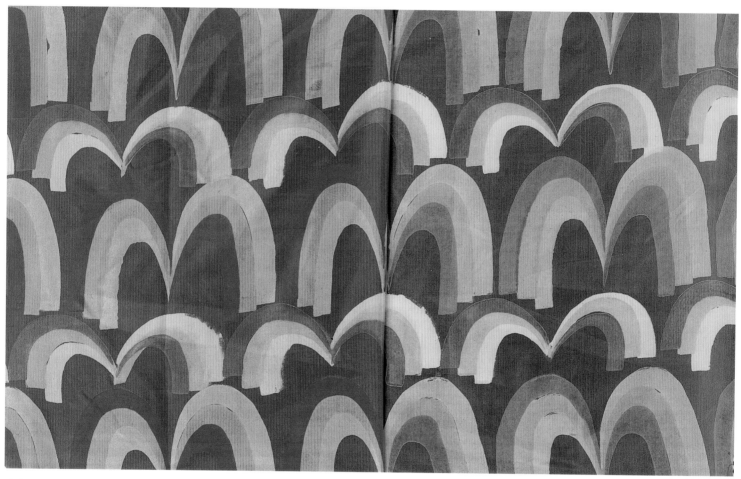

212

212. ANONYMOUS. Composition of M-shaped motifs. 1925–30.

213. Edouard BENEDICTUS. *Relais 1930*, pl. 13. 1930.

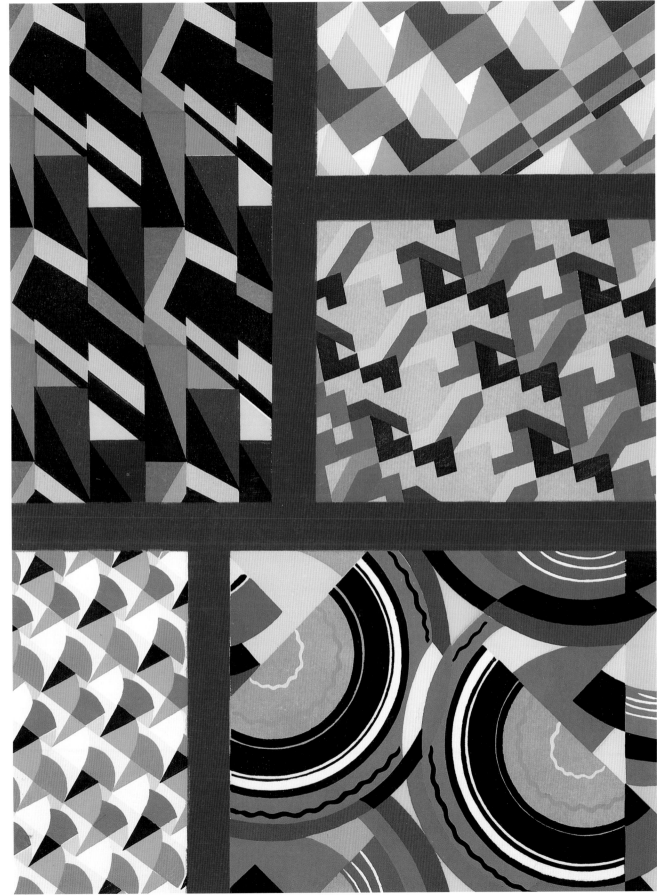

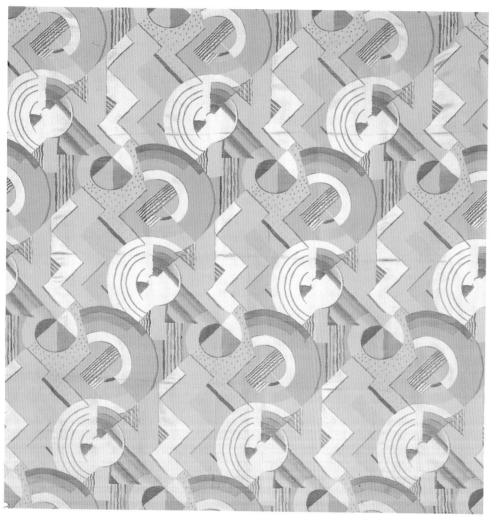

214

214. Robert BONFILS. 'Variations'. 1929.

215. Robert BONFILS. 'Variations', fabric design. 1929.

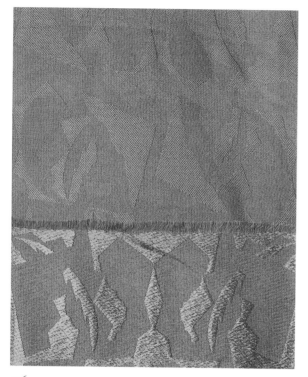

216

217

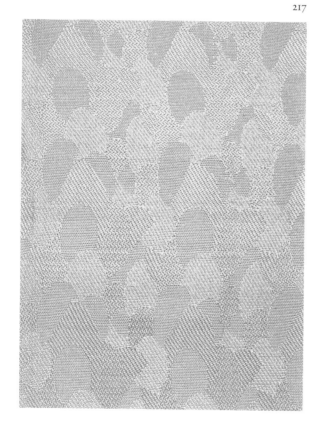

218

216. Hélène HENRY. 'Les Quartiers'. 1926.

217. Hélène HENRY. 'Petals'. 1925.

219. Hélène HENRY. 'Hens'.
1927–28.

218. Hélène HENRY. 'Martel'. 1927–28.

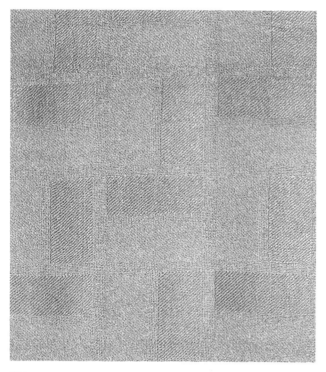

220

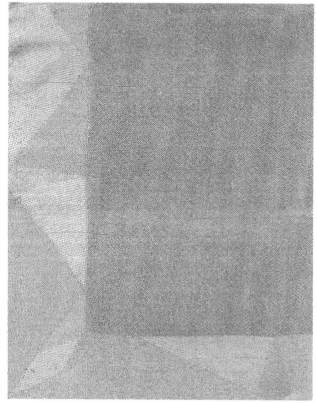

221

222

220. Hélène HENRY.
'Rectangles'. 1928–29.

221. Hélène HENRY. Detail of a
curtain panel. 1929.

222. Hélène HENRY. 'Broken
Sticks'. 1927.

223. Hélène HENRY. ►
'Rectangles'. 1928–29.

224

226

225

227

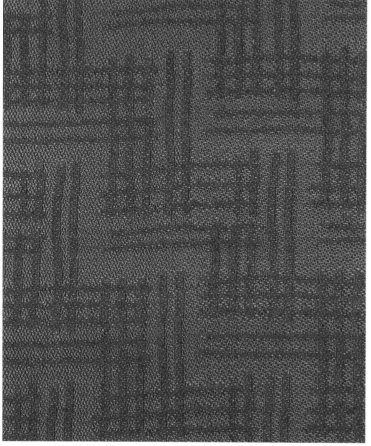

224. Hélène HENRY.
'Bluebells'. *c.* 1925.

225. Hélène HENRY.
'Lattices'. 1926–27.

226. Hélène HENRY.
Detail of ill. 227.

227. Hélène HENRY.
'Bricks', geometric motif. 1925–30.

228. Hélène HENRY.
'Spots'. 1925.

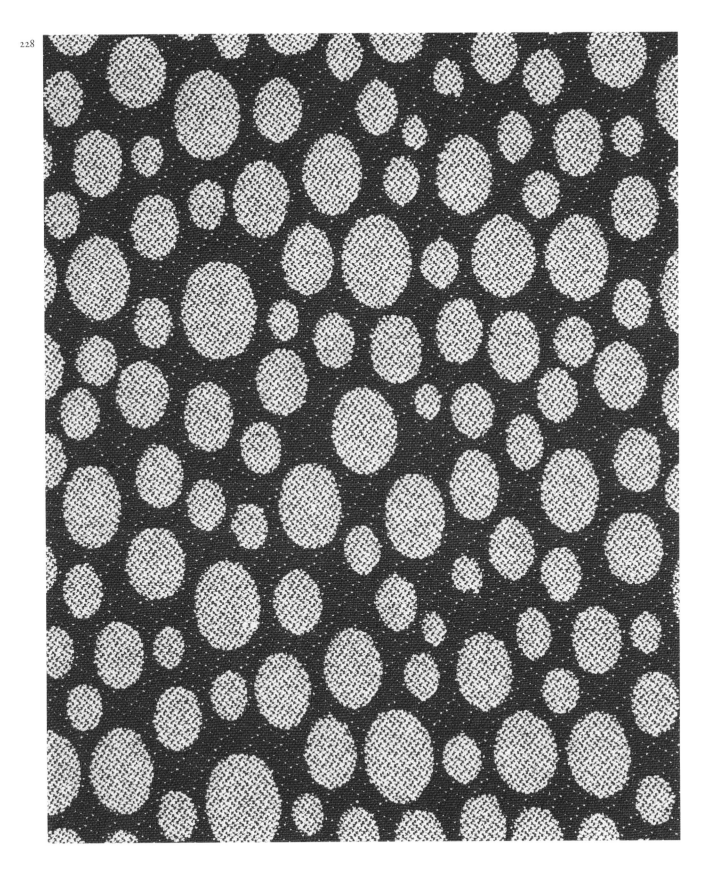

228

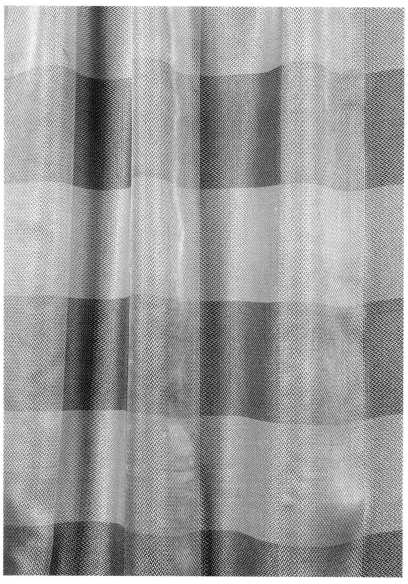

229

230

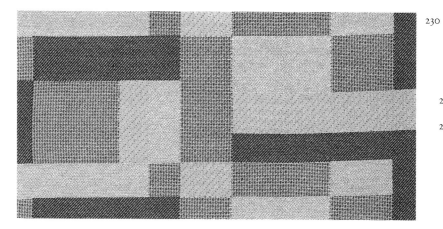

229. Hélène HENRY. Squares. 1927.

230. Hélène HENRY. Geometric pattern. 1927–28.

231. Ketty RAISIN (and/or Michel DUBOST).
'Lines and Lights'. 1925–35.

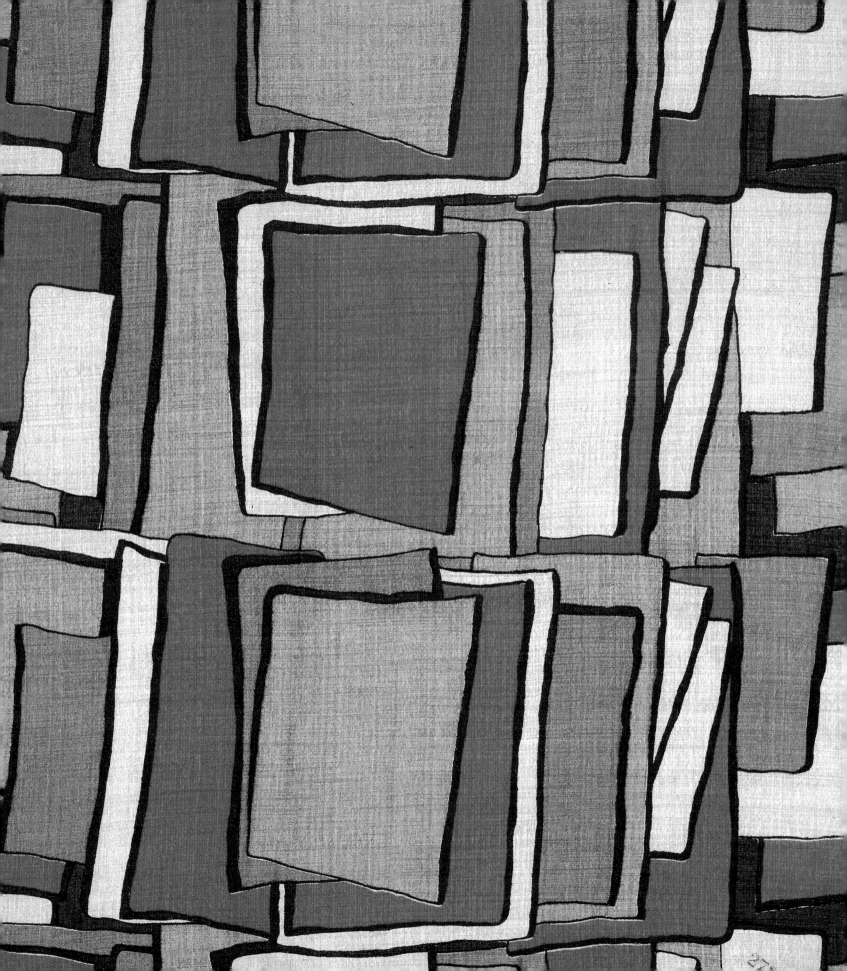

◀ 232. CHANEL. Abstract
pattern. 1929.

233, 234, 235. CHANEL. Abstract pattern
in three different colourways. 1929.

236

237

236. RODIER. Squares and rectangles
with parallel lines. 1932.

237. RODIER. Triangles with dots and
cross-hatching. 1932.

Opposite:

238. RODIER. *Creations for Spring and
Summer 1932,* New York. 1932.

239. RODIER. *Creations for Spring and
Summer 1932,* New York. 1932.

240. ANONYMOUS. Geometric pattern
with squares and dots. 1931.

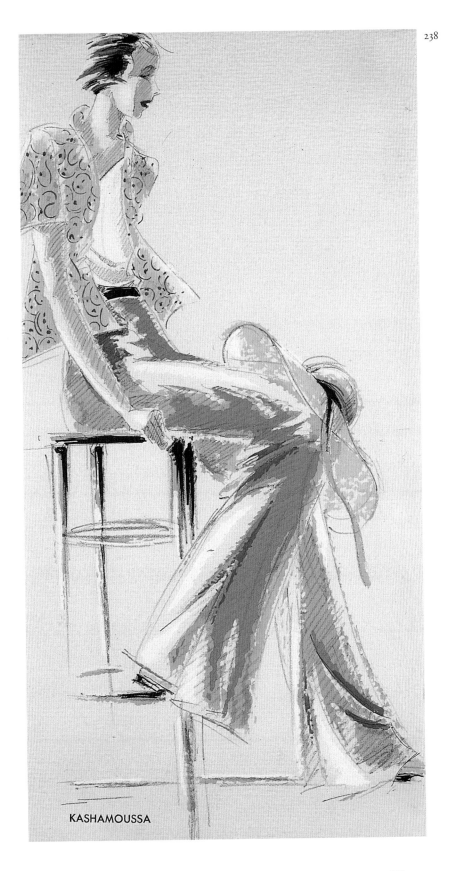

KASHAMOUSSA

238

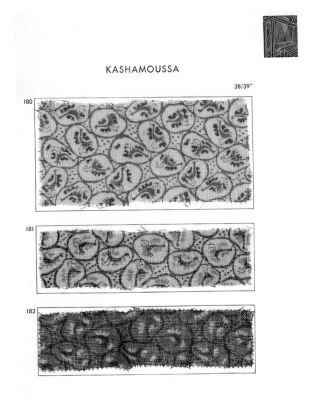

KASHAMOUSSA

38/39"

239

240

241

242

241. Attr. RODIER. Geometric composition. 1930–35.

242. Attr. RODIER. Geometric composition with square shapes. 1930–35.

243. ANONYMOUS. Geometric composition
with polygons filled with dots. 1931.

243

244

245

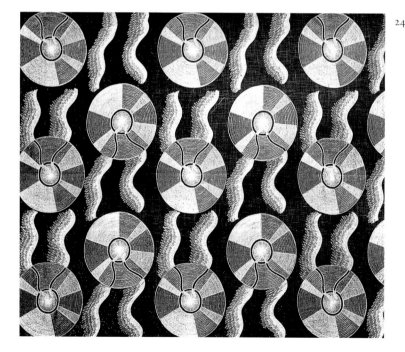

244. RODIER. Composition of four-sided shapes with geometric motifs. 1928.

245. RODIER. Geometric composition with discs and wavy lines. 1929.

246. RODIER. Pattern of overlapping squares. 1928.

247. RODIER. Geometric composition with polygons and spots. 1928.

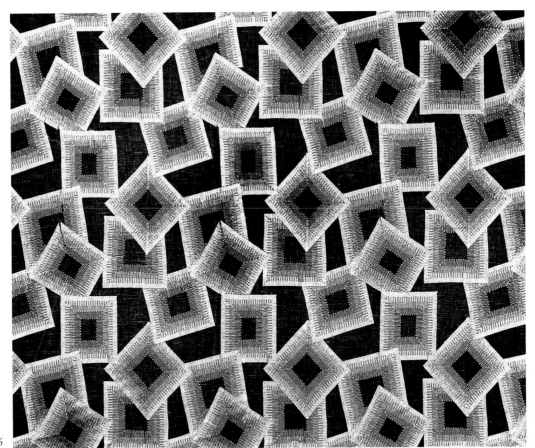

246

247

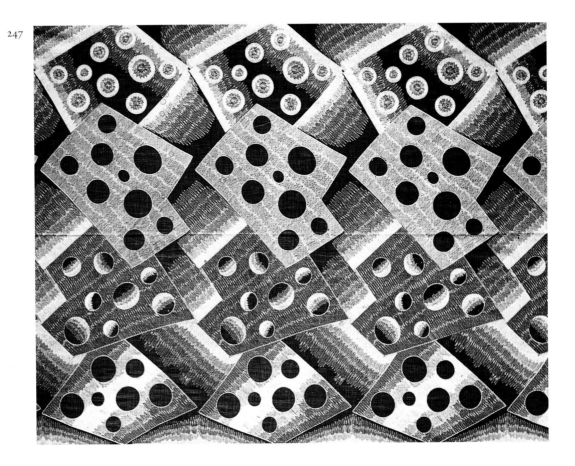

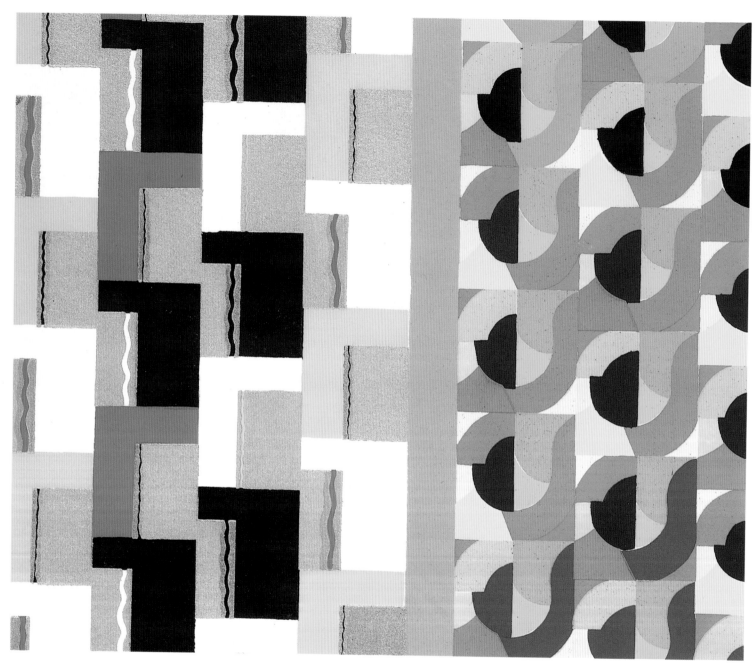

248

248. Edouard BENEDICTUS. *Relais 1930*, pl. 4. 1930.

249

249. ANONYMOUS. Interlocking blocks, fabric design. 1928.

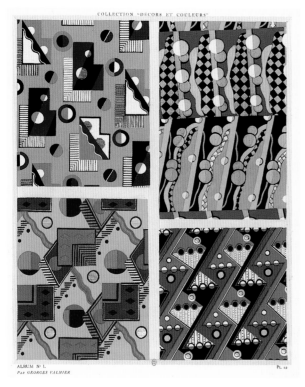

250

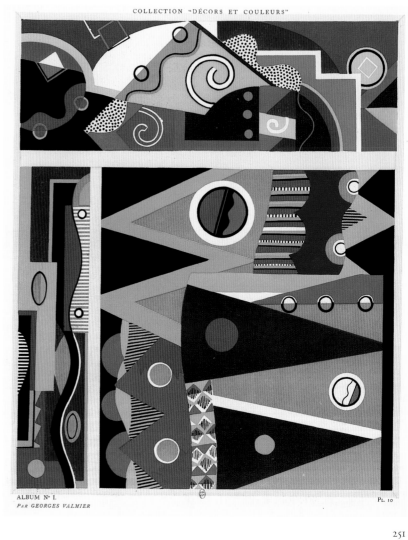

251

250. Georges VALMIER. *Album No. 1,* pl. 12. 1929–30.

251. Georges VALMIER. *Album No. 1,* pl. 10. 1929–30.

252. Georges VALMIER. *Album No. 1,* pl. 3. 1929–30. ▶

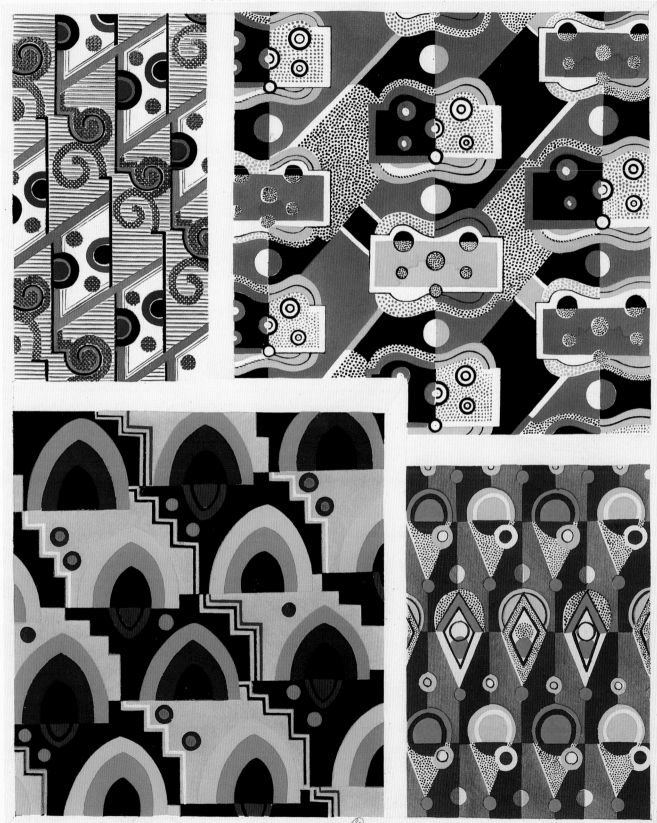

ALBUM Nº I.

Par GEORGES VALMIER

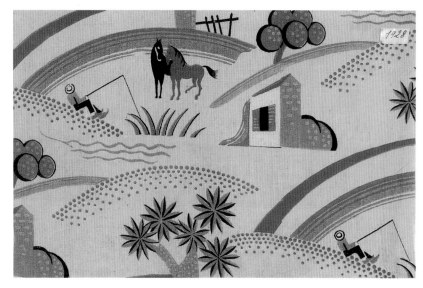

253

254

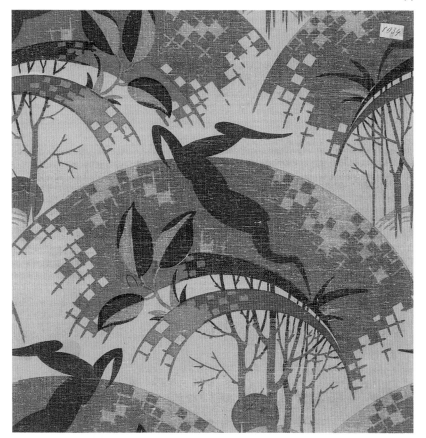

255. Jacques CAMUS. *Dessins*, pl. 18. 1929. ▶

253. ANONYMOUS. Pastoral scene. 1928.

254. ANONYMOUS. Leaping gazelle on a composite ground. 1934.

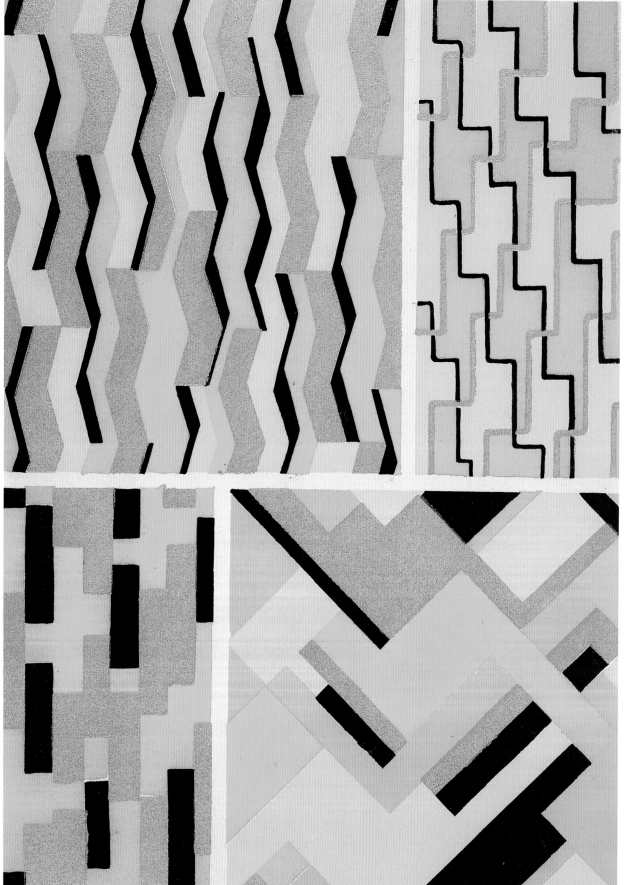

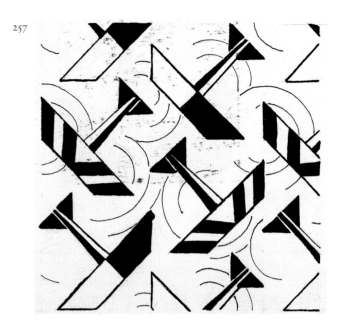

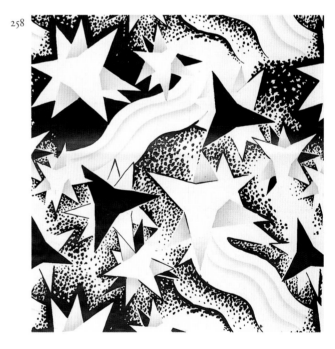

257. ANONYMOUS. Pattern of planes on ground of sound
waves, fabric design. 1929.

256. Boris LACROIX. *Dessins,* pl. 19. 1929.

258. Robert BONFILS. Shooting stars, fabric design. 1930.

259

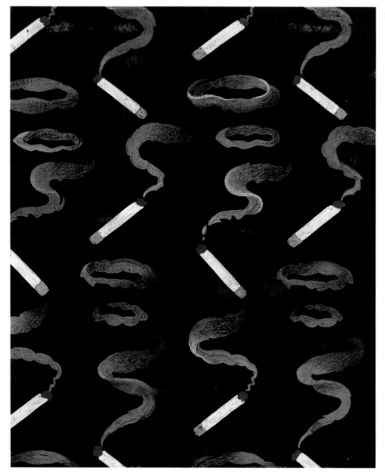

259. ANONYMOUS. Lighted cigarettes, fabric design. 1930.

260. ANONYMOUS. Cocktails. 1930. ▶

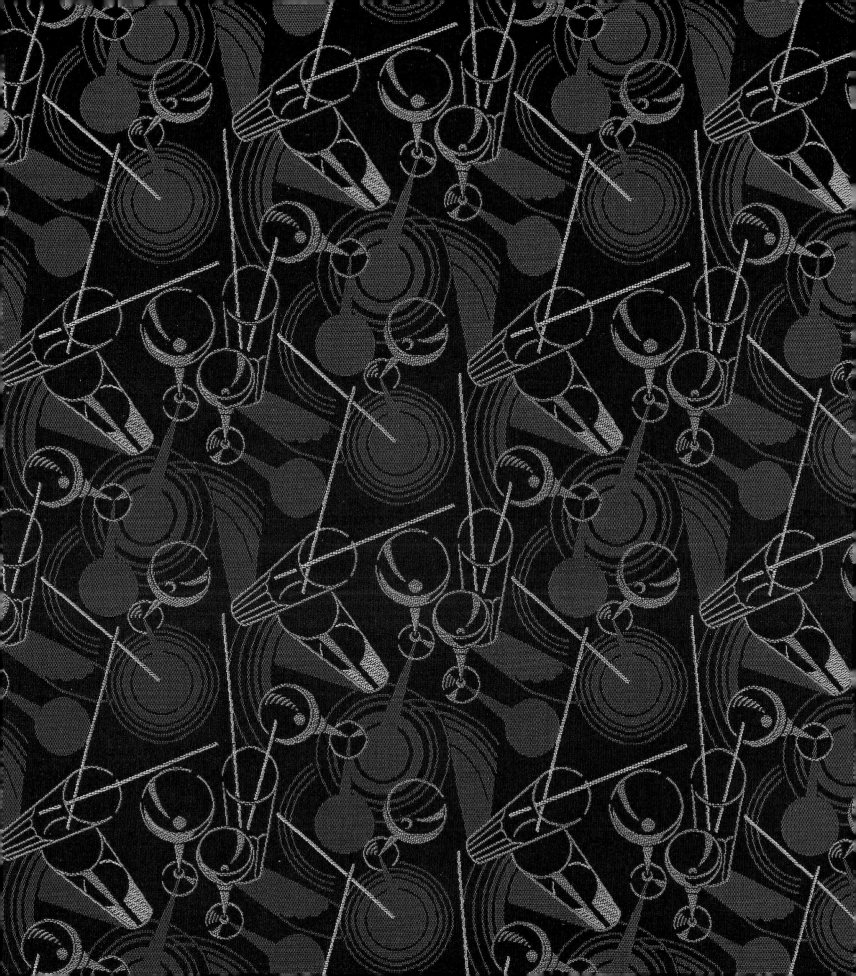

261

261. ANONYMOUS. All-over with branches, fabric design. 1929.

262. Alfred LATOUR. All-over with seashells. 1929. ▶

264

◄ 263 ANONYMOUS. Golfers. 1931–32.

264. ANONYMOUS. Colourways for the
pattern shown opposite.

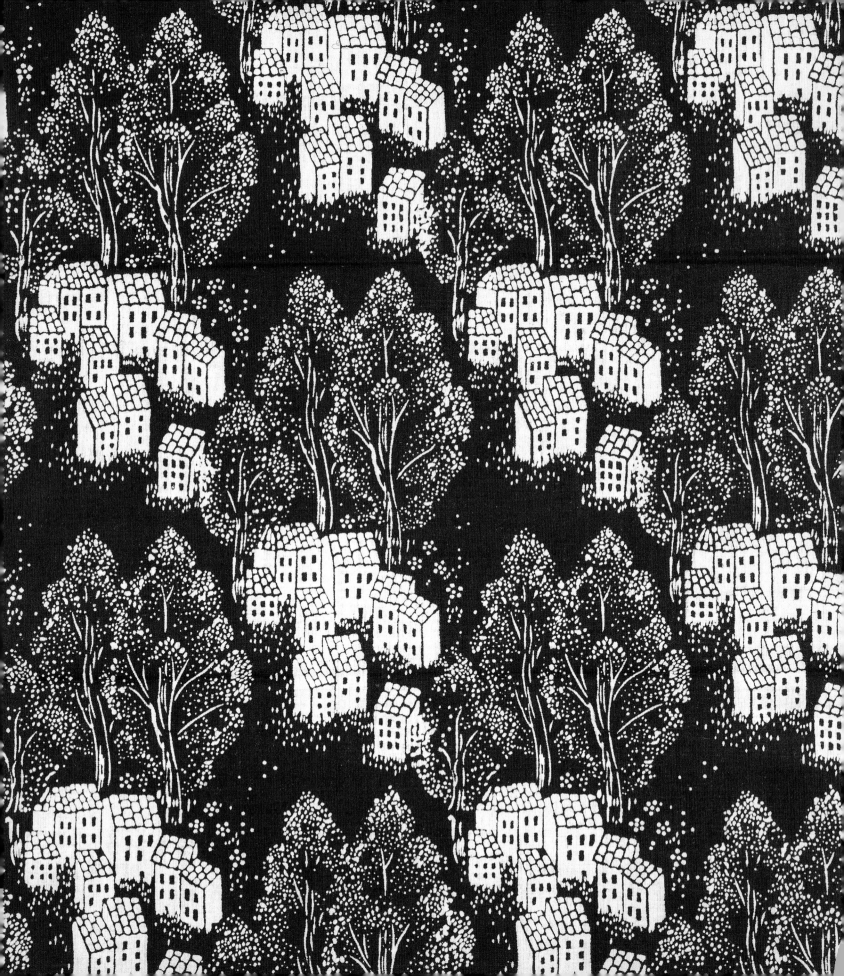

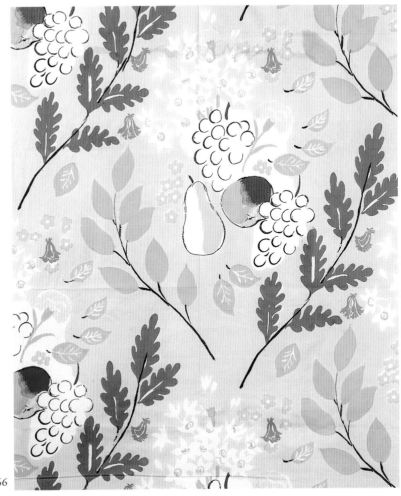

266

267

266. Paule MARROT. 'Fruits'. 1933.

267. Paule MARROT. Harlequin print. 1934.

◀ 265. Paule MARROT. 'Little Houses'. 1925.

268

268. Emile-Alain SEGUY. *Prismes*, pl. 31. 1931.

269. ANONYMOUS. Floral and geometric all-over. 1930. ▶

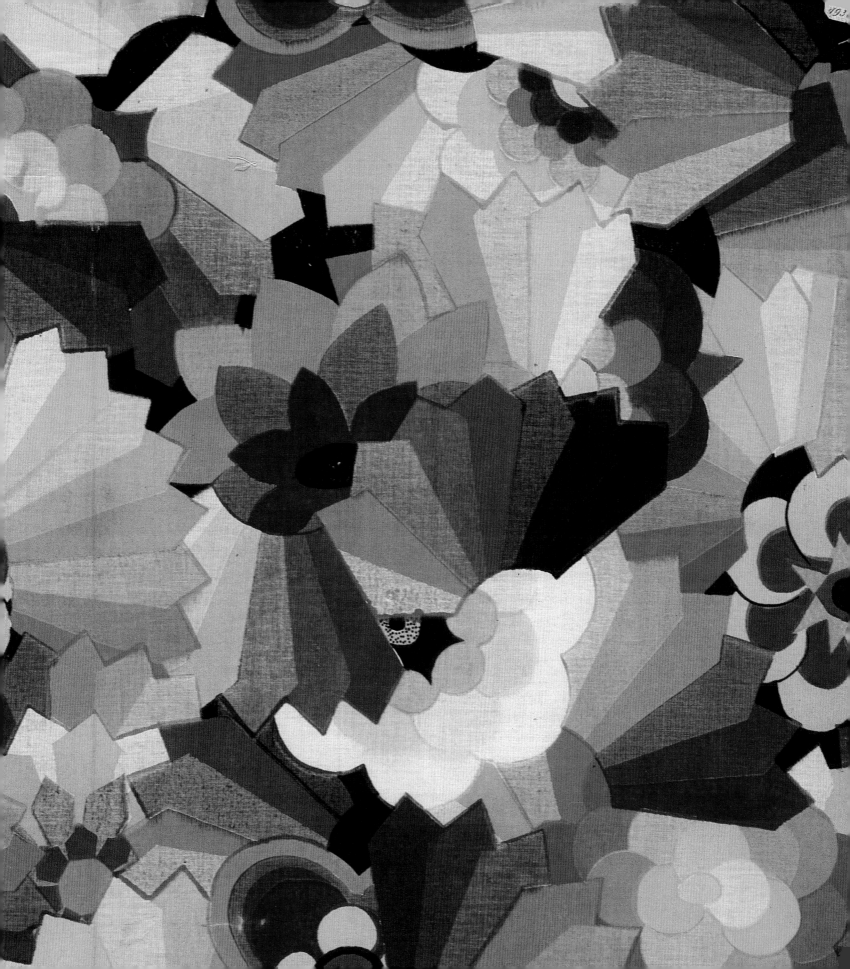

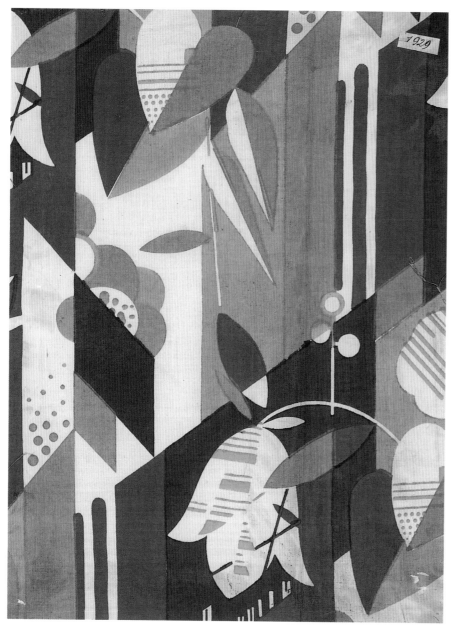

270

270. ANONYMOUS. Stylized flowers and leaves on a geometric ground. 1929.

271 and 272. ANONYMOUS. Modernist stripes. 1928.

271

272

273. ANONYMOUS. Stylized flowers and leaves. 1930.

273

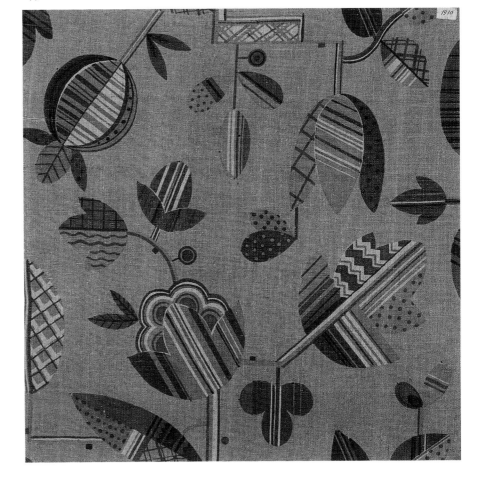

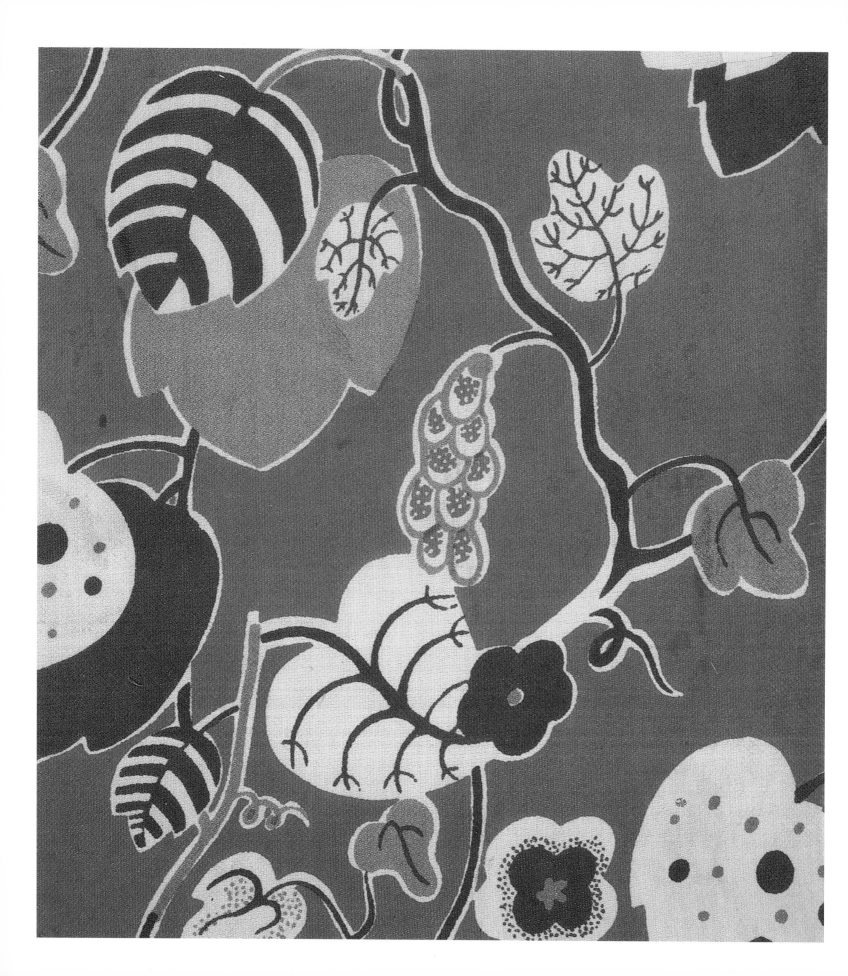

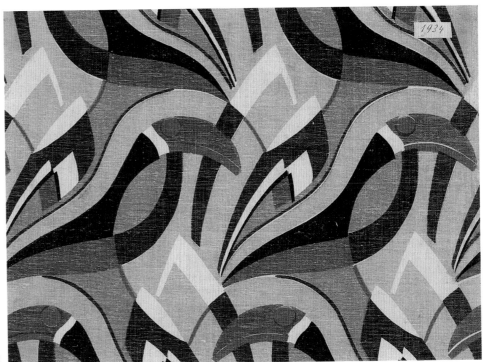

275

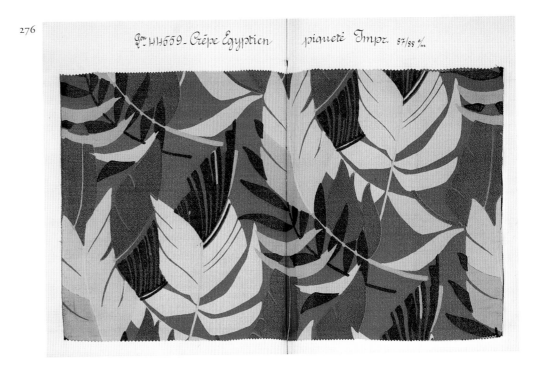

276

275. ANONYMOUS. Frieze of geometric toucans. 1934.

276. ANONYMOUS. Naturalistic palm leaves. 1931.

◀ 274. ANONYMOUS. Stylized leaves. 1934.

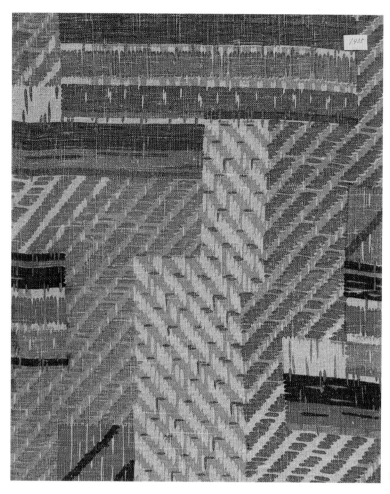

277

278

277. ANONYMOUS. Pattern of rectangles and diagonal stripes. 1933.

278. ANONYMOUS. Geometric composition inspired by leaves. 1933.

279. ANONYMOUS. Geometric composition ▶
with stripes and four-sided shapes. 1933.

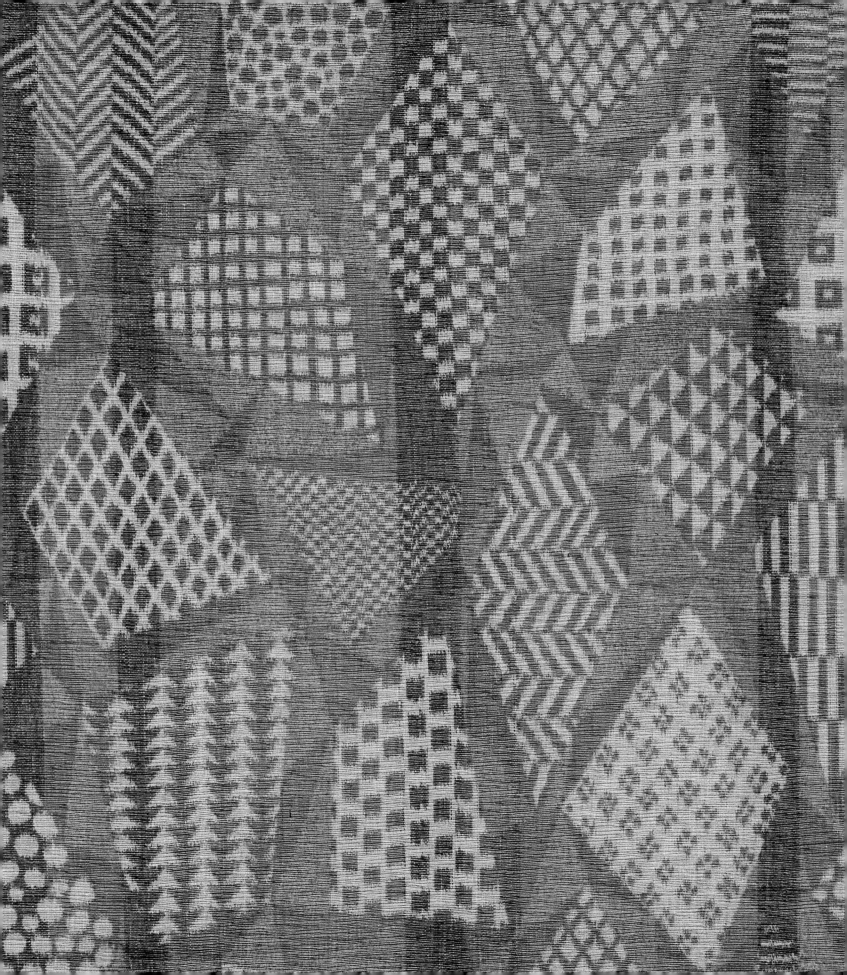

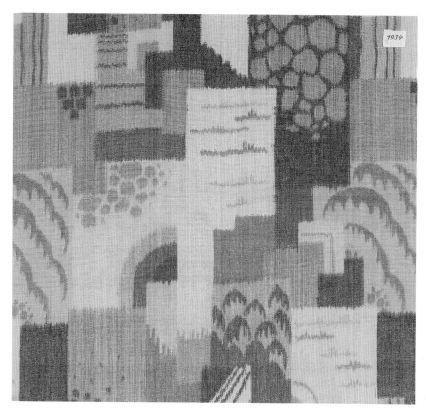

280

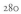

281

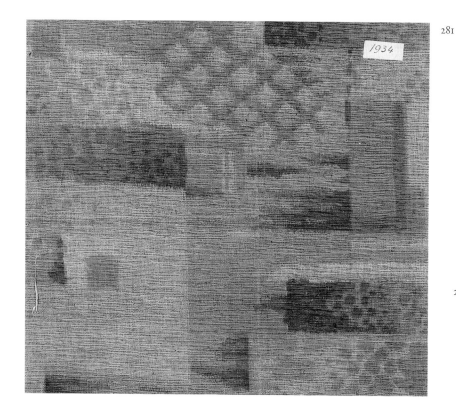

280, 281. ANONYMOUS. Abstract geometric compositions. 1934.

282. ANONYMOUS. Geometric composition with perspective effect. 1931.

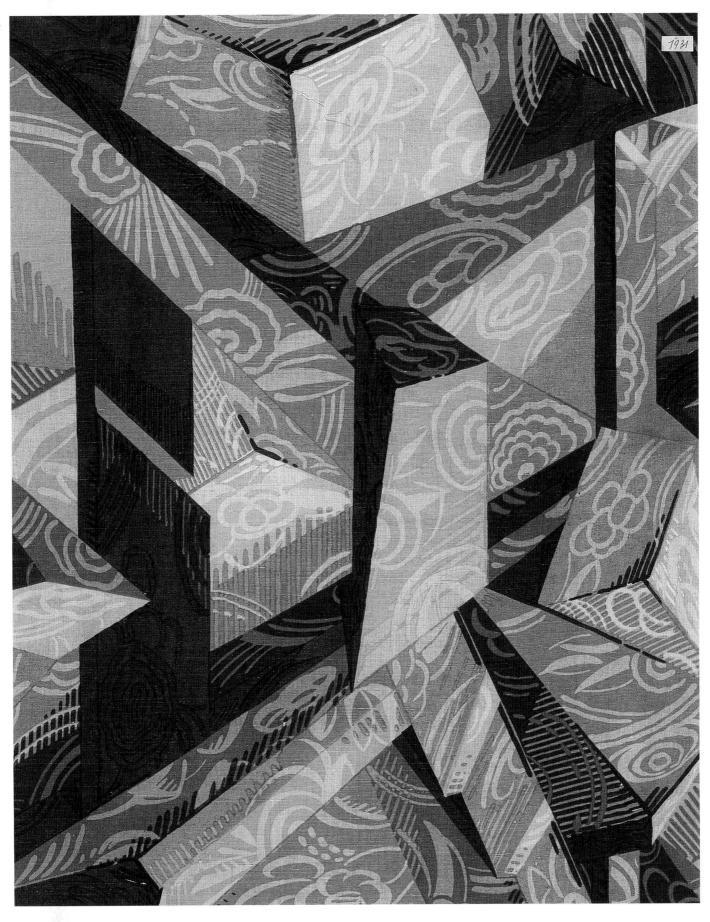

284

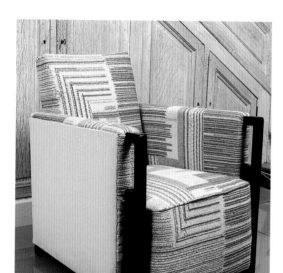

283

283. Attr. Jean LURÇAT. Fabric used to cover an armchair by the cabinetmaker Krass. 1930–35.

284. Jean LURÇAT. Print used as a wall covering in a decorative scheme by Pierre Chareau. 1929.

e.-a. séguy

PRISMES - 28

éditions d'art Charles Moreau - Paris

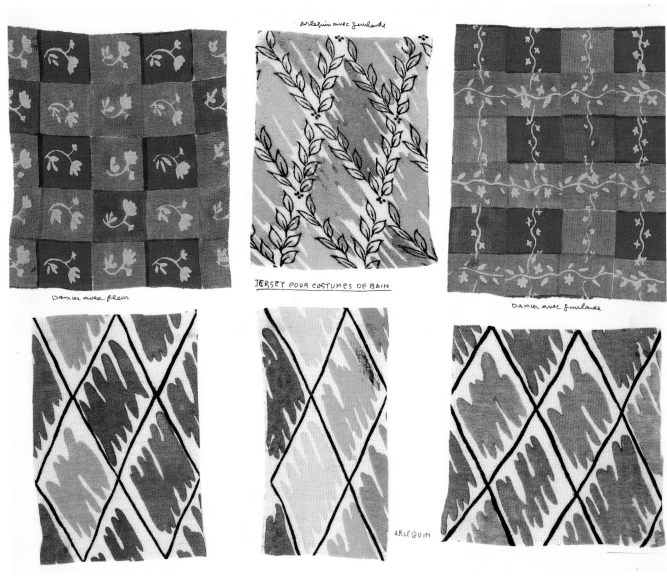

285. Emile-Alain SEGUY. *Prismes*, pl. 28. 1931.

286. Marianne CLOUZOT. Fabric swatches for swimwear. 1937–38.

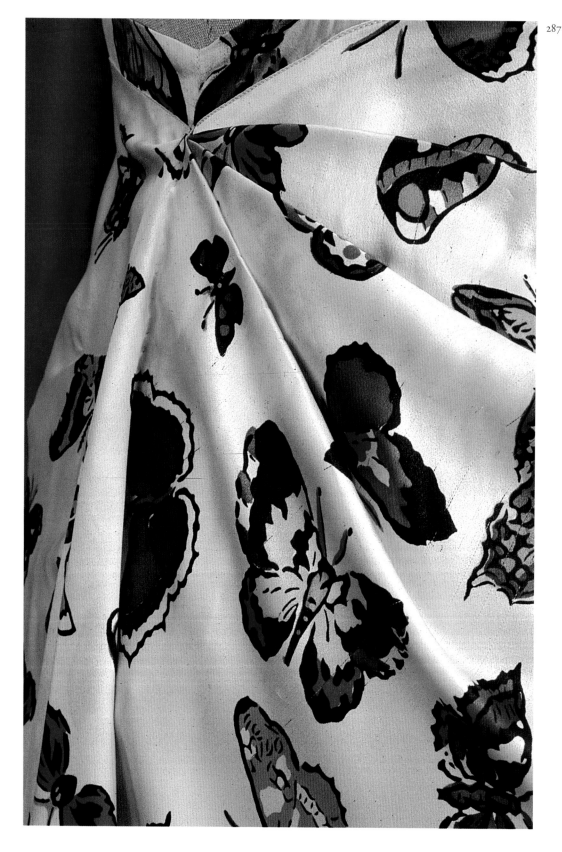

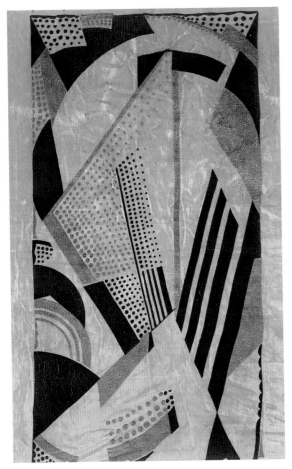

288

289

288. ANONYMOUS. Detail of scarf with geometric
design. *c.* 1930.

289. ANONYMOUS. Geometric composition with
floral motif. 1924–25.

◄ 287. Elsa SCHIAPARELLI. Detail of an evening
dress with butterfly motif. Summer 1937.

290

291

290. ANONYMOUS. Stem of stylized palmettes. 1932.

291. Maurice DUFRENE. Interlinked curls of ribbon. 1925-30.

292. Michel DUBOST. 'Rhythm'.
Decorative panel. 1936.

THE LATE PERIOD (1931–45)

Dark times arrived. The Depression hit France in 1931, and constant social upheavals had to be faced within an increasingly unstable and threatening international context. In these conditions, the decorative arts lost their elite clientele and were forced to bend to the directives of industrial production and to accept the more practical demands of social classes that were less keen on ostentation. Despite continuing technological advances, the textile industry suffered in competition with bright new paints and wallpapers, and could not maintain its supremacy. Taste itself experienced a distinct falling away, which put a brake on creativity. Professionals and public alike took shelter in traditional values. Buyers turned away from the 'modern style', favouring classical, rustic or regional styles; a fashion began for Provençal prints. As a result, many manufacturers began to reissue older designs, at no risk and no cost.

A new generation of decorative artists and fashion designers now entered the ring with a new aesthetic approach, in clear opposition to the masters of modernism who had now run out of steam. From 1935 on, baroque, mannerist and neoclassical schools began to emerge, battling for a return to figurative art and developing a specialized repertoire of motifs (seashells, stars, arabesques, calligraphy; ill. 294). These were combined with a highly original approach to narrative designs, which either depicted contemporary social trends (tourism and travel; ills 297, 299), or nostalgia for a disappearing world ('Valses de France', ill. 309; 'Trades', ill. 305), with a few artists, such Madeleine Lagrange, even sailing close to a right-wing ideology. In this respect, the hot-air balloon theme used by Paule Marrot in 1936 (ill. 303) stands at the meeting point of all such themes. It comes as no surprise that geometric abstraction had lost the wind from its sails and seemed old-fashioned after 1935. The little of this style that remained used 'optical' effects which prefigured styles that were to follow (ills 293, 295).

The majority of fabric designs after 1935, however, tended towards greater and greater simplicity; often reduced to a few lines, or light floral patterns in just two or three shades. The influence of nature was prominent: textures mattered more than

motifs, while colour was no longer allowed to shine at its full brilliance, and was restricted to the dullest parts of the spectrum. Beige, ivory, brick red and greenish hues: these became the colours of a colourless period. These factors showed that the decorative style that had been developed over the previous two decades by a generation of exceptional artists had now passed its peak, and was destined to a decrepitude which the reactionary currents of historical circumstance would only hasten.

The decline of Art Deco became widespread in all fields, and was plain to see at the 1937 Exposition des Arts et Techniques, which was organized and held in difficult circumstances and was to be the last before the outbreak of war. Most of the furnishings and decorative schemes reflected values and preoccupations that were alien to the functionalist ideals that the members of U.A.M. had had such difficulty in imposing. Everything was already in overdrive. Textiles were outshone by the versatility of ceramics, and eclipsed by the vibrant murals by Robert Delaunay, Léger, and Dufy (*La Fée Electricité*), and so were forced to give up the crown they had secured just twelve years earlier at the 1925 Paris exhibition. Beset by economic problems and difficulties in establishing their own identity, textiles lost their social impact and were once again relegated to the rank of a minor artform.

Nevertheless, a few artists, particularly women artists, persevered in their work, and upheld the honour of textiles with their creations. Principal amongst these was Sonia Delaunay. She did not produce many more 'simultaneous fabrics' after her own business closed down, but she still continued to design both clothing and furnishing fabrics for the Metz department store in Amsterdam throughout the early 1930s. Orders from her friends in the profession allowed Hélène Henry to keep her looms in business and, until the outbreak of war, she maintained the modernist standards of rigour of design and respect for her materials in the field of luxury decoration. Paule Marrot, meanwhile, achieved some recognition after the 1932 Salon, and continued her atypical and highly personal work away from the mainstream; her floral prints (ills 266, 300, 301) went on to

become highly successful after the war. Her works were manufactured on an industrial scale by Ribeauvillé, allowing her to concentrate on design, and her work was regularly shown at the Salon des Artistes Décorateurs (1932–39). Contrary to the image conveyed by her most commercial work, she was not exclusively devoted to floral decoration; her designs could also be figurative (ill. 302) or anecdotal (ills 265 and 304). In around 1935 she even went against her own temperament and experimented with geometric shapes (ill. 267), apparently influenced by the work of Sonia Delaunay.

In 1943, the Musée des Arts Décoratifs organized a major retrospective of Lyons silks. At this exhibition, designs from 1925 were given pride of place, counting for almost twenty per cent of the exhibits, but contemporary manufacturers also used the opportunity to promote their latest designs (ills 305, 307–9). These give a vivid picture of taste under the Occupation, and confirm that, at least so far as textiles were concerned, the break with the aesthetics of floral and geometric Art Deco was now complete. Decoration had set off on a new path.

293

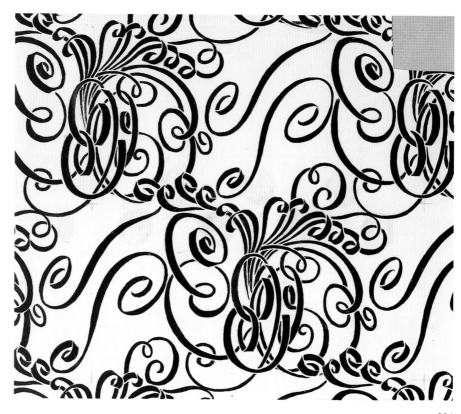

294

293. ANONYMOUS. Geometric composition with curved, diagonal and straight lines. 1935.

294. Alfred LATOUR. Calligraphic flourishes. 1942.

295. ANONYMOUS. Trompe l'oeil pattern. 1935.

295

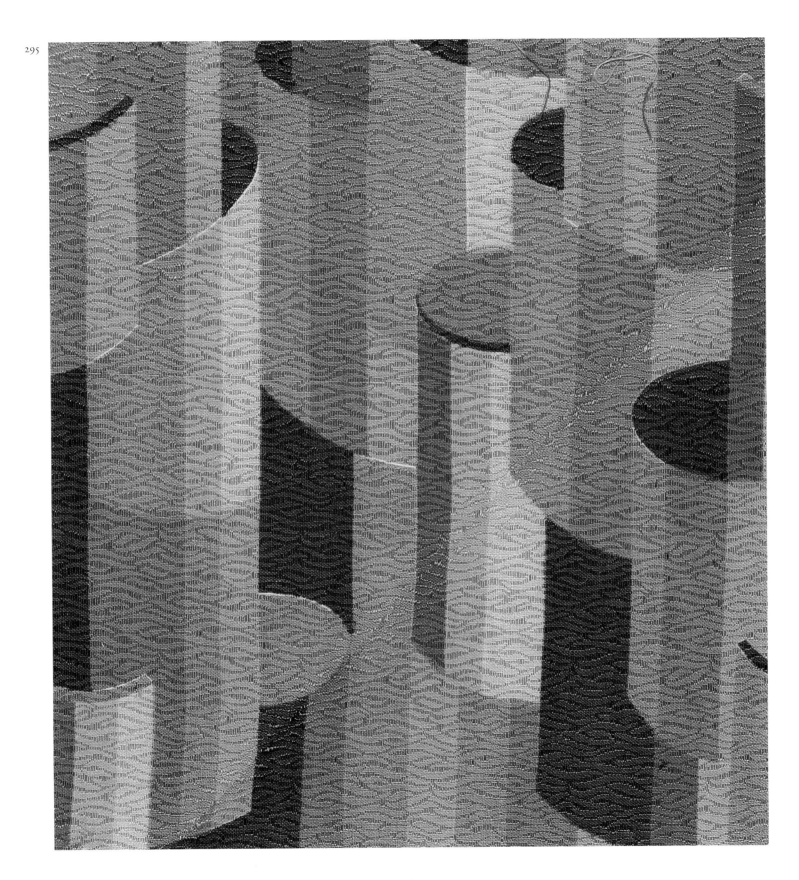

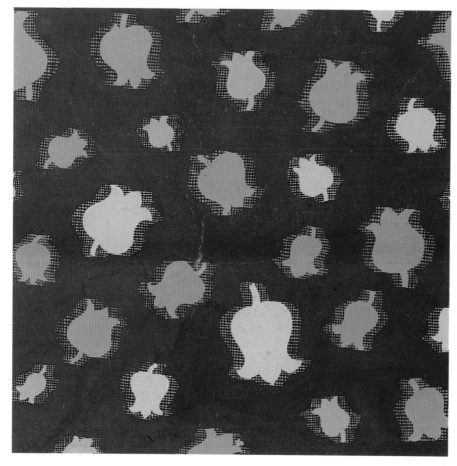

296

296. ANONYMOUS. Irregularly spaced motif of stylized tulips. 1944–45.

297. ANONYMOUS. Fans, including a bullfight motif. 1938. ▶

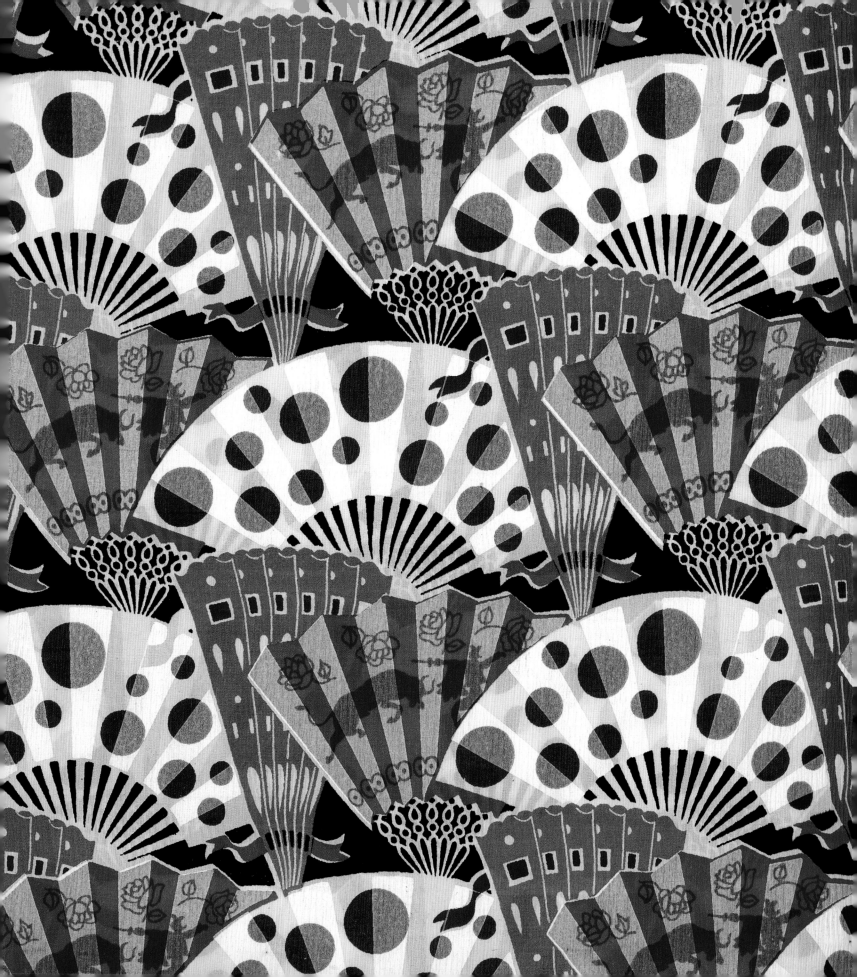

299

◄ 298. ANONYMOUS. Rear windows. 1938.

299. ANONYMOUS. New leisure pursuits. 1937.

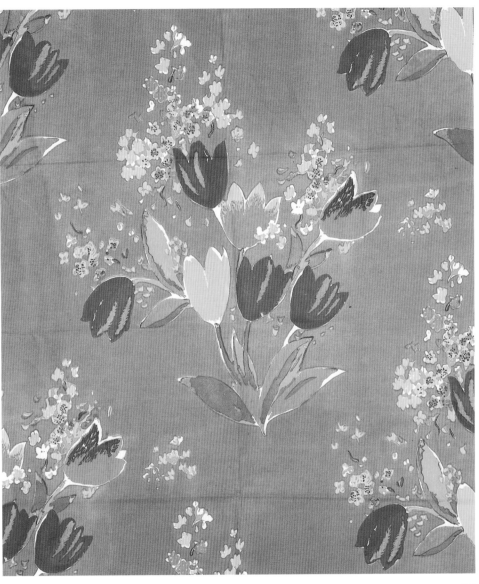

301

300. Paule MARROT. 'Hot Sun'. 1938.

301. Paule MARROT. Tulips. 1937.

302. Paule MARROT. Butterflies. 1936.

303. Paule MARROT. Hot air balloons. 1938–39.

304. Paule MARROT. 'The Happy Isle'. 1941. ▶

305

305. Madeleine LAGRANGE. Trades. Pre-1943.

306. ANONYMOUS. Travel and tourist attractions. 1939. ▶

307

307. Suzanne JANIN. Oriental hunting scene. Pre-1943.

308. DESPIERRE. 'Amazons'. Pre-1943. ▶

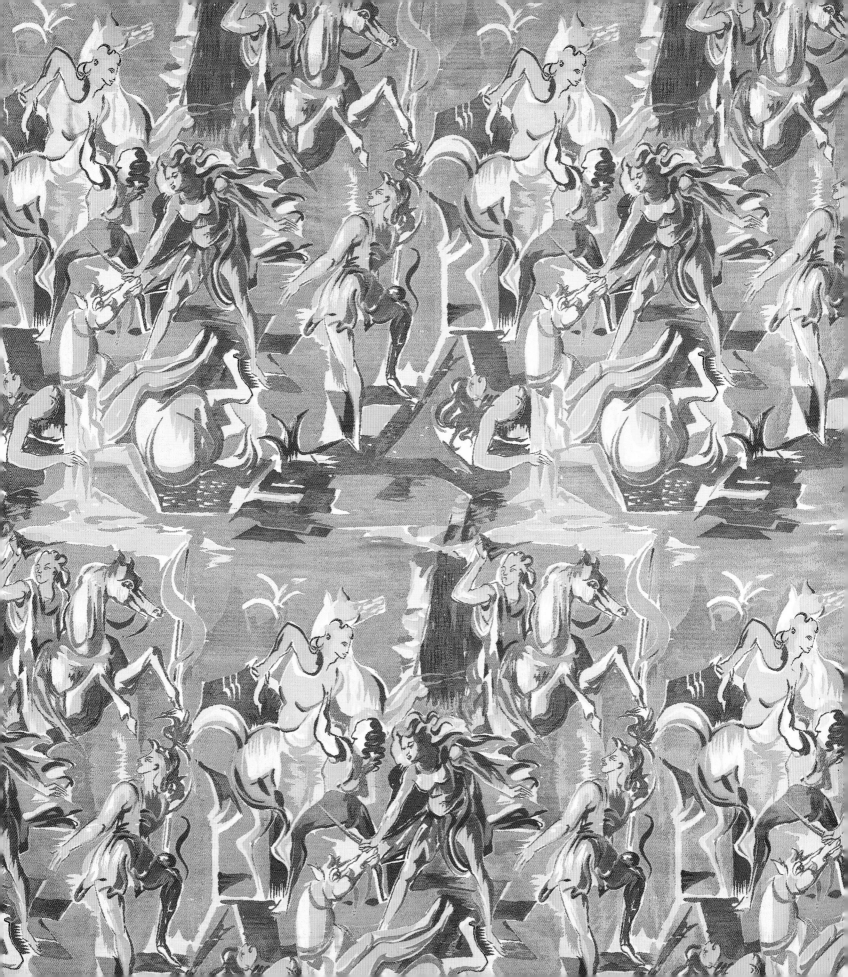

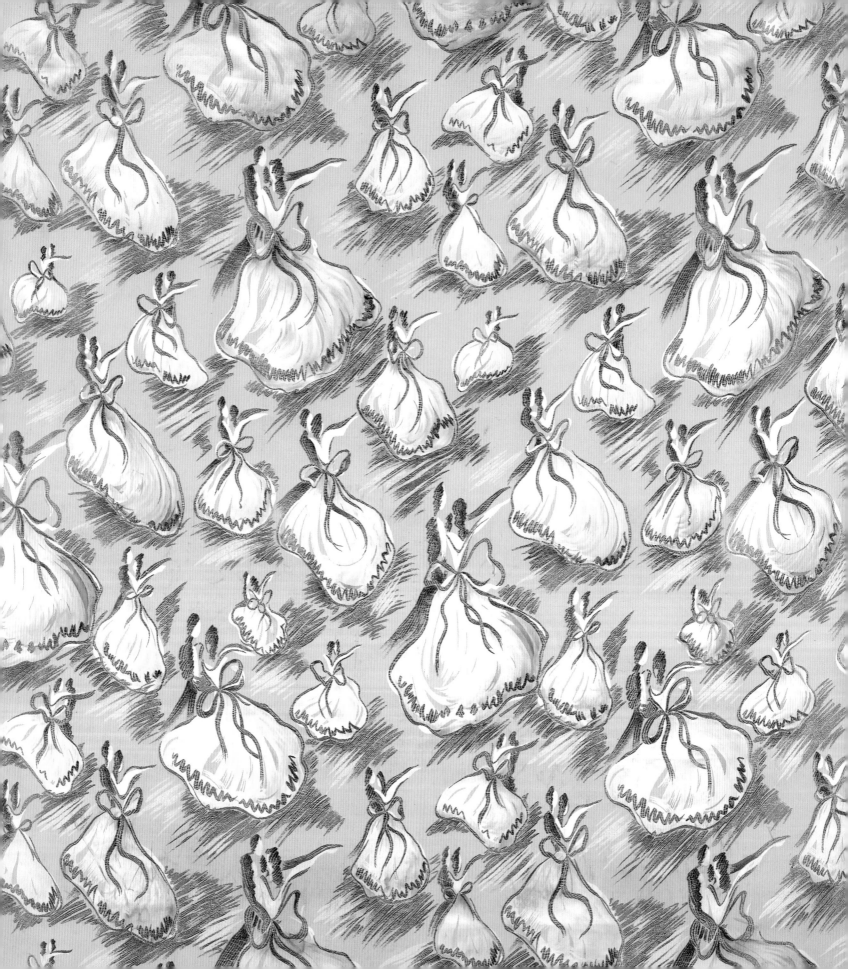

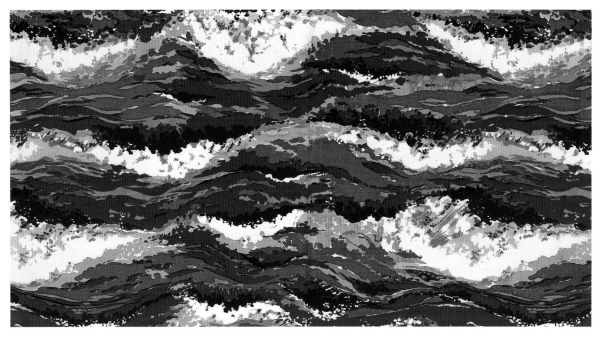

310

◄ 309. MARGIRIER & BERMOND. 'Valses de France'. 1943. 310. ANONYMOUS. Waves. 1939.

LIST OF ILLUSTRATIONS

Information in the illustration list is given in the following order. First, the **designer** of the work, followed by a **title or description**; titles given in inverted commas (' ') come from contemporary sources and were often chosen by the artist, so should be considered the true name of the design. These are followed by the known or approximate **date** of manufacture, and the name of the **company or manufacturer** where it is known. Next comes the type of item (fabric, design, illustration, photo) and its method of production: for textiles, the **production technique** is given (print, weave), and where this can be identified, the **composition** (unless otherwise stated, all prints are on a cotton support) and the **type** of textile (damask, satin, cloth, etc.). Also given is the **repeat size**, given in centimetres, height before width: the abbreviation **HD** means a half-drop repeat, meaning one which is staggered by half its height on each row; or, where a textile is incomplete, the size of the sample shown. Finally, the **application** of the fabric is given in parentheses (CL = clothing, FU = furnishing), and lastly the museum or other **location** of the piece illustrated.

In addition to **comments** of historical, artistic or cultural interest, the author has also included details, where known, of contemporary **exhibitions** at which a fabric was shown, and of any contemporary books or magazines in which it was **reproduced**.

A NEW BEGINNING (1910–23)

1. Georges BARBIER. 'The Sparrow Girl'. Dress by Paquin. Colour plate published in *Gazette du Bon Ton*, 1912, no. 2. 24 x 18 cm. [CL]. Private collection.

The pattern on the fur-trimmed jacket uses a stylized flower motif, a geometric grid of lines, and strong colours, all key elements of the Art Deco style.

2. Paul FOLLOT. Roses. 1911. Tassinari-Chatel. Silk weave. 27 x 27 cm. HD; woven width 54 cm. [FU]. Tassinari-Chatel Archives.

This design rather uneasily combines the stylized modernity of the rosebuds and the strongly Art Nouveau feel of the composition. The long-established Lyons firms of Tassinari-Chatel, Cornille and Brunet-Meunié were the leading producers of furnishing fabrics for the Art Deco movement. For many years Tassinari-Chatel was the exclusive manufacturer of fabric designs by Edouard Benedictus, and also produced designs by Karbowski, Plumet, Nathan and Beaumont, as well as Clarinval's 'The Four Elements' (ills 71–73) and the more modernist designs of Printz and Herbst. Today Tassinari-Chatel draw on their extensive archive of period designs (the firm was founded in the reign of Louis XV) to recreate luxury fabrics for use in prestige restoration projects.

3. Raoul DUFY. Roses and leaves with elephants. 1912. Bianchini-Férier. Printed on silk satin. 34 x 25 cm. [FU]. Musée de la Mode et du Textile, UCAD, Paris.

This design was first produced as a print, but later became available as a woven fabric, produced probably after the war. The cheerful style of the painter Dufy played a key role in the development of the decorative arts of the twentieth century, but it was only after a series of attempts that his fabric designs were successfully produced, from 1911 onwards. At first they were block-printed for wall decorations, or for the couturier Poiret, who had provided him with a studio, called the 'Petite Usine'. Although only a few designs are known to date from this period of barely a year, they were so distinctive that Dufy was soon persuaded to join the dynamic, expanding Lyons firm of Atuyer-Bianchini-Férier, in a collaboration which lasted until 1928 (Clouzot declared in 1920 that 'it was a perfect example of a successful partnership between designer and manufacturer'). Dufy became an expert in the techniques of textile design for the fashion trade, and as a freelance designer for Bianchini-Férier he produced a huge range of thousands of designs, about a quarter of which went into production. At first they were printed, but were soon also made available in woven silk, using the most sophisticated techniques. Some were designed specifically as furnishing fabrics (see ill. 56), but most were made for clothing and were used by the greatest couturiers of the day, particularly by Poiret but also by Lelong, Molyneux, Patou, Vionnet, and many others. Zervos declared in 1925 that 'Dufy has demonstrated that there is no such thing as a major or minor art form, and that textile design is not merely a humble art incapable of aspiring to beauty.'

4. Paul IRIBE. Floral all-over. 1911. Made by André Groult. Printed on linen cloth. 42 x full width of 76 cm. [FU]. Shown at the Salon d'Automne of 1911 (as wall covering in the small Groult salon). Reproduced in *Art et Décoration*, January 1912. Musée de la Mode et du Textile, UCAD, Paris.

André Groult was one of the most dynamic participants in the revival of the decorative arts during the first decade of the twentieth century. Like Süe, Mare, Ruhlmann and Poiret, he created a design team from among his artist friends, commissioning them to produce prototype designs for printed cloth as well as for wallpaper, and oversaw the production process (although he was not the manufacturer). Textiles designed by decorators or painters such as Drésa, Constance Lloyd, Carlègle, André, Iribe or d'Espagnat were shown at the Salon d'Automne in 1911 (see also ill. 15); these were very popular, and were quickly reproduced in the magazine *Art et Décoration*. These designs established Groult at the forefront of the new approach to textile design that had already begun before the First World War.

5. Georges BARBIER. 'White crêpe-de-chine dress with fox-fur trim. Otterskin and skunk coat'. Colour plate from *Journal des Dames et des Modes*, no. 20, 10 December 1912, pl. 39. 22 x 14 cm [CL]. Bibliothèque Forney, Paris.

6. Louis SÜE and Jacques PALYART. Colourways for a lampas. 1913. Made by Lamy & Gautier for Atelier Français (trademark in the selvedge). Woven silk taffeta. 50 x 65 cm full width. [FU]. Prelle Archives. Shown at the Salon d'Automne, 1913.

The old Lyons firm Lamy & Gautier, founded in the middle of the eighteenth century, chose to produce cloth from the designs of several young decorative

artists. Among them were Groult (ill. 9), Ruhlmann (ill. 93), and most notably the Atelier Français, founded in 1912 by Süe and Palyart (ills 6 and 7). The silk was woven on traditional hand looms, resulting in narrow widths of fabric (55 to 65 cm). When the two partners separated, Süe turned to Lauer or Cornille, but Palyart continued to use the Lyons firm (see ill. 10), and in 1925 asked them to revive production of the pink version of this design, shown at the top of the selection of colour swatches. The Lyons-born textile designer Aimé Prelle bought shares in Lamy after the war, and became the sole proprietor of the firm in 1927. This accounts for the preservation of modern designs such as this one in the firm's archives; today it specializes in high quality period reproductions for the stately homes of France.

7. **Louis SÜE and Jacques PALYART. Display stand at the Salon d'Automne, 1913.** Includes the fabric in ill. 6. Illustrated in *Art et Décoration*, January 1914, p. 28. Bibliothèque Forney, Paris.

Note the strong emphasis on fabrics in this display.

8. **FABIUS. 'Painted silk chiffon and taffeta dress'.** Colour plate from *Journal des Dames et des Modes*, no. 184, 1 August 1914, pl. 184. 22 x 14 cm. [CL]. Bibliothèque Forney, Paris.

9. **André GROULT. Floral motif. 1913.** Lamy & Gautier. Silk lampas. 64 x full width of 55cm. [FU]. Prelle Archives.

10. **Jacques KLEIN. Floral and vegetal motif. 1920.** Made by Atelier Français. Silk lampas. 64 x full width of 67 cm. [FU]. Reproduced in Léon Moussinac, *Etoffes d'ameublement tissées et brochées*, Albert Lévy, 1925, pl. 19. Prelle Archives.

The name of Palyart, at the time the sole director of Atelier Français, appears on the label attached to this sample in the Prelle Archives, probably indicating that his firm owned the design. This does not rule out Moussinac's suggestion that Jacques Klein, then aged just twenty and a future partner in the firm La Maîtrise, may have been the designer.

11. **Emile-Alain SEGUY. Colour plate from *Primavera*, 1913, pl. 5.** Bibliothèque des Arts Décoratifs, UCAD, Paris.

Séguy was known for his surface decoration; he produced many fabric designs, and published several collections of floral and vegetal motifs for use in textile production (such as *Suggestions pour étoffes et tapis*, Charles Massin, 1924). The most important of these, *Les Fleurs et leurs applications décoratives*, published in 1902, rivalled the collections published by Grasset. Séguy's enthusiastic personality allowed his work to develop rapidly; he published the pattern book *Primavera* in 1913, completely revolutionizing the field with his exuberant range of colours which came to characterize the Art Deco style.

12. **Emile-Alain SEGUY. Colour plate from *Primavera*, 1913, pl. 17.** Bibliothèque des Arts Décoratifs, UCAD, Paris.

13. **André MARE. Stylized floral motif. 1912–13.** Cornille for the Compagnie des Arts Français. Silk lampas with raised threads. 16 x 16 cm. [FU]. Musée de la Mode et du Textile, UCAD, Paris. Shown at the Salon des Artistes Décorateurs, 1919. Reproduced in *Art et Décoration*, 1919, p. 42.

This fabric was bought from Cornille in June 1920, and is attributed to André

Mare on the museum's inventory card. However, as with ill. 18 (see the relevant note), 'Atelier Français' is woven into the selvedge, suggesting that it was part of a batch produced before the war for Louis Süe's workshop (probably by Lamy & Gautier). This exceptional, strikingly coloured lampas and Mare's design 'Abundance' were both re-issued by Compagnie des Arts Français.

14. **Paul VERA. 'Deities of the Countryside'. 1919–20.** Lauer for Compagnie des Arts Français. Lightweight cotton print. 85 x 42.5 cm. HD. [FU]. Musée de la Mode et du Textile, UCAD, Paris. Reproduced in G. Quénioux, *Les Arts Décoratifs Modernes (France)*, Larousse, 1925, p. 276 and in *Demeure Française*, 1927-1, p. 38.

15. **Albert ANDRÉ. Country scene with figures. 1911.** Made by André Groult. Percale print. 34 x 37 cm. HD. [FU]. Shown at the Salon d'Automne of 1911. Musée d'Art et d'Histoire, Brussels.

Albert André was a painter, like others who produced designs for Groult, such as Marie Laurencin; he was strongly influenced by his friend Renoir, and is well known for his paintings of outdoor scenes. His early experience of producing designs for silk fabrics was particularly useful to Groult. The competence of the design of this pastoral 'toile peinte' owes as much to his background as to his artistic inspiration. Groult had been an antique dealer before devoting himself to interior decoration, and as can be seen here, reverted to the standard eighteenth century practice of printing the manufacturer's name prominently on the edge of the fabric.

16. **Louis SÜE and André MARE. Bunches of peonies. 1919–20.** Compagnie des Arts Français. Cotton and silk damask. 64 x 64 cm. [FU]. Musée de la Mode et du Textile, UCAD, Paris.

The Museum's index card mistakenly refers to this example as 'Bouquets', which is another well-documented design. This may be 'Garden Silk', no. 1015 in the Compagnie des Arts Français textile catalogue.

17. **André MARE. 'Abundance'. 1913.** Manufactured by Lamy & Gautier (pattern 7148) for Atelier Français (trade mark woven into the selvedge). Silk damask, woven width 65 cm. [FU]. Prelle Archives. Shown at the exhibition 'Soieries Modernes d'Ameublement', Lyons, 1934; 'Soieries Lyonnaises', Pavillon du Marsan, 1943.

Although the label on this sample in the Prelle archives gives the designer as Louis Süe, the attribution to André Mare on the Musée des Arts Décoratifs inventory card seems more plausible: it was recorded soon after the acquisition of the second version illustrated (ill. 18), and the founders of Compagnie des Arts Français may have been the source. Apart from stylistic similarities, there is documentary proof of collaboration between Mare and Süe, particularly in textile design, in the pre-war years. The appearance of the name Süe on the Prelle sample should therefore be interpreted as meaning 'commissioned by Louis Süe, director of Atelier Français'. Produced by Atelier Français between 1913 and 1916, the design was also used by Palyart in 1921. The pattern was later listed as no. 1003 in the catalogue of Compagnie des Arts Français, and was used in the decorative scheme for the private house of the couturier Jean Patou in 1926 to cover the alcove divan in his atelier. In the Musée des Arts Décoratifs collection there is a lampas by André Mare, originally bought from Compagnie des Arts Français in 1920, with a similar design, which could easily be confused with 'Abundance'. (UCAD, inv. no. 21841, reproduced by Moussinac, pl. 28 in *Etoffes d'ameublement tissées et brochées*, Albert Lévy, 1925).

18. André MARE. 'Abundance'. 1919. Lauer for Compagnie des Arts Français. Musée de la Mode et du Textile, UCAD, Paris.

This fabric sample was made immediately after the foundation of Compagnie des Arts Français; nevertheless it has the manufacturer's name Atelier Français woven into the selvedge, proving that André Mare claimed ownership of this pre-war design, including the Jacquard cards, which were transferred from Lamy & Gautier to Lauer. (see preceding entry).

19. Louis SÜE and André MARE. 'Corpus Christi'. 1919–20. Compagnie des Arts Français (ref. 1018). Silk damask. 69 x 64 cm. [FU] Musée de la Mode et du Textile, UCAD, Paris.

This fabric was used as a wall covering, notably in Jean Patou's couture salons, which were decorated by Compagnie des Arts Français.

20, 21 and 22. Atelier MARTINE. Small floral motif. 1918–19. Screen print on wild silk. Each c. 35 x 80 cm. [FU?] Victoria and Albert Museum, London.

Paul Poiret is one of the most appealing personalities in the development of the Art Deco style, remarkable for his commitment, invention, impeccable taste and role as entrepreneur, but is justifiably best known for his innovative fashion designs. Soon after his early success (at the age of just thirty) he began to take a great interest in graphic design, and commissioned two very young illustrators (Iribe, followed by Lepage) to make fashion plates of his designs, produced with stencils, for lavishly produced catalogues. He gathered first-class artists around him, such as Louis Süe and Raoul Dufy, and through his sister's links with André Groult, launched into interior decoration; this led to the establishment in 1911–12 of his informal school for young girls with no previous artistic training (or conditioning), so that the spontaneity of their vision would have free rein. He made the one proviso that they should 'find their inspiration in his garden'. The Atelier Martine's productions immediately enjoyed huge success, partly thanks to the couturier's social connections, but also because of the genuine freshness of the naive but extremely attractive Choses à la Mode that the so-called 'Martines' designed. The floral print fabrics of the Atelier Martine, with their intense colours, uninhibited ideas and fluidity of design, marked the dramatic arrival of Fauvism in the field of furnishing fabrics.

23. Jacques-Emile RUHLMANN. Young lady's bedroom, decorated with 'The Park' fabric from ill. 24. Colour plate published in *Les Arts de la Maison*, A. Morancé, vol. 2, 1924, pl. 22. [FU]. Bibliothèque Forney, Paris.

24. Jacques-Emile RUHLMANN. 'The Park'. 1920. Cotton print. 100 x 31 cm. HD. [FU]. Musée de la Mode et du Textile, UCAD, Paris. Reproduced in Léon Moussinac, *Etoffes imprimées et papiers peints*, Albert Lévy, 1924, pl. 38.

25. Raoul DUFY. Advertisement for the 'Toiles de Tournon' range. Published in *Les Arts de la Maison*, A. Morancé, vol. 4, 1925. Bibliothèque Forney, Paris.

26. Raoul DUFY. 'Hunting'. 1918. Bianchini-Férier. Toile de Tournon. Print. 42 x 40 cm. (The image is reversed at each repeat, a feature described by Clouzot as 'dessin à retour'.) [FU]. Musée de la Mode et du Textile, UCAD, Paris. Reproduced in Léon Moussinac, *Etoffes imprimées et papiers peints*, Albert Lévy, 1924, pl. 2, and in *Les Arts de la Maison*, A. Morancé, vol. 1, 1923, p. 37.

After the war, Dufy began to produce designs for textiles, adapting what he had learned from his woodcut illustrations for Apollinaire's *Bestiaire*. He returned to some of his earlier motifs (for example 'Hunting' and 'Fishing') to reinterpret the traditional Toiles de Jouy with a new freshness, as well as a sometimes old-fashioned charm. The type of motif is particularly suited to block-printing; several monochrome versions were made (although there are others using more than one colour) on unbleached linen or cotton, in keeping with the rustic quality of woodcuts; they were printed at the Bianchini-Férier factory at Tournon, in the Ardèche, which gave the range its name.

27. Raoul DUFY. 'Fishing'. 1918. Bianchini-Férier. Toile de Tournon. Print. 43 x 40 cm (alternate reversed image). [FU]. Musée de la Mode et du Textile, UCAD, Paris. Reproduced in *Art et Décoration*, 1920/2, p. 180; Léon Moussinac, *Etoffes imprimées et papiers peints*, Albert Lévy, 1924, pl. 2 and in G. Quénioux, *Les Arts Décoratifs Modernes (France)*, Larousse, 1925, p. 277. (see ill. 26).

28. Raoul DUFY. 'Tennis'. 1919–20. Bianchini-Férier. Toile de Tournon. Print. 62 x 40 cm. [FU]. Musée de la Mode et du Textile, UCAD, Paris. Reproduced in G. Quénioux, *Les Arts Décoratifs Modernes (France)*, Larousse, 1925, p. 278. The design for this fabric is in the Bianchini-Férier archives, and reproduced in Dora Perez-Tibi, *Dufy*, 1989, ill. 141.

29. Raoul DUFY. Tortoise motif. 1920. Bianchini-Férier. Artificial silk lampas. 45 x 33 cm. [FU]. Musée de la Mode et du Textile, UCAD, Paris.

Many variations on this motif were produced, the earliest dating from 1912. (Several publications allow these to be compared: Honfleur exhibition catalogue, 1993, pp. 68–69; Perez-Tibi, *Dufy*, 1989, p. 97; Tourlonias and Vidal, 1998, pp. 92–93). 'Dufy's fabrics were like a ray of sunlight on a gloomy day; they were embraced by the fashion industry, giving it a note of fun and spontaneity that had not been seen before.' (Sonia Delaunay, 'L'influence de la peinture sur l'art vestimentaire', a lecture at the Sorbonne, 27 January 1927.)

30. GOYENECHE. Decorative scheme for a summer room, with curtains and cushions using Dufy's 'Africa'. Displayed at the Pavillon des Alpes Maritimes; coloured reproduction of photograph from Léon Deshairs, *Intérieurs en couleurs. Exposition des Arts Décoratifs, Paris, 1925*, Albert Lévy, 1926, pl. 44. [FU]. Bibliothèque Forney, Paris.

31. Atelier PRIMAVERA. 'Advice from a Lady of Fashion', 1920–21. Sales catalogue for the store Printemps, showing a range of printed furnishing fabrics [FU]. Author's collection.

The design studios of the big department stores played a crucial part in spreading the Art Deco aesthetic among the urban middle classes. Although less affluent, this clientele was just as eager for new themes, images and ranges of colours as those who patronized the well-known interior decoration firms. Furnishing fabrics, particularly prints, which were less durable, but cheaper, along with printed wallpapers, were the foremost means of spreading the new language of design, mainly as they were the most affordable. The Primavera studio opened by the Printemps store in 1912 was a particularly fertile example, and soon had competition from Galeries Lafayette's La Maîtrise (ill. 112), Bon Marché's Pomone, and the Magasins du Louvre's Studium (ill. 110), which was the last of these specialist departments to open; it was run by a team of young

people who were all under the age of twenty-five at the time of the 1925 international exhibition.

32. Fernand NATHAN. Tendril motif. 1914. Tassinari-Chatel. Silk lampas. 27.5 x 27.5 cm; woven width 55 cm. [FU]. Musée Historique des Tissus, Lyons.

33. André GROULT. Fern motif. 1913. Lamy & Gautier. Damask; silk. 41 x full woven width of 65 cm. [FU]. Musée Historique des Tissus, Lyons. Shown at the exhibition 'Soieries Moderne d'Ameublement', Lyons, 1934.

34. Atelier MARTINE. 'Wallflowers'. Printed velvet. 1923. Colour print published in Les Arts de la Maison, A. Morancé, vol. 1, 1923, pl. 18. [FU]. Bibliothèque Forney, Paris. Also reproduced in Léon Moussinac, Etoffes imprimées et papiers peints, Albert Lévy, 1924, pl. 27.

This handsome all-over floral design (here printed on velvet) was used by Poiret in 1927 when the Atelier Martine was commissioned to decorate the cabins of the passenger ship Ile-de-France.

35. Atelier MARTINE. Anemones. c. 1925–30. Block print on cotton. 52 x 62 cm. [FU]. Musée de l'Impression sur Etoffes, Mulhouse. Published in Echos des Industries d'Art, August 1930.

36. Atelier MARTINE. Nasturtium, tulip and cornflower motif. 1920–25. Block print on unbleached cotton. 52 x 62 cm. [FU]. Musée de l'Impression sur Etoffes, Mulhouse. Shown at the Exposition des Arts Décoratifs, Paris, 1925, and reproduced in Rapport Général de l'Exposition des Arts Décoratifs vol. 6, pl. 21.

This plate shows two trial printings of the same design on one piece of cloth, one with an undyed background and the other on black.

37. Anonymous. Patriotic motif. 1917–18. Print. 45 x 40 cm; full width 80 cm. HD. [FU]. Musée de l'Impression sur Etoffes, Mulhouse.

Fabrics of this type were often hastily and conventionally designed, but they show for the first time the impact of current events on textile design, as well as a wider awareness of the emergence of a new style. Sometimes they reuse familiar themes (as here, with the chequerboard pattern), and sometimes show greater innovation, as in ill. 38. Topical designs such as these were intended both to boost civilian morale and to celebrate military victories; they were also used for wallpapers. Süe and Mare produced at least one design of this type, and became prominent organizers of Victory parties.

38. Anonymous. Patriotic motif. 1917–18. Lauer. Print. 84 x 42 cm. [FU]. Musée de la Mode et du Textile, UCAD, Paris.

See entry for ill. 37.

39. Anonymous. Floral pattern. 1920. Coudurier, Fructus & Descher, Lyons. Satin print. 33.5 x 62.5 cm; each row is a full repeat. [CL]. Musée Historique des Tissus, Lyons.

40. Umberto BRUNELLESCHI. Coloured woodcut. 1914. Plate from Journal des Dames et des Modes, no. 78, 20 July 1914, pl. 181. 22 x 14 cm. [CL]. Bibliothèque Forney, Paris.

FLORAL ART DECO (1919–31)

41. Raoul DUFY. Indienne with partridge motif. 1926–28. Bianchini-Férier. Toile de Tournon. Print. 51 x 65 cm. [FU]. Musée de la Mode et du Textile, UCAD, Paris. See entry for ill. 26.

42. Advertisement for Bianchini-Férier fabrics. 1929. Features an armchair covered with a Dufy design (ill. 41), and behind it a panel covered with 'Variations' by Bonfils (ills 214 and 215). From Mobilier et Décoration, 1929. [FU]. Author's collection. See entry for ill. 26.

43. Raoul DUFY. 'The Tuileries'. 1920–21. Bianchini-Férier. Woven silk. 21 x 33 cm. [FU]. Musée de la Mode et du Textile, UCAD, Paris.

This fragment is the only record of this design in French collections; it comes from the estate of Robert Bonfils, who was working for Bianchini-Férier at the same time as Dufy.

44. Raoul DUFY. 'Bagatelle' or 'Le Pré Catelan'. 1919. Bianchini-Férier. Woven silk. 52 x 42 cm. [FU]. Musée Historique des Tissus, Lyons. Reproduced in Les Arts de la Maison, A. Morancé, vol. 1, 1923, pl. 24, and in Léon Moussinac, Etoffes d'ameublement tissées et brochées, Albert Lévy, 1925, pl. 15.

'Bagatelle' is easily confused with 'Longchamp', an almost identical but slightly less successful version of the same motif, which was issued by Bianchini-Férier in satin the previous year for the couture market.

45. Paul POIRET. Dressing gown made from the fabric 'Bagatelle' by Raoul Dufy. (See ill. 44.) Musée de la Mode et du Costume, Paris (Photo C. Fribourg).

46. Edouard BENEDICTUS. 'China'. 1924. Tassinari-Chatel for La Maîtrise. Silk lampas. [FU]. Reproduced in Léon Moussinac, Etoffes d'ameublement tissées et brochées, Albert Lévy, 1925, pl. 10. Tassinari-Chatel Archives.

47. Edouard BENEDICTUS. Variations, 1923, pl. 13, Colour plate showing a decorative design. Bibliothèque Forney, Paris.

Like his sometime colleague Maurice Verneuil (see ill. 209), Benedictus began his career at the height of the Art Nouveau period, specializing at that time in designs on leather. Nevertheless he welcomed the irresistible movement for stylistic change that began around 1912, and his own work flourished during the 1920s. His two published collections of highly original motifs were very successful, and he became one of the most admired and prolific designers of Art Deco floral themes (Variations, 1923 and Nouvelles Variations, 1928). At first his fabrics were produced in silk by Tassinari-Chatel, and later he exploited the luminosity of spun rayon, in partnership with Brunet-Meunié. Benedictus played a prominent part at the 1925 exhibition, where he showed his lampas and Savonnerie carpet designs to great effect with other decorative artists in the 'French Embassy' pavilion. (see ills 48–54, 213 and 248).

48. Edouard BENEDICTUS. 'Leaves'. Fabric design. 1923. Gouache on paper. 25 x 33 cm. Cabinet des Dessins, UCAD, Paris.

49. Edouard BENEDICTUS. 'Leaves'. 1924. Tassinari-Chatel for La

Maîtrise. Silk lampas. [FU]. Shown at the Exposition des Arts Décoratifs, Paris, 1925. Reproduced in Léon Moussinac, *Etoffes d'ameublement tissées et brochées*, Albert Lévy, 1925, pl. 39. Tassinari-Chatel Archives.

50. Edouard BENEDICTUS. 'Cineraria'. Fabric design. 1923–24. Gouache on paper. 25 x 32 cm. Cabinet des Dessins, UCAD, Paris.

51. Edouard BENEDICTUS. 'Cineraria'. 1924. Tassinari-Chatel. Woven. 55 x 58.5 cm. [FU]. Tassinari-Chatel Archives. Reproduced in *Art et Décoration*, 1924/1, p. 99; Léon Moussinac, *Etoffes d'ameublement tissées et brochées*, Albert Lévy, 1925, pl. 32.

52. Edouard BENEDICTUS. 'Fountains'. 1925. Brunet-Meunié. Cotton and fibranne lampas. 80 x 63 cm. HD. [FU]. Musée Historique des Tissus, Lyons. Shown at the Exposition des Arts Décoratifs, Paris, 1925, as a wall covering in the drawing room of the 'French Embassy' stand.

See entries for ills 47 and 213.

53. Edouard BENEDICTUS. 'Golden Fruits' (also known as 'The Chinese Lanterns'). 1924–25. Brunet-Meunié. Cotton and rayon damask. 43 x 32 cm. [FU]. Musée de la Mode et du Textile, UCAD, Paris. Shown at the Exposition des Arts Décoratifs, Paris, 1925, and 'L'Art de la Soie', Palais Galliera, 1927. Reproduced in *Echos des Industries d'Art*, August 1927.

Brunet-Meunié took over the production of Benedictus's designs before the 1925 exhibition. As a result of their collaboration, artificial fibres such as rayon became widely used in the production of furnishing fabrics. As well as being a brilliant designer, Benedictus was a trained chemist; he recognized the strengths and limits of the new material, and made designs which balanced the relative densities of the weave in the background areas and the motif, so that the cloth was neither too soft or too stiff, and which made the most of the unparalleled sheen of artificial silk. Brunet-Meunié also produced the designs of other artists such as Séguy, Jallot, Beaumont and Crevel.

54. Edouard BENEDICTUS. 'Trellis'. 1924–25. Brunet-Meunié. Cotton and fibranne lampas. 43 x 32 cm. [FU]. Musée de la Mode et du Textile, UCAD, Paris. Shown at the Exposition des Arts Décoratifs, Paris, 1925. Reproduced in G. Quénioux, *Les Arts Décoratifs Modernes (France)*, Larousse, 1925, p. 268.

'His imaginative use of line is matched by his use of colour; Benedictus is both daring and controlled at the same time. He explores not one form, but all forms; he uses contrast; he juxtaposes opposites; strong colours set each other off, and elsewhere there are more subtle areas; even when his colours clash, the result is a harmony of reconciliation and calm, because he knows that a furnishing fabric... should have a restful effect on the mind and eye.' (Gaston Varenne, *Art et Décoration*, 1924/1, p. 104).

55. Edouard BENEDICTUS. 'Athena'. 1924–25. Brunet-Meunié. Artificial silk lampas. 44 x 32.5 cm. [FU]. Musée de la Mode et du Textile, UCAD, Paris. Shown at the Exposition des Arts Décoratifs, Paris, 1925.

Described as a 'modern brocade' on the manufacturer's label.

56. BIANCHINI-FÉRIER. Display of furnishing fabrics by Dufy, Bonfils and Martin, made by the firm. Colour plate from *Larousse Ménager*, 1926, p. 1114. [FU]. Author's collection. (By kind permission of Editions Larousse).

57. Raoul DUFY. 'Jungle'. 1922. Bianchini-Férier. Satin print. 39 x 32 cm (with reversed motif effect). [FU]. Musée Historique des Tissus, Lyons. Exhibited at 'Soieries Lyonnaises', Pavillon de Marsan, 1943. Published in *Gazette du Bon Ton*, 1920, no. 8, pl. 40; G. Quénioux, *Les Arts Décoratifs Modernes (France)*, Larousse, 1925, p. 277; *Art et Décoration*, 1920/2, p. 177.

Dufy and Bianchini-Férier created several versions of this 'Persian' motif, altering the treatment of the image and the colourway (see ill. 60). 'It is normal practice for a design to be explored using a number of different colourways, and sometimes for only one of them, inevitably the one that the artist himself has chosen, to be exactly right, while the others are merely acceptable. This does not occur with Dufy, as each different and carefully thought-out harmony is a unique discovery.' (*Mobilier et Décoration*, May 1925, p. 27). The example shown here comes from the swatch books of the Paris office of Bianchini-Férier, recently acquired by the Lyons museum through public funding. This priceless collection documents over one hundred years of outstanding creativity.

58. Robert BONFILS. 'Oasis'. 1926. Bianchini-Férier. Silk damask. 66 x 65 cm. [CL]. Victoria and Albert Museum, London. Shown at the exhibition 'L'art de la Soie', Palais Galliera, 1927; 'Soieries Modernes d'Ameublement', Lyons, 1934. Reproduced in *Echos des Industries d'Art*, June 1927; *Demeure Française*, 1928/1, p. 36.

59. Robert BONFILS. Elephant heads. 1925–30. Bianchini-Férier. Silk satin with silver lamé. 42 x 30 cm. [FU]. Musée de la Mode et du Textile, UCAD, Paris.

This striking motif shows a contemporary taste for a rather fanciful exoticism which now appears dated; it is also a feature of the work of Dufy (see ills 3, 57 and 60), Charles Dufresne (ill. 76) and Jean Beaumont (ills 86 and 87).

60. Raoul DUFY. 'Jungle'. 1922. Bianchini-Férier. Silk lampas. 34 x 32 cm. (with reversed motif effect). [FU]. Musée Historique des Tissus, Lyons.

A variation on ill. 57; for other versions see the Honfleur exhibition of 1993, pp. 64 to 67; Perez-Tibi, *Dufy*, 1989, pp. 108–9; Tourlonias and Vidal, 1998, p. 99; Lyons exhibition, 1999, no. 119L.

61. Raoul DUFY. 'Dresses for Summer 1920'. *Gazette du Bon Ton*, 1920, vol. 4, pls 21–24, coloured print. 24 x 74 cm. [CL]. Musée de la Mode et du Costume, Paris.

Dufy's stylish, informal illustration shows off a range of styles by his friend Poiret, most of them made in fabrics of his own design, manufactured by Bianchini-Férier.

62. Raoul DUFY. 'Paris'. 1923. Bianchini-Férier. Silk lampas. 78 x 130 cm. (The design has no repeat in the width). [FU]. Musée Historique des Tissus, Lyons. Shown at the Exposition des Arts Décoratifs, Paris 1925; 'Soieries Modernes d'Ameublement', Lyons, 1934; 'Soieries Lyonnaises', Pavillon de Marsan, 1943. Reproduced in *Mobilier et Décoration*, May 1925, p. 28; Roberto Papini, *Le Arti d'Oggi*, Rizzoli, Milan, 1930, pl. 411.

'To do justice to Dufy's vision and explore the possibilities of large scale effects, in other words to accommodate the scope of his decorative ideas, a loom was specially constructed to weave cloth 128 cm wide. The artist is to be congratulated on having created a composition that is sufficiently varied and well balanced on such an unprecedented scale, and equally the manufacturer deserves praise for having unhesitatingly responded with a practical tour de force.' (*Mobilier et Décoration*, May 1925, p. 27).

63. Raoul DUFY. 'Paris'. 1923. Bianchini-Férier. Silk lampas. 78 x 130 cm. (The design has no repeat in the width). [FU]. Musée de la Mode et du Textile, UCAD, Paris.

'Most of our contemporaries are not aware of the pre-eminence of Raoul Dufy in the artistic developments of our times. He revived the art of wood engraving... and he also led the way when he set up a textile design workshop, producing beautiful designs which are the pride of their manufacturers... his imagination is always alert, he constantly brings some new embellishment to our surroundings. His artistic sense is never at fault, and his joyful, warm inspiration... provides him with new opportunities every day.' (René Jean, *Demeure Française*, 1928, no 2, p. 60).

64. Robert BONFILS. 'Anemones'. 1926–27. Bianchini-Férier. Toile de Tournon. Print. 26 x 57. [FU]. Musée de la Mode et du Textile, UCAD, Paris. Shown at the exhibition 'Toile imprimé et papier peint', Palais Galliera, 1928. Reproduced in *Mobilier et Décoration*, September 1928, p. 166.

65 and 66. Attr. Robert BONFILS. Fabric design with leaf motif. 1931. Ill. 66 shows four repeats mounted together, and ill. 65 a detail of the same motif in red. Bianchini-Férier. Gouache on paper. 65 x 50 cm. [FU/CL?]. Musée Historique des Tissus, Lyons.

67. Robert BONFILS. 'Africa'. 1922–23. Bianchini-Férier. Woven silk. HD. [CL]. Victoria and Albert Museum, London. (A preparatory maquette is in the Cabinet des Dessins at UCAD, inv. no. 44016).

Robert Bonfils and Dufy were the principal designers for the Lyons manufacturer Bianchini-Férier; Bonfils's outstanding talent made an important contribution to the success of the firm for around ten years, and his designs were widely noticed and discussed by the critics. The many examples reproduced here illustrate the range, versatility and skill shown by Bonfils, both in the planning of the design and its adaptation to the fabric. Better known today as an illustrator and designer of book bindings, Bonfils was appointed a lecturer in design at the Ecole Estienne after the war. He undertook all kinds of decorative work, including murals for the tea room at the Printemps store, designs for Sèvres porcelain, and cartoons for tapestries. His textile work is now unjustly forgotten.

68. Michel DUBOST. Stylized tropical fruits. 1924–25. Ducharne. Silk satin lamé. 38 x 29 cm. [CL]. Musée de la Mode et du Textile, UCAD, Paris. Shown at the Exposition des Arts Décoratifs, Paris, 1925.

69. Anonymous. Water plants. Winter 1922. Coudurier, Fructus & Descher, Lyons. 'Syrian brocade'. 49 x 60 cm. [CL]. Musée Historique des Tissus, Lyons.

70. Georges LEPAPE. 'Belle Impéria'. Evening coat made from a Bianchini velvet. 1912. Colour plate from *Gazette du Bon Ton*, 1912, no. 8, pl. 59. 24 x 18 cm. [CL]. Bibliothéque Forney, Paris.

71. Yvonne CLARINVAL. 'The Four Elements: Air' (sometimes called 'Sky'). 1923. Tassinari-Chatel. Silk lampas. 52 x 32 cm. [FU]. Tassinari-Chatel Archives. Shown at the Exposition des Arts Décoratifs, Paris, 1925; 'L'Art de la Soie', Palais Galliera, 1927; 'Soieries Lyonnaises', Pavillon de Marsan, 1943. Reproduced in G. Quénioux, *Les Arts Décoratifs Modernes (France)*, Larousse, 1925, p. 269; Roberto Papini, *Le Arti d'Oggi*, Rizzoli, Milano, 1930, pl. 414; also *Demeure Française*, 1928, no. 1.

This design is one of the most characteristic textiles of the 1920s, and was much exhibited and reproduced; the combination of the exuberance of the motif and the surface richness of the weave made it extremely popular. Although the classical theme seems an unlikely one for a modern textile design, it is treated with a confidence which reinforces the freshness and eloquence of the image. 'Four Elements' is almost Yvonne Clarinval's only known work. Eugène Printz included this lampas in his presentation at the Salon des Artistes Décorateurs of 1926; he probably was supplied with the material by the manufacturer Tassinari, who also produced his designs.

72. Yvonne CLARINVAL. 'The Four Elements: Water'. 1923. Tassinari-Chatel. Silk lampas. 49 x 32 cm. [FU]. Musée Historique des Tissus, Lyons. Exhibitions and publications: see ill. 71; also reproduced in *Renaissance de l'Art Français*, 1925, p. 400; *Demeure Française*, 1928/1, p. 38; *Art et Industrie*, October 1928, p. 33.

See entry for ill. 71.

73. Yvonne CLARINVAL. 'The Four Elements: Earth'. 1923. Tassinari-Chatel. Silk lampas. 58 x 32 cm. [FU]. Tassinari-Chatel Archives. Exhibitions and publications: see ill. 71; also reproduced in *Renaissance de l'Art Français*, 1925, p. 400; *Art et Industrie*, October 1928, p. 33.

See entry for ill. 71.

74. Marianne CLOUZOT. Music and painting. 1923. Gouache design for print. 46 x 46 cm. [FU]. M. Clouzot Archives.

The precociously talented Marianne Clouzot, daughter of the curator of the Galliera museum, was only fifteen years old when she produced this design. Her work was soon much in demand with textile producers, and she went on to design a series of prints in a similar style for the department store A La Place Clichy; they were shown in 1928 at an exhibition of printed fabrics and wallpapers, and brought her universal acclaim.

75. Anonymous. Summer. 1924. Coudurier, Fructus & Descher, Lyons. Printed on silk crêpe. 38 x 29 cm. HD. [CL]. Musée Historique des Tissus, Lyons.

76. Charles DUFRESNE. 'Voyage'. 1919–20. Lauer for Compagnie des Arts Français. Cotton print. 44 x 44 cm. HD. [FU]. Musée de la Mode et du Textile, UCAD, Paris. Reproduced in Léon Moussinac, *Etoffes imprimées et papiers peints*, Albert Lévy, 1924, pl. 42; *Art et Décoration*, 1925/1, p. 161.

77. Maurice CROZET. Flower and leaves. 1924. La Maîtrise. Print. Sample 31 x 48 cm. [FU]. Musée de l'Impression sur Etoffes, Mulhouse. Reproduced in Léon Moussinac, *Etoffes imprimées et papiers peints*, Albert Lévy, 1924, pl. 27.

78. La MAÎTRISE. Branch of magnolia blossom. 1927. Print. 62 x 42 cm. [FU]. Musée de l'Impression sur Etoffes, Mulhouse.

79. Jean-Gabriel DARAGNÈS. 'Macaws'. 1921. La Maîtrise. Print. 36 x 50 cm. [FU]. Musée de l'Impression sur Etoffes, Mulhouse. Shown at the Salon d'Automne of 1921. Reproduced in Léon Moussinac, *Etoffes imprimées et papiers peints*, Albert Lévy, 1924, pl. 16; *Art et Décoration*, 1924/1, p. 114.

Daragnès specialized in book design, as illustrator, engraver and printer. He drew on his printing experience when he turned to textile design, since the two

fields require similar skills, and other respected engravers such as Laboureur followed his example.

80. Anonymous. Branch of stylized leaves and flowers. 1928. Print. 80 x 79 cm. [FU]. Musée de l'Impression sur Etoffes, Mulhouse.

This design is unusual for the large size of the repeat: previously, the width was limited by the size of wood blocks that a single printer could handle. Here the width of the print was achieved by using the silk screen process.

81. Robert MAHIAS. 'My Hat Has Blown Away'. 1923. Viacroze. Print. 120 x 81 cm. [FU]. Musée de l'Impression sur Etoffes, Mulhouse. Shown at the exhibition 'Toile imprimée et papier peint', Palais Galliera, 1928. Reproduced in *Art et Décoration*, 1923, p. 94; Clouzot, *Papiers peints et Tentures modernes*, Charles Massin, 1928, pl. 32; *Demeure Française*, 1928/3, p. 63.

Mahias was a painter and illustrator, and also had an interest in the applied arts, such as stained glass and mosaic, through his training at the Ecole des Arts Décoratifs. A newcomer to textile design, he had a distinctive style, demonstrated by this charming 'genre' scene reminiscent of the traditional Toiles de Jouy (it was also produced as a wallpaper by Impressions du Landy). He took advantage of two technical innovations: line engraving on zinc plates, allowing for a generous repeat size, and the use of new printing inks. All Mahias's fabrics and wallpapers were in this recognizable style.

82. Alberto LORENZI. 'On Holiday'. 1921–22. Bianchini-Férier. Silk lampas. 56 x 32 cm. [FU]. Musée Historique des Tissus, Lyons. Shown at the Salon des Artistes Décorateurs, 1922; 'Soieries Modernes d'Ameublement', Lyons, 1934. Reproduced in *Art et Décoration*, 1922/1, p. 104; *Mobilier et Décoration*, March 1922, p. 16; Luc Benoist, *Les tissus, la tapisserie, les tapis*, Paris, Rieder, 1926, pl. 13.

The firm Atuyer, Bianchini and Férier was set up at the end of the nineteenth century, and quickly made its mark with a dynamic commercial approach, the high quality of its products, and its commitment to responding to new developments in the world of fashion. It had offices in Paris, and through Charles Bianchini was able to recruit talented designers who were not only designers for industry but also artists. Foremost among these were Raoul Dufy (see ill. 3) and Robert Bonfils (see ill. 67), but other important names included Alberto Lorenzi, Charles Martin, Emile Séguy, Alfred Latour, and later, Pierre de Belay. The work of Bianchini-Férier, the most prestigious firm of silk weavers of the twentieth century, is well represented in the Musée Historique des Tissus in Lyons, which has a large number of albums of their original artwork, as well as a full collection of fabric swatches (see ill. 57).

83. Alberto LORENZI. 'A Walk in the Park'. 1921–22. Bianchini-Férier. Silk lampas. 36 x 32 cm. HD. [FU]. V&A Museum, London. Shown at the Salon des Artistes Décorateurs, 1922. Reproduced in *Art et Décoration*, 1922/1, p. 105; *Mobilier et Décoration*, March 1922, p. 16; Léon Moussinac, *Etoffes d'ameublement tissées et brochées*, Albert Lévy, 1925, pl. 15.

A strikingly coloured version of a typical 'genre' motif.

84. Georges BARBIER. 'The Wind'. Colour plate taken from *Falbalas et Fanfreluches*, 1926. [CL]. Private collection.

85. Michel DUBOST. 'Forest Full of Birds'. 1925–30. Ducharne. Silk

lampas. 27 x 29.5 cm. Symmetrical HD. [FU]. Musée Historique des Tissus, Lyons.

This sample was made at the Ecole de Tissage at Lyons, where Dubost taught until 1922. He later entrusted some of his own projects to the school, like other designers, to give the students the opportunity to work on modern designs rather than on reproductions of classic styles, which was the traditional Fabrique Lyonnaise procedure.

86. Jean BEAUMONT. 'Rainforest'. 1924–25. Cornille. Cotton and silk damask. 68 x 64 cm. [FU]. Musée de la Mode et du Textile, UCAD, Paris. Shown at the Exposition des Arts Décoratifs, Paris, 1925 and 'Soieries Modernes d'Ameublement', Lyons, 1934. Reproduced in Léon Moussinac, *Etoffes d'ameublement tissées et brochées*, Albert Lévy, 1925, pl. 14.

87. Jean BEAUMONT. 'The Garden of Eden'. 1924–25. Tassinari-Chatel. Rayon and silk damask. 50 x 32 cm. [FU]. Tassinari-Chatel Archives. Shown at the Exposition des Arts Décoratifs, Paris, 1925, 'L'Art de la Soie', Palais Galliera, 1927, 'Soieries Modernes d'Ameublement', Lyons, 1934, 'Soieries Lyonnaises', Pavillon de Marsan, 1943. Reproduced in *Rapport Général de l'Exposition des Arts Décoratifs*, Paris, 1925, vol. 6, pl. 27; *Echos des Industries d'Art*, June 1927.

This nostalgic evocation of the Golden Age received a great deal of publicity, and presumably commercial success too, to judge by the number of times it was exhibited. Beaumont used the same motif in some designs for the Manufacture de Sèvres.

88. Jean BEAUMONT. Tapestry cover for an armchair by Jules Leleu. 1929. Shown at the Salon des Artistes Décorateurs, 1929. [FU]. UCAD, Lévy Collection.

89. Michel DUBOST. 'The Bowl.' 1919–20. Silk brocade lampas, with chenille highlights. 55 x full woven width of 60 cm. Symmetrical HD. [FU]. Musée Historique des Tissus, Lyons. Shown at the Exposition des Arts Décoratifs, Paris, 1925, 'Soieries Modernes d'Ameublement', Lyons, 1934.

See entry for ill. 90. Designed and made at the Ecole de Tissage at Lyons (source of the sample) when Dubost was teaching there.

90. Michel DUBOST. 'The Lion Court'. 1922. Ducharne. Silk lampas. 128 x full woven width of 62 cm. [CL]. Musée Historique des Tissus, Lyons.

Michel Dubost taught textile design at the Ecole de Tissage at Lyons, and was later appointed artistic director by François Ducharne; he became the 'talented conductor of an orchestra of machines', before setting up and managing his own design studio in Paris. He returned from a visit to Spain having been fascinated by the Arabic palaces, which inspired some of his famous designs, including 'Alhambra', and 'The Lion Court', shown here. 'He aims above all to give his idea a visual unity. Wherever he goes, he memorizes the images which impress him: doves flying through the pillars of the Alhambra, a bowl of fruit [ill. 89], deer in a park. He frames the image that recreates his first impression with flat areas in one or two dominant colours, and then he has the complete concept for the fabric.' (Luc Benoist, *Art et Décoration*, 1925/1, p. 25).

91. Ms LARBITRAY. 'Rain' or 'Flower Garden at the Château'. 1924. Silk brocade. 37.5 x 33.5 cm. HD. [FU]. Musée Historique des Tissus, Lyons. Shown at the Exposition des Arts Décoratifs, Paris, 1925. Reproduced in Henri Algoud, *La Soie, art et histoire*, Payot, 1928, pl. 16.

This design by a student at the Beaux-Arts school in Lyons was woven at the Ecole de Tissage. It is described enigmatically as a 'topiary design' on its original label, and has an atmospheric, dreamlike quality. It is very likely that it was never commercially produced.

92. Henri STEPHANY. Pigeons with urns and flowers. 1924–25. Cornille for Ruhlmann. Cotton and silk damask. 95 x 65 cm. [FU]. Musée de la Mode et du Textile, UCAD, Paris. Shown at the Exposition des Arts Décoratifs, Paris, 1925 (wall covering in the drawing room of the 'Collector's Residence'); also at the Salon d'Automne, 1928. Reproduced in Maurice Dufrène, *Ensembles Mobiliers. Exposition Internationale 1925*, Charles Moreau, 1925, 1st series, pl. 26, 2nd series, pl. 1; Léon Deshairs, *L'Hôtel du Collectionneur. Groupe Ruhlmann*, Albert Lévy, 1926, pl. 5 and 6; *Mobilier et Décoration*, 1926, p. 165.

Henri Stéphany was among the most representative and gifted of Art Deco artists to specialize in surface decoration. Unfortunately there are few examples of his fabrics in public collections, although there are a greater number of his wallpaper designs. He was principal assistant to Ruhlmann in the production of textile designs (see the motif in ill. 95), before he began his own business around 1925, supplying designs to a great number of both manufacturers and producers, often in competition with each other.

93. Jacques-Emile RUHLMANN. Ribbon brocade. 1922–23. Cornille. Silk lampas. 47 x 32 cm. [FU]. Prelle Archives. Shown at the Exposition des Arts Décoratifs, Paris, 1925. Reproduced in Léon Moussinac, *Etoffes d'ameublement tissées et brochées*, Albert Lévy, 1925, pl. 45; Maurice Dufrène, *Ensembles Mobiliers. Exposition Internationale 1925*, 2nd series, Charles Moreau, 1925, pl. 5.

The firm of Cornille began as a Parisian commercial enterprise, rather than a Lyons silk manufacturer, but by the beginning of the century it owned two factories, one at Lyons and one at Puteaux. Under the dynamic leadership of Georges Cornille the company began to work in partnership with decorative artists such as Guimard, and after the war with the modernizers; Cornille later became president of the furnishing textiles employers' federation, and an active director of UCAD. The combination of his Parisian base and his practical commitment to the profession ensured that he became the producer and manufacturer most associated with Art Deco, weaving for Compagnie des Arts Français, Ruhlmann, Dufet, Nathan, Prou, Follot, Dufrène and de Andrada, Leleu, and Primavera.

94. Jacques-Emile RUHLMANN. Armchair covered with ribbon brocade. 1922–23. [FU]. Galerie De Vos, Paris. Shown at the Exposition des Arts Décoratifs, Paris, 1925, in the boudoir of the 'Collector's Residence'. Reproduced in Maurice Dufrène, *Ensembles Mobiliers. Exposition Internationale 1925*, 2nd series, Charles Moreau, 1925, pl. 5; Léon Deshairs, *L'Hôtel du Collectionneur. Groupe Ruhlmann*, Albert Lévy, 1926, pl. 16.

This chair was re-covered with the material that Ruhlmann chose to feature in his 1925 presentation.

95. Henri STEPHANY. Composition with flowers and pigeons. 1925. Cornille for Ruhlmann. Described as 'Indian damask' on the label: sample from the Ecole de Tissage. Silk. 105 x 65 cm. [FU]. Musée Historique des Tissus, Lyons.

Comparison with ill. 92 illustrates how even the best-known designers of the period used to produce a number of variations on their favourite themes.

96. Atelier RUHLMANN. Floral pattern with narrative scenes. 1920–25. Block print on cotton lawn. 124 x 132 cm. [FU]. Musée Historique des Tissus, Lyons.

97. Anonymous. Chimpanzees. 1922. Print. 34 x 41 cm. [FU]. Musée de l'Impression sur Etoffes, Mulhouse.

See ill. 99 for a motif with a similar theme.

98. Anonymous. All-over with foliage, Native American with bow, zebra and panther. 1925. Print. 48 x 43 cm. [FU]. Musée de l'Impression sur Etoffes, Mulhouse.

The designer of this exotically themed fabric, designed for a child's bedroom, was not concerned with factual accuracy – it shows a Native American alongside an African zebra.

99. Germaine LABAYE. Chimpanzees and tropical vegetation. 1925. Atelier Pomone. Print. 57 x 64 cm. [FU]. Musée de l'Impression sur Etoffes, Mulhouse. Reproduced in G. Quénioux, *Les Arts Décoratifs Modernes (France)*, Larousse, 1925, p. 275.

100. Anonymous. Figurative motif with stylized trees, house and viaduct. 1923. Print. 88 x 43 cm. [FU]. Musée de l'Impression sur Etoffes, Mulhouse.

101. Anonymous. Composition with pendants and rosettes. 1923. Print. 45 x 42 cm. [FU/CL]. Musée de l'Impression sur Etoffes, Mulhouse.

102. Anonymous. Highly formalized floral motif. 1924. Print. 63 x 40 cm. [FU]. Musée de l'Impression sur Etoffes, Mulhouse.

103. D.I.M. 'Floréal'. 1920–25. Block print on linen cloth. 40 x 20 cm. HD. [FU]. Musée de la Mode et du Textile, UCAD, Paris. Shown at the exhibition 'Toile imprimée et Papier peint', Palais Galliera, 1928. Reproduced in *Mobilier et Décoration*, September 1928; *Demeure Française*, 1928/3, p. 69; Clouzot, *Papiers peints et Tentures modernes*, Charles Massin, [1928], pl. 18.

104. D.I.M. Aeroplane cabin decorated for the Farman company. 1925. Reproduced in *Rapport Général de l'Exposition des Arts Décoratifs*, Paris, Larousse, 1927, vol. 4: Furniture, pl. 28. [FU]. Author's collection.

The fabric used here has a similar graphic style to 'Floréal', shown above, but a slightly different motif.

105. Various designers. Display of modern furnishing fabrics. Colour plate from *Larousse Ménager*, 1926, p. 1166. [FU]. Author's collection. By kind permission of Editions Larousse.

From left to right, the samples shown are by Atelier Martine, Dufy ('Africa'), Martine, Dufy ('Harvest'), D.I.M. ('Floréal'), and Martine again.

106. Maurice DUFRENE. Floral motif. 1919–20. Cornille. Block print. 44.5 x 43 cm. [FU]. Musée de la Mode et du Textile, UCAD, Paris.

107. Marguerite PANGON. Design on velvet for a coat. Colour plate from Yvanhöe Rambosson, *Les Batiks de Madame Pangon*, Charles Moreau, 1925, pl. 3. 24 x 32 cm. [CL]. Bibliothèque Forney, Paris.

The Javanese craft of batik (resist-dyeing with wax) was brought to Europe by the Dutch colonists at the beginning of the century; it became very popular with avant-garde artists such as Marion Dorn. Before the war, Mme Pangon had already perfected the technique with her modern designs for the couture market, as well as occasionally for furniture fabrics. She exhibited with Francis Jourdain and Hélène Henry at the 1925 Paris exhibition (in the Crès pavilion with Jourdain, the Fontaine pavilion with Süe and Mare, and on two stands at the Grand Palais); this success prompted the publication of Rambosson's book.

108. Marguerite PANGON. Chiffon scarf. Colour plate from Yvanhöe Rambosson, *Les Batiks de Madame Pangon*, Charles Moreau, 1925, pl. 13. 24 x 32 cm. [CL]. Bibliothèque Forney, Paris. Shown at the exhibition 'L'Art de la Soie', Palais Galliera, 1927. Reproduced in *Demeure Française*, 1928/1, p. 34.

See previous entry.

109. Marguerite PANGON. Upholstery velvet. Colour plate from Yvanhöe Rambosson, *Les Batiks de Madame Pangon*, Charles Moreau, 1925, pl. 22. 24 x 32 cm. [FU]. Bibliothèque Forney, Paris.

See note for ill. 107.

110. STUDIUM LOUVRE. *L'Art décoratif moderne aux Grands Magasins du Louvre*, 1925. Catalogue published for the Exposition des Arts Décoratifs, showing fabrics by Jean Burkhalter, Maurice Matet, Etienne Kohlmann and Jules Coudyser. [FU]. Author's collection.

See entry for ill. 31.

111. André WILQUIN. Advertising poster for cretonne furnishing fabrics. Lithograph for the Magasins du Louvre. 1930–35. 74 x 114 cm. [FU]. Bibliothèque Forney, Paris.

112. La MAÎTRISE. *Tapis, Rideaux, Ameublement*. Catalogue for the Galeries Lafayette, 11 September 1923. Page showing fabrics by Dufrène, Brochard, Marcoussis. [FU]. Author's collection.

See entry for ill. 31.

113. Atelier MARTINE. Decorative scheme for the barge *Amours*. 1925. Sketch by Boris Grosser. Taken from Léon Deshairs, *Intérieurs en Couleurs. Exposition des Arts Décoratifs, Paris, 1925*, Albert Lévy, 1926, pl. 38. [FU]. Bibliothèque Forney, Paris.

Poiret had three barges moored at the Quai d'Orsay as part of the 1925 exhibition; the *Amours* was designed to concentrate on interior decoration, and was a showcase for the professionalism of the Atelier Martine. This sketch made on the spot and the following plate show that the Martines' taste for colour and an array of textiles (curtains, carpets and cushions) had changed very little since its beginnings in 1912.

114. Atelier MARTINE. Decorative scheme for the barge *Amours*. 1925. Black-and-white photo with colour wash, reproduced in *Rapport Général de l'Exposition des Arts Décoratifs*, Paris, Larousse, 1927, vol. 4: Furniture, pl. 41. [FU]. Author's collection.

See previous entry.

115. Attr. Raoul DUFY. Clover-leaf pattern. *c.* 1930. Design for Bianchini-Férier fabric. Gouache on paper. 37 x 31 cm. [CL]. Musée Historique des Tissus, Lyons.

116. SIMÉON. 'Le Plaisir à la Mode'. Evening coat in a fabric by Bianchini. Colour plate from *Gazette du Bon Ton*, 1921, no. 1, pl. 3. 24 x 18 cm. [CL]. Private collection.

117. Charles MARTIN. 'Pineapples'. 1922–23. Bianchini-Férier. Silk lampas. 72 x 21 cm. HD. [FU]. Musée de la Mode et du Textile, UCAD, Paris. Shown at the Exposition des Arts Décoratifs, Paris, 1925 (covers for the armchairs in the main salon of the 'French Embassy' stand, arranged by the Société des Artistes Décorateurs); also at 'Soieries Lyonnaises', Pavillon de Marsan, 1943. Reproduced in *Mobilier et Décoration*, May 1925, p. 28; René Chavance, *Une Ambassade Française*, Charles Moreau, 1925, pl. 11. (see also ill. 56).

Charles Martin was a designer and illustrator who produced plates for fashion magazines; his very individual style became part of the new trend in graphic design created by *Gazette du Bon Ton* and *Modes et Manières d'Aujourd'hui* (1913). Many interior decorators looking for a new approach were keen to work with him, intrigued by his elegant, almost eighteenth-century style of drawing and composition. For Groult he designed wallpapers and panels, and for Süe and Mare he produced fabric designs. 'Charles Martin has also excelled in the design of fabric patterns. Let us look again... at this damask with pineapples. It is a damask of mingled pink and grey, the pink with a soft, almost silvery sheen, like the flesh of a Japanese amaryllis. It is a fabric as beautiful as the finest made in the sixteenth century.' (Georges Barbier, *La Renaissance de l'Art Français*, 1927, p. 196). Martin's date of birth is given by Bénézit as 1844, but this is accepted as a misprint for 1884; Martin was in fact a contemporary of Lepage and Marty, who were his fellow pupils in Cormon's studio at the Beaux-Arts in Paris.

118. Anonymous (attr. Raoul DUFY). Large roses in rows and columns. 1925. Fabric design for Bianchini-Férier. Gouache on paper. 42 x 40 cm. [CL]. Musée Historique des Tissus, Lyons.

The Bianchini-Férier swatch books in Musée Historique des Tissus contain three different colourways for this design, which has been attributed to Dufy.

119. Anonymous. La Croisière Noire. 1924–25. Silk lampas. 34 x 15 cm. HD. [CL]. Musée Historique des Tissus, Lyons.

A good example of the use of commemorative textile designs; this one celebrates a 1925 expedition across Africa by motor car. Handlooms and silk-screen printing processes can be quickly prepared, and some manufacturers used them to produce limited runs of novelty materials for clothing, on themes that were topical for one season. This practice became more widespread with the production of a variety of patriotic designs from 1917 onwards.

120. Raoul DUFY. Tiger lilies. *c.* 1925. Fabric design for Bianchini-Férier. Gouache and watercolour on paper. 49 x 63 cm. [CL]. Musée Historique des Tissus, Lyons.

Only a few repeats in the central area have been coloured; the design is completed in outline around the border.

121. Raoul DUFY. Bluebells. *c.* 1925. Fabric design for Bianchini-Férier. Gouache on paper. 50 x 65 cm. [CL]. Musée Historique des Tissus, Lyons.

122. Frédéric ROBIDA. Fabric design. 1925–30. Gouache on paper. 44 x 29 cm. [FU]. Bibliothèque Forney, Paris.

Frédéric Robida may have been related to the great turn of the century illustrator and caricaturist Albert Robida (famous for his reconstruction of 'Old Paris' shown at the Exposition Universelle of 1900); he became a decorative artist during the first decade of the century, and regularly exhibited his work at the Salon des Artistes Décorateurs. The sheets of his designs bequeathed to the Bibliothèque Forney (probably by his family) are now the only record of his work.

123. Frédéric ROBIDA. Fabric design. 1925–30. Gouache on paper. 28 x 20 cm. [FU]. Bibliothèque Forney, Paris.

See entry for ill. 122.

124. Frédéric ROBIDA. Fabric design. 1925–30. Gouache on paper. 28 x 22 cm. [FU]. Bibliothèque Forney, Paris.

See entry for ill. 122.

125. Anonymous. Stylized floral pattern. Summer 1923. Coudurier, Fructus & Descher, Lyons. Woven silk with gold thread. 41.5 x 30 cm. [CL]. Musée Historique des Tissus, Lyons.

126. Anonymous. Arabesques and cornucopias. 1924–25. Ducharne. Silk lamé lampas. 52 x 29 cm. [CL]. Musée de la Mode et du Textile, UCAD, Paris. Shown at the Exposition des Arts Décoratifs, Paris, 1925.

127. Frédéric ROBIDA. Fabric design. 1925–30. Gouache on paper. 40 x 40 cm. [FU]. Bibliothèque Forney, Paris.

Delicate, multi-coloured butterflies were one of the most popular themes for textiles of the period; some examples are shown here.

128. Emile-Alain SEGUY. 'Roses and Butterflies'. 1926. Bianchini-Férier. Silk damask. 63 x 65 cm. [FU]. Musée Historique des Tissus, Lyons. Shown at the exhibition 'L'Art de la Soie', Palais Galliera, 1927; 'Soieries Modernes d'Ameublement', Lyons, 1934. Reproduced in *Echos des Industries d'Art*, June 1927; *Demeure Française*, 1928/1, p. 36.

Séguy was a naturalist by training, specializing in entomology. He became a prolific producer of textile designs, using to great advantage the high level of drawing skill then required of specialists in the natural sciences. He published two pattern books: *Butterflies* (Tolmer, 1925–26), and *Insects* (Duchartre and Van Buggenhoudt, Paris, 1929). The example shown here is taken from a set of Bianchini-Férier swatch books recently acquired by the Lyons museum (see entry for ill. 57). The Musée de Mulhouse collection contains a sample of fabric (ill. 129) with a nearly identical design.

129. Attr. Emile-Alain SEGUY. Butterflies on stylized roses. 1926. Cotton print. 50 x 40 cm. [FU]. Musée de l'Impression sur Etoffes, Mulhouse.

Like most pattern designers, Séguy was happy to sell variations on the same motif to different commercial producers. He sold another butterfly motif damask to Volay and Biguet in the same year, as well as a velvet printed by Duchesne and Binet in 1927.

130. Anonymous. Floral motif on a geometric ground. 1926. Print. 78 x 39 cm. [FU]. Musée de l'Impression sur Etoffes, Mulhouse.

131. Anonymous. Floral bouquet on a geometric ground. 1930. Print. 80 x 65 cm. [FU]. Musée de l'Impression sur Etoffes, Mulhouse.

Probably a design by Stéphany: a similar one by him was shown at Palais Galliera in 1928.

132. Anonymous. Bowl of fruit. 1929. Print. 65 x 40 cm. [FU]. Musée de l'Impression sur Etoffes, Mulhouse.

A striking and original composition, combining realism and fantasy, with a daring use of colour.

133. Anonymous. Stylized flowers. 1926. Fabric design for Bianchini-Férier. Gouache on paper. 46 x 53 cm. [FU/CL?]. Musée Historique des Tissus, Lyons.

134. Madeleine VIONNET. Detail of ill. 135. 1921–22. [CL]. Musée de la Mode et du Textile, UFAC, Paris.

An openwork decoration of formalized flowers, composed of three appliqué layers of georgette crêpe.

135. Madeleine VIONNET Dress with appliqué bodice. Winter 1921–22. Musée de la Mode et du Textile, UFAC, Paris.

136. Anonymous. Geometric floral bouquet. 1925. Woven. 39 x 30 cm. [CL]. Musée Historique des Tissus, Lyons.

137. CALLOT Sisters. Evening coat. c. 1925. Musée de la Mode et du Textile, UFAC, Paris.

138. Anonymous. Fabric used for the coat in ill. 137. c. 1925. Black crêpe de Chine with gold lamé. [CL]. Musée de la Mode et du Textile, UFAC, Paris.

139 and 140. Anonymous. Pattern of stylized flowers and leaves. 1926. Fabric design for Bianchini-Férier, in two colourways. Gouache on paper. Ill. 139: 56 x 46 cm; Ill. 140: 26.5 x 49 cm. [CL]. Musée Historique des Tissus, Lyons.

141 and 142. Anonymous. 'Crêpe gauze'. 1931. Double page from a swatch book, with a single sample on the left and the other available colourways on the right. Coudurier, Fructus & Descher, Lyons. Woven silk lamé crêpe, printed. 22 x 7.5 cm. HD. [CL]. Musée Historique des Tissus, Lyons.

143. Anonymous. Geometric composition with overlapping squares of stylized decoration. Summer 1923. Coudurier, Fructus & Descher, Lyons. Chiffon print. 20 x 15 cm. HD. [CL]. Musée Historique des Tissus, Lyons.

144. Jean MERCIER. Advertisement for a furnishing store. 1924. Lithograph poster. 127 x 81 cm. [FU]. Bibliothèque Forney, Paris.

145. Lina de ANDRADA. Furnishing fabric made into a dress. c. 1925. Paul Dumas. Print. Length: 99 cm. [FU]. Musée de l'Impression sur Etoffes, Mulhouse (Sauvy Bequest).

As this example shows, furnishing fabrics were sometimes used to make clothes in the 1920s and 1930s. The Martel brothers wore trousers and jackets made from fabric by Hélène Henry, and Paule Marrot often made dresses from her prints, which were originally designed for furnishings. The dress shown here belonged to her old friend Marthe Sauvy, who probably sewed it herself from a favourite fabric.

146. René PROU and Albert GUENOT. Decorative scheme for a country-house living room, shown by Atelier Pomone at the Salon des Artistes Décorateurs. 1929. Taken from Léon Bouchet, *Intérieurs au Salon des Artistes Décorateurs, 1929*, Charles Moreau, 1929, pl. 34. Coloured print. [FU]. Bibliothèque Forney, Paris.

147. Raoul DUFY. 'Aqueduct' (or 'Summer'). 1925. Wall hanging. Hand painted on cotton cloth. 276 x 418 cm. [FU]. Shown at the Exposition des Arts Décoratifs, Paris, 1925 on Paul Poiret's barge *Orgues*. Photo Philippe Sebert, with kind permission.

Raoul Dufy and Paul Poiret worked together on the production of original prints, a partnership only temporarily interrupted by Charles Bianchini. Poiret kept a close eye on Dufy's work for Bianchini-Férier and often used the lampas, brocades or cottons designed by his friend to create his couture clothes. They were professionally reunited for the 1925 Paris exhibition, collaborating on the decorative scheme for one of Poiret's three barges; he hoped they would provide good publicity for his luxury creations, but in fact the venture only hastened his financial ruin. The inside of the barge *Orgues* was to be used for fashion shows, and Poiret commissioned Dufy to decorate it with fourteen very large hangings, all of which he painted himself at the Tournon factory. 'I had for a long time been considering making large compositions which could be folded up like sheets, and hung on walls for special occasions... I wanted to make them decorative, i.e. pictorial. I therefore constructed my background from three strips, three widths of cotton cloth each dyed a different colour, chosen to make a suitable horizontal sequence. I drew my design on this background, and used bleaching dyes to paint landscapes, figures, animals, objects and so on, all lit from a low side angle, which separates the forms vertically into light and shade.' (Raoul Dufy, manuscript quoted by Dora Perez-Tibi in *Dufy*, London, 1989, pp. 71–72). The hanging shown here is still in the possession of the Poiret family.

148. RODIER. Constellations. 1928. Black-and-white photo taken to register the design with the Conseil des Prud'hommes, 5 April 1928. 16 x 20 cm. [FU]. Paris Archives.

The Rodier firm, one of the most important of the late nineteenth and first half of the twentieth century, deserves an entire book devoted to its history. It was established at the time of Napoleon III and specialized in the production of the cashmere shawls then in vogue; from 1910–20 onwards, Paul Rodier expanded the firm's production to include high fashion fine fabrics for the couture market. He differentiated himself from the Lyons tradition by specializing in costly Tibetan goat cashmeres, or Kashas; Rodier employed several thousand home-workers around Bohain, in the Vermandois region, to weave his cloth on hand looms, ideal for the production of small amounts of exclusive, unusual fabric for an eager luxury clientele. The producer-manufacturer established a reputation not only for the excellence of his designs (there were three to four thousand new styles a year) but also for the quality of their manufacture. The firm's policy was to develop the use of a wide range and combination of threads, in order to offer weaves of great variety, specifically for

the clothing trade, but also from 1925 onwards for furnishing, gauzes, and even table linen and car rugs. Rodier enjoyed inventing mysterious and exotic names, and marketed fabrics named Djersador, Sinellic, Parquetine, Burécla, and a large number of variations on the name 'Kasha': Ziblikasha, Dallikasha, Tuslikasha, Dramouslikasha, Hindikasha, Dialikasha, Kashamoussa (see ill. 238), among others. Unfortunately, the business began to fail after the war, and was bought up by Lesur: it was dismantled with no regard for its historical significance, and there are no examples of Rodier fabrics in museum collections. Without any fabrics to reproduce in colour, it is all the more important to publish these black-and-white photos of some of his designs, as a record both their undeniable interest and the distinction of a company that was among the great textile producers of the Art Deco period.

149. RODIER. Composition with starfish and shells. 1928. Black-and-white photo taken to register the design with the Conseil des Prud'hommes, 4 October 1928. Cotton voile embroidered with artificial silk. 7.5 x 6 cm. [FU/CL]. Paris Archives.

See entry for ill. 148.

150. RODIER. Composition with crescent moons, stars and clouds. 1928. Black-and-white photo taken to register the design with the Conseil des Prud'hommes, 25 May 1928. Cotton voile embroidered with artificial silk. 8.5 x 6 cm. [FU/CL]. Paris Archives.

See entry for ill. 148.

151. RODIER. 'Sailing Ships'. 1927. Black and white photo taken to register the design with the Conseil des Prud'hommes, 4 August 1927. 19.5 x 14.5 cm. [FU]. Paris Archives. Reproduced in *Art et Industrie*, October 1928, p. 29.

See entry for ill. 148.

MODERNISM AND GEOMETRY (1923–36)

152. Anonymous. Three roses on a geometric ground. 1930. Print. 83 x 76 cm. [FU]. Musée de l'Impression sur Etoffes, Mulhouse.

The design is typical of the fabrics produced by Lisières Fleuries. See below.

153. Anonymous. Geometric pattern with flower. 1929. Lisières Fleuries. Print. 61 x 40 cm. [FU]. Musée de l'Impression sur Etoffes, Mulhouse.

An illustration of mass-produced fabrics' transition from traditional floral motifs to strictly geometric modernism. See also ills 154, 155 and 270.

154. Anonymous. Pots of flowers on a geometric ground. 1930. Lisières Fleuries. Print. 68 x 75 cm. [FU]. Musée de l'Impression sur Etoffes, Mulhouse.

A few cuttings in the Mulhouse collection are all that now survives of the Lisières Fleuries fabrics. The firm specialized in geometric treatments of nominally floral motifs, with large repeats, using several colours. The brand name was later bought from its enigmatic founder, Vernet, by the great Parisian specialist in printed fabrics, Paul Dumas, at an unknown date.

155. Anonymous. Geometric composition based on floral forms. 1929. Print. 60 x 39 cm. [FU]. Musée de l'Impression sur Etoffes, Mulhouse.

See entry for ill. 153.

156. Anonymous. Geometric composition with squares and circles. 1930. Print. 43.5 x 43.5 cm. [FU]. Musée de l'Impression sur Etoffes, Mulhouse.

157. Anonymous. Geometric composition. 1928. Print. 36 x 48 cm. [FU]. Musée de l'Impression sur Etoffes, Mulhouse.

158. Sonia DELAUNAY. Stylized floral pattern. 1923–24. Simultaneous Fabric no. 39. Printed on silk chiffon. 45 x 35 cm. [CL]. Musée Historique des Tissus, Lyons.

There are few floral motifs in the work of Sonia Delaunay, but this example shows that she was able to use them successfully. See the matching bodice and cloche hat made from this material illustrated in Jacques Damase, *Sonia Delaunay: Fashion and Fabrics*, London and New York, 1991, p. 81.

159. Sonia DELAUNAY. Parallel and right-angled stripes. 1925. Simultaneous Fabric. Printed on silk chiffon. 46 x 35 cm. [CL]. Musée Historique des Tissus, Lyons.

160. Sonia DELAUNAY. Geometric composition with squares and shuttle-shapes. 1924. Simultaneous Fabric no. 41. Printed on silk. 52 x 35 cm. [CL]. Musée de l'Impression sur Etoffes, Mulhouse.

161. Sonia DELAUNAY. Dress made from printed crêpe de Chine, black-and-white photo. 1926. [CL]. UCAD, Lévy Collection. Published in Luc Benoist, *Les Tissus de Sonia Delaunay, Art et Décoration*, 1926/2, p. 143.

Sonia Delaunay always enjoyed adding decorative touches to everyday environments. She used her artistic talents to create many attractive utilitarian objects, from her exile in Portugal in 1915 when she decorated pots, to the pack of cards she devised for the museum at Bielefeld University in 1960, via the 1924 decorative scheme for her own apartment in the boulevard Malesherbes. She was naturally interested in textiles, and in 1911 she made a patchwork quilt for the bed of her son Charles. She made collage book bindings from scraps of cloth, and caused a sensation at the Bal Bullier in pre-war Paris with her 'simultaneous dresses', made in accord with the theory of simultaneous perception of colours devised by the chemist Eugène Chevreul. In 1918 she designed the costumes for a production of *Cleopatra* by Diaghilev's Ballets Russes, and from 1922–23 onwards she grew increasingly involved in textile and fashion design; she soon devoted herself to it entirely, concentrating at first on her Russian heritage of embroidery. ('Colour alone, in the way it is organized, its dimensions, the way its interrelations are distributed across the surface of the canvas, fabric or furniture – of space in general – determines the rhythm of the forms; and these forms resemble architectural designs in colour, playing in fugal forms.' Robert Delaunay, 1923). Based on her researches and pictorial concepts, Delaunay's 'simultaneous fabrics' were an immediate success in artistic, wealthy cosmopolitan circles, and her revolutionary impact on the fashion world was to be deep and permanent. Together, Delaunay, Hélène Henry and Eric Bagge ensured the radical rebirth of textile design which brought France international recognition.

162. Sonia DELAUNAY. Geometric square motif. 1927. Simultaneous Fabric. Printed on silk chiffon. 40 x 17 cm. [CL]. Musée Historique des Tissus, Lyons.

163. Sonia DELAUNAY. Composition with divided lozenges, triangles and stripes. *c.* 1926. Simultaneous Fabric. Muslin print. Length 53 cm. [CL]. Musée Historique des Tissus, Lyons.

Also available as a cotton print.

164. Sonia DELAUNAY. Design for Simultaneous Fabric no. 186. 1926. Gouache on paper. 31 x 47 cm. [CL]. Cabinet des Dessins, UCAD

165. Sonia DELAUNAY. Design for Simultaneous Fabric no. 34, August 1924. Gouache on paper. 50 x 32.5 cm. [CL]. Cabinet des Dessins, UCAD

166. Sonia DELAUNAY. Colour plate from *Sonia Delaunay, Ses Peintures, ses Objets, ses Tissus Simultanés, ses Modes*, Librairie des Arts Décoratifs, [1925], pl. 2. Private collection.

This album consists of twenty large format colour plates by Sonia Delaunay, showing a selection of her fashion projects and designs; it was produced for publicity purposes to coincide with the 1925 Exposition des Arts Décoratifs, where she shared a stand with Jacques Heim on the Pont Alexandre III, and showed her recent work, including her first 'simultaneous fabrics'. Her friend André Lhote wrote in the preface: 'We are grateful to Sonia Delaunay for her unfailing inventiveness, for the light touch she has introduced into women's clothing, for the way she has so charmingly clothed the soft curves of the human form with geometric shapes, and for her assured and unusual colour contrasts.'

167, 168 and 169. Sonia DELAUNAY. Multi-coloured circles on black and grey squares. 1927. Simultaneous Fabric no. 194. Printed on silk chiffon. *c.* 50 cm. [CL]. Musée Historique des Tissus, Lyons.

170. Sonia DELAUNAY. Colour chart for Simultaneous Fabric no. 194. 1927. 21.5 x 24 cm. [CL]. Musée Historique des Tissus, Lyons.

'The quality of Sonia Delaunay's fabrics is not only to do with their geometry. If that was so, they would be easy to copy. Their charm comes from the wonderful harmony and delightful contrasts of the colours.... The most unusual or familiar of tones are brought together by a highly gifted eye. Sonia Delaunay's passion for colour does not need to be explained: it is plain to see.' (Luc Benoist, *Art et Décoration*, 1926/2, p. 143).

171. Sonia DELAUNAY. Harlequin check. 1926–27. Simultaneous Fabric. Printed on cotton velvet. 32 x 32 cm. Diagonal repeat. [CL]. Musée de la Mode et du Textile, UCAD, Paris. Shown at the Salon des Artistes Décorateurs, 1934. Reproduced in *L'Art Vivant*, February 1932.

See colour chart on same page.

172. Sonia DELAUNAY. Jacket made from harlequin check fabric shown in ill. 171. 1928. Print. [CL]. Musée de la Mode et du Costume, Paris. (photo C. Walter, Paris-Musées).

173. Sonia DELAUNAY. Colour chart for Simultaneous Fabric no. 189. 1927. 21.5 x 24 cm. [CL]. Musée Historique des Tissus, Lyons.

174. Sonia DELAUNAY. Overlapping scales. 1923–24. Simultaneous Fabric no. 11. Printed on silk chiffon. 55 x 30 cm. [CL]. Musée Historique des Tissus, Lyons.

See dress made with this fabric, ill. 175.

175. Sonia DELAUNAY. Colour plate from *Sonia Delaunay, Ses Peintures, ses Objets, ses Tissus Simultanés, ses Modes*, Librairie des Arts Décoratifs, [1925], pl. 16. 36 x 57 cm. Private collection.

See entries for ills 166 and 174.

176. Elise DJO-BOURGEOIS. Cotton print designs. Colour plate from *Répertoire du Goût Moderne*, Albert Lévy, 1928, vol. 1, pl. 31. [FU]. Bibliothèque Forney, Paris. Shown at the exhibition 'Toile Imprimée et Papier peint', Palais Galliera, 1928. Reproduced in *Paris 1928*, A. Calavas (Librairie des Arts Décoratifs), 1928, pl. 57, and in Clouzot, *Papiers peints et Tentures modernes*, Charles Massin, [1928], pl. 20.

Elise was married to the avant-garde architect and interior decorator Djo-Bourgeois, who collaborated with Mallet-Stevens on the decoration of the Villa Noailles at Hyères. The minimalist style and muted colours of her fabrics and carpets perfectly complemented the spareness of her husband's decorative schemes. When he needed less restrained textiles than his wife's prints, he turned to the richer textures of the fabrics woven by Hélène Henry. These two designers, together with Sonia Delaunay, were among the few decorative artists to represent France in the major exhibition of modern textiles which toured the United States in 1930–31.

177. Sonia DELAUNAY. Geometric design with stepped stripes and squares. 1924–25. Simultaneous Fabric. Print. 62 x 26 cm. [CL]. Musée de l'Impression sur Etoffes, Mulhouse.

178. Sonia DELAUNAY Geometric design with stepped stripes and squares. 1924–25. Simultaneous Fabric. Print. 72 x 34 cm. [CL]. Musée de l'Impression sur Etoffes, Mulhouse.

'People who think that the current movement will not last are wrong. At the beginning of each new season they announce in vain that geometric designs will soon go out of fashion, to be replaced with new ones based on old motifs, and they are very much mistaken: geometric designs will never go out of fashion because they have never been in fashion.' (Sonia Delaunay, 'L'influence de la peinture sur l'art vestimentaire', a lecture given at the Sorbonne, Paris, 27 January 1927).

179. Sonia DELAUNAY. Geometric design with stepped and parallel stripes. 1924. Simultaneous Fabric no. 46. Print. 63 x 26 cm. [CL]. Musée de l'Impression sur Etoffes, Mulhouse.

180. Sonia DELAUNAY. Geometric design with stepped and parallel stripes. 1926. Simultaneous Fabric no. 146. Cotton print. 29 x 50 cm. [CL]. Musée de l'Impression sur Etoffes, Mulhouse.

181 to 184. Sonia DELAUNAY. Directional motif with triangles and vertical dashes. 1928. Simultaneous Fabric no. 214. Print. 27 x 40 cm. [CL]. Musée de l'Impression sur Etoffes, Mulhouse.

'Today there is a new movement influencing fashion, as well as interior decoration, the cinema and all the visual arts...; we are just beginning to investigate the infinite possibilities of new colour relationships, which are the basis of the modern vision. We can expand, perfect, or develop them, people

other than us can even continue what we have begun, but we cannot go backwards.' (Sonia Delaunay, 'L'influence de la peinture sur l'art vestimentaire', lecture at the Sorbonne, 27 January 1927).

185. Sonia DELAUNAY. Large cellular motif with dots. 1928. Simultaneous Fabric no. 290. Print. 47 x 51 cm. HD. [CL]. Musée de l'Impression sur Etoffes, Mulhouse.

186. Sonia DELAUNAY. Colour chart for Simultaneous Fabric no. 899. 1929. 21.5 x 24 cm. [CL]. Musée Historique des Tissus, Lyons.

187. Anonymous. Geometric composition with ground of squares and rectangles. 1925. Print. 24 x 19 cm. [FU/CL]. Musée de l'Impression sur Etoffes, Mulhouse.

188. Anonymous. Five tulips on a geometric ground. 1930. Print. 76 x 80 cm. [FU]. Musée de l'Impression sur Etoffes, Mulhouse.

The design is typical of Lisières Fleuries fabrics. See entry for ill. 154.

189. Anonymous. All-over with lemons and leaves. 1930. Fabric design for Bianchini-Férier. Gouache on paper. 33 x 28 cm. [CL]. Musée Historique des Tissus, Lyons.

190. Anonymous. All-over with figures looking at posters. 1925–30. Schulz, Lyons. Printed on rayon crêpe. 15 x 13 cm. [CL]. Musée Historique des Tissus, Lyons.

191. Eric BAGGE. 'One Way' from *Créations Eric Bagge. Tissus. Velours. Impressions*, p. 22 of Lucien Bouix catalogue no. 41. 1927–28. 15 x 22.5 cm. [FU]. Bibliothèque Forney, Paris.

192. Eric BAGGE. 'One Way'. 1928. Lucien Bouix. Cotton print. 59 x 45 cm. [FU]. Musée de l'Impression sur Etoffes, Mulhouse.

Eric Bagge was a prominent exponent of a restrained modernism, and worked in many different areas of design. His reputation as an architect and decorator was made when several of his schemes were shown at the 1925 exhibition, in the Goldscheider, Fontanis, Stained Glass and 'French Embassy' pavilions, and on the Saddier stand. In 1927 he decorated one of the luxury suites on the passenger ship *Ile de France*, and was appointed by Mercier, a major Parisian manufacturer, as artistic director of his luxurious Champs-Elysées store, the Palais de Marbre. Bagge was particularly interested in surface decoration, designing wallpapers for Desfossés-Karth, and was responsible for the production of a collection of both printed and woven fabrics for Bouix (see ill. 191 and below) which were shown at the 1929 Salon des Artistes Décorateurs: they were all entirely geometric in design, in rather muted colours, and as a set are one of the greatest achievements of geometric Art Deco fabric design.

193. Eric BAGGE. 'Synthesis'. from *Créations Eric Bagge. Tissus. Velours. Impressions*, p. 18 of Lucien Bouix catalogue no. 41. 1927–28. 15 x 22.5 cm. [FU]. Bibliothèque Forney, Paris.

194. Eric BAGGE. 'Synthesis'. 1927–28. Lucien Bouix. Cotton print. 65.5 x 64 cm. [FU]. Musée de l'Impression sur Etoffes, Mulhouse. Reproduced in Clouzot, *Le Décor Moderne dans la Tenture et le Tissu*, Charles Massin, *c*. 1930, pl. 24.

195. Eric BAGGE. 'Fir Trees' and 'L'Age Heureux' from *Créations Eric Bagge. Tissus. Velours. Impressions*, p. 23 of Lucien Bouix catalogue no. 41. 1927–28. 32 x 25 cm. [FU]. Bibliothèque Forney, Paris.

196. Eric BAGGE. 'Elevation' and 'Frissons' from *Créations Eric Bagge. Tissus. Velours. Impressions*, p. 2 of Lucien Bouix catalogue no. 41. 1927–28. 32 x 25 cm. [FU]. Bibliothèque Forney, Paris.

197. Eric BAGGE. Swatch no. 9 from *Créations Eric Bagge. Tissus. Velours. Impressions*, p. 44 of Lucien Bouix catalogue no. 41. 1927–28. 19 x 12.5 cm. [FU]. Bibliothèque Forney, Paris.

The examples of textured weave here and on the following page should be compared with those of Hélène Henry (ills 216 to 230). It is clear that her commitment to high-quality work for interior decoration, supported by thorough and demanding research into the effect of different textures, was closely rivalled by the mass-produced and marketed fabrics of Eric Bagge and Lucien Bouix, his agent; Bouix worked in the rue du Mail, in the heart of the Paris's furnishings district, and became well known for the range and quality of his modern collections, which earned him the distinction of being chosen to be the exclusive distributor of Rodier's furnishing fabrics.

198. Lucien BOUIX. Swatch no. 17493 from *Tissus fantaisie: styles modernes et anciens*, p. 16 of catalogue no. 43. 1928–29. 16 x 9 cm. [FU]. Bibliothèque Forney, Paris.

199. Lucien BOUIX. Swatch no. 17503 from *Tissus fantaisie: styles modernes et anciens*, p. 15 of catalogue no. 43. 1928–29. 16 x 9 cm. [FU]. Bibliothèque Forney, Paris.

See entry for ill. 197.

200. Lucien BOUIX. Swatch no. 17585 from *Tissus fantaisie: styles modernes et anciens*, p. 13 of catalogue no. 43. 1928–29. 16 x 9 cm. [FU]. Bibliothèque Forney, Paris.

See entry for ill. 197.

201. Jean BURKHALTER. Abstract pattern. 1929. Made by Pierre Chareau. Print. 40 x 21 cm. HD. [FU]. Victoria and Albert Museum, London.

See examples of different colourways below.

202 and 203. Jean BURKHALTER. Colour variations for ill. 201. 1929. Print. Both *c.* 15 x 25 cm. [FU]. Langer-Martel Archives.

204. Atelier PRIMAVERA. Abstract pattern. 1926. Print. 81 x 67.5 cm. [FU]. Musée de l'Impression sur Etoffes, Mulhouse.

205. Jean BURKHALTER. Abstract pattern with range of colourways. 1928–30. Made by Metz, Amsterdam. Printed on cotton cloth or voile. [FU]. Langer-Martel Archives. Shown at the second U.A.M. exhibition, Galerie Georges Petit, Paris, 1931.

Joseph de Leeuw, proprietor of the Metz stores in Amsterdam, was a great champion of modernist decorative design, particularly textiles. He introduced himself to Sonia Delaunay at the 1925 Paris exhibition, and became her manufacturer when she gave up marketing her own work. He also opened up the Dutch market to prints by other designers committed to geometric modernism, notably Gerrit Rietveld and the Wiener Werkstätte, and French designers Elise Djo-Bourgeois (see ill. 176) and Jean Burkhalter, colleague of Pierre Chareau.

206. Jean BURKHALTER Geometric composition. 1924. Manufactured by Pierre Chareau. Printed on grey cotton. HD. [FU]. Langer-Martel Archives. Reproduced in *Les Arts de la Maison*, A. Morancé, vol. 3, 1924, pl. 8 and in Sonia Delaunay, *Tapis et Tissus*, Charles Moreau, 1929, Collection L'Art International d'Aujourd'hui, pl. 26.

This fabric was used to decorate the guest room at the studio of the sculptors Jean and Joël Martel on the rue Mallet-Stevens. Apart from their obvious artistic affinities, there was another reason for the choice: the Martels and Burkhalter were brothers-in-law.

207. Adrien GARCELON. *Inspirations, 80 compositions modernes en couleur*, Charles Massin, 1928, pl. 19. Colour plate. Bibliothèque Forney, Paris.

208. Adrien GARCELON. *Inspirations, 80 compositions modernes en couleur*, Charles Massin, 1928, pl. 8. Colour plate. Bibliothèque Forney, Paris.

209. Maurice and Adam VERNEUIL. *Kaléidoscope*, Albert Lévy, 1927, pl. 20. Colour plate. Bibliothèque Forney, Paris.

Maurice Verneuil, formerly an associate of Grasset and author of *La Plante et ses applications ornamentales* (1897–99), illustrates here the conversion of artists of the Art Nouveau period to geometricism; Benedictus followed suit with his *Relais* series.

210. Maurice and Adam VERNEUIL. *Kaléidoscope*, Albert Lévy, 1927, pl. 5. Colour plate. Bibliothèque Forney, Paris.

211. Maurice and Adam VERNEUIL. *Kaléidoscope*, Albert Lévy, 1927, pl. 18. Colour plate. Bibliothèque Forney, Paris.

212. Anonymous. Composition of M-shaped motifs. 1925–30. Printed on silk voile. Length: 35 cm. [CL]. Musée Historique des Tissus, Lyons.

213. Edouard BENEDICTUS. *Relais 1930*, Vincent, Fréal et Cie, 1930, pl. 13. Colour plate. Bibliothèque Forney, Paris.

'Benedictus was one of the exponents of floral decoration [see ill. 46 and following], and is now equally adept at creating designs with geometric motifs; his experiments have produced a new spare style, with pleasing results.' (*Mobilier et Décoration*, 1929/2, p. 22). These colour plates from *Relais*, published after his early death, show the extent of this conversion.

214. Robert BONFILS. 'Variations'. 1929. Bianchini-Férier. Woven silk rayon. 40 x 42 cm. Diagonal repeat. [FU]. Musée de la Mode et du Textile, UCAD, Paris. Reproduced in *Paris, 1929*, A. Calavas (Librairie des Arts Décoratifs), 1929, pl. 41.

This archetypal Art Deco geometric design was an unprecedented success. Interior decorators used it extensively, and Bardyère included it in his display at the Salon des Artistes Décorateurs of 1929; it was repeatedly published,

imitated, and even plagiarized; in 1990 it was even used on a quilt cover.

215. Robert BONFILS. 'Variations'. 1929. Design for ill. 214. Gouache on paper. 1929. 25 x 30 cm. [FU]. Musée Historique des Tissus, Lyons.

216. Hélène HENRY. 'Les Quartiers' (sometimes called 'Arabesques'). 1926. Woven cotton and rayon. 52 x 62 cm. [FU]. Musée de la Mode et du Textile, UCAD, Paris. Reproduced in *Echos des Industries d'Art*, August 1927; *Mobilier et Décoration*, 1927, p. 1 and 1929, p. 140.

This fabric, possibly commissioned by Joubert and Petit, was used by D.I.M., and then by Michel Dufet. As with Sonia Delaunay (see ill. 158), naturalistic motifs are the exception in the work of Hélène Henry, and only occur in her early designs (here a stylized leaf is clearly identifiable). True to her commitment to the progressive wing of decorative artists, she was a founding member of the Union des Artistes Modernes, which adopted all the principles of functionalism which she demanded of her own work, and which she consistently followed.

217. Hélène HENRY. 'Petals' (or 'Scales'). 1925. Woven fibranne and rayon. 18 x 16 cm. Musée de la Mode et du Textile, UCAD, Paris. Shown at the Exposition des Arts Décoratifs, Paris, 1925, in the music room of the 'French Embassy' decorated by D.I.M.

218. Hélène HENRY. 'Martel' (or 'Geometry'). 1927–28. Woven cotton and rayon. 81 x 42 cm. [FU]. Musée de la Mode et du Textile, UCAD, Paris. Shown at the Salon des Artistes Décorateurs, 1928. Reproduced in *Mobilier et Décoration*, 1928, p. 166 and 1929, p. 142; *Art et Industrie*, 1928, *The Ideal Home*, London, April 1929.

This weave was named after the modernist sculptors Jean and Joël Martel, who commissioned it as part of the decorative scheme of their villa and studio, designed by Robert Mallet-Stevens; its unusually large repeat made it very suitable as a wall covering. The sculptor twins were particularly fond of Hélène Henry's woven fabrics, and even had clothes tailored from them.

219. Hélène HENRY. 'Hens' (or 'Butterflies'). 1927–28. Cotton and rayon damask. 10 x 31 cm. [FU]. Van Melle Archives.

220. Hélène HENRY. 'Rectangles'. 1928–29. Woven cotton and rayon. 26 x 30 cm. [FU]. Musée de la Mode et du Textile, UCAD, Paris. Shown at the Salon d'Automne, 1929, and at the first exhibition of the U.A.M., in 1930. Reproduced in *Art et Décoration*, 1930/2, p. 64 and 1931/1, p. 11.

Although the museum inventory card attributes this design to Chareau, it is now accepted as the work of Hélène Henry, an attribution supported by her archives and contemporary publications. It is a variation of ill. 223.

221. Hélène HENRY. Detail of a curtain panel with a border of triangular motifs. 1929. Composite weave using cotton, twill, satin and bouclé satin threads; cotton and rayon. Repeat size: 65 cm. [FU]. Van Melle Archives.

222. Hélène HENRY. 'Broken Sticks'. 1927. Woven cotton and rayon. 50 x 32 cm. [FU]. Musée de la Mode et du Textile, UCAD, Paris. Reproduced in *Echos des Industries d'Art*, August 1927; *Mobilier et Décoration*, 1929/1, p. 142.

The work of Hélène Henry and Sonia Delaunay is united by the same precision of design, subtle balance of forms and colours, and emphasis on composition: their shared ideological and artistic principles led them both to join the Union des Artistes Modernes. Yet they worked in different worlds and were opposites in many ways: Sonia, the colour theorist, produced printed fabrics for the fashion industry, using traditional luxurious silk, while the craftswoman Hélène Henry wove furnishing fabrics on her own loom, in unobtrusive combinations of muted colours, using newly created artificial fibres. Their techniques could hardly be more different, but they represent the positive and negative of the same image; their shared modernist ideal.

223. Hélène HENRY. 'Rectangles'. 1928–29. Cotton and rayon. 31 x 31 cm. HD. [FU]. Van Melle Archives. Shown at the Salon d'Automne, 1929, and at the first exhibition of the U.A.M., in 1930. Reproduced in *Art et Décoration*, 1930/2, p. 64 and 1931/1, p. 11; *Mobilier et Décoration*, 1934, p. 354.

This highly abstract and sophisticated design was made with many variations of colour, motif and composition, including tone-on-tone patterns with monochrome rectangles. Variant of ill. 220.

224. Hélène HENRY. 'Bluebells'. *c.* 1925. Jacquard weave cotton and fibranne. 37 x 24.5 cm. [FU]. Van Melle Archives.

225. Hélène HENRY. 'Lattices'. 1926–27. Fibranne and rayon. 15 x 15 cm; HD. [FU]. Van Melle Archives. Shown at the Salon d'Automne, 1929. Reproduced in *Art et Décoration*, 1931/1, p. 10; *Mobilier et Décoration*, 1934, p. 352.

226 and 227. Hélène HENRY. 'Bricks', geometric motif; detail shown in ill. 227. 1925–30. Jacquard weave cotton. 41 x 120 cm. [FU]. Van Melle Archives. Shown at the Exposition des Arts et Techniques, Paris, 1937, in the U.A.M. pavilion.

This pattern was probably designed by Pierre Chareau; it was used by D.I.M. and by René Herbst, a close friend of Hélène Henry and godfather to her son.

228. Hélène HENRY. 'Spots'. 1925. Double Jacquard cotton weave. 30 x 30 cm. [FU]. Reproduced in *Art et Industrie*, September 1933. Van Melle Archives.

229. Hélène HENRY. Squares. 1927. Cotton and rayon. 26 x 26 cm; full woven width 80 cm. [FU]. Van Melle Archives. Shown at the Salon d'Automne of 1927 on the Eugène Printz stand.

'What marvellous use an artist like Madame Hélène Henry has made of this material [artificial silk]; with contrasts of shade and texture, a magical use of colour and great technical mastery she has achieved results of a truly eloquent restraint.' (Gaston Derys, *L'Art vivant*, February 1933).

230. Hélène HENRY. Geometric pattern. 1927–28. Cotton and rayon. Sample, 85 x 34 cm. [FU]. Van Melle Archives. Shown at the Salon d'Automne of 1929.

231. Ketty RAISIN (and/or Michel DUBOST). 'Lines and Lights.' 1925–35. Silk velvet. 63 x full woven width of 65 cm. [FU]. Musée Historique des Tissus, Lyons.

This is the only fabric in this book that demonstrates the influence of the Bauhaus weaving school ethos. It comes from the Dubost archives placed in the Lyons museum in 1975 at the time of the exhibition 'Les Folles Années de la Soie'. Undocumented before this date, it raises a number of questions: was it made by Michel Dubost, or more likely on stylistic grounds, by his wife Ketty

Raisin? The date of its manufacture is unknown. Where was it woven, and was it ever put into production, or did it remain a one-off experiment?

232. CHANEL. Abstract pattern. 1929. 'Tissus Chanel' printed on the selvedge. Screen print on wild silk. 48.5 x 58 cm. [CL]. Victoria and Albert Museum, London.

Coco Chanel chose several textile designers to work for her, all of whom were destined for success: Hélène Henry, who supplied her with 'kilometres of bouclé mohair fabric', Sonia Delaunay, from whom she bought a number of designs, and Iliazd (though he was probably not the designer of the Chanel examples shown here); he was an old friend and colleague of Sonia Delaunay, and a renowned typographer. Between 1927 and 1933 he was artistic and technical director of the Chanel fabric department.

233, 234 and 235. CHANEL. Abstract pattern in three different colourways. 1929. 'Tricots Chanel' printed on the selvedge. Silk-screen print on wild silk. *c.* 50 cm each. [CL]. Victoria and Albert Museum, London.

236. RODIER. Squares and rectangles with parallel lines. 1932. Black-and-white photo taken to register the design with the Conseil des Prud'hommes, 21 October 1932. Print. 7 x 8 cm. [FU/CL]. Paris Archives.

See entry for ill. 148.

237. RODIER. Triangles with dots and cross-hatching. 1932. Black-and-white photo taken to register the design with the Conseil des Prud'hommes, 9 August 1932. Print. 10.5 x 6.5 cm. [FU/CL]. Paris Archives.

'The current trend, with which we are not unfamiliar, and which we have responded to in our designs in a variety of imaginative ways, is for restrained colours and lines, and geometric patterns, avoiding severity with subtle areas of muted colours.' (P. Rodier, *Echos des Industries d'Art*, no. 25, August 1927, p. 10).

238 and 239. RODIER. 'Kashamoussa', from *Creations for Spring and Summer 1932*, commercial catalogue for Rodier's New York office. 23.5 x 51 cm. Ill. 239 shows the swatch card for the style illustrated. [CL]. Musée de la Mode et du Costume, Paris.

240. Anonymous. Geometric pattern with squares and dots. 1931. Artificial silk weave. 32.5 x 31.5 cm. [CL]. Victoria and Albert Museum, London.

241 and 242. Attr. RODIER. Geometric compositions. 1930–35. Marketed by Betty Joël. Woven. Ill. 241: 36 x 30.5 cm. HD. Ill. 242: 17 x 27.5 cm HD. [FU]. Victoria and Albert Museum, London.

The interior decorator Betty Joël was one of the most enthusiastic promoters of European Art Deco in Britain, together with Curtis Moffatt. Rodier fabrics similar to this example were available in her boutique, supporting this attribution.

243. Anonymous. Geometric composition with polygons filled with dots. 1931. Woven cotton and rayon. 30.5 x 23.5 cm. [FU]. Victoria and Albert Museum, London.

Possibly a Rodier design.

244. RODIER. Composition of four-sided shapes with geometric motifs. 1928. Black-and-white photo taken to register the design with the Conseil des Prud'hommes, 10 April 1928. Print. 21 x 15 cm. [FU/CL]. Paris Archives.

See entry for ill. 148.

245. RODIER. Geometric composition with discs and wavy lines. 1929. Black-and-white photo taken to register the design with the Conseil des Prud'hommes, 1 February 1929. Cotton voile embroidered with artificial silk. 8 x 6 cm. [FU/CL]. Paris Archives.

246. RODIER. Pattern of overlapping squares. 1928. Black-and-white photo taken to register the design with the Conseil des Prud'hommes, 10 April 1928. Print. 21 x 15 cm. [FU/CL]. Paris Archives.

247. RODIER. Geometric composition with polygons and spots. 1928. Black-and-white photo taken to register the design with the Conseil des Prud'hommes, 4 October 1928. Cotton voile embroidered with artificial silk. 8 x 6 cm. [FU/CL]. Paris Archives.

248. Edouard BENEDICTUS. *Relais 1930*, Vincent, Fréal et Cie, 1930, pl. 4. Colour plate. Bibliothèque Forney, Paris.

249. Anonymous. Interlocking blocks. 1928. Fabric design for Bianchini-Férier. Gouache on paper. 25 x 32 cm. [CL]. Musée Historique des Tissus, Lyons.

250. Georges VALMIER. *Album no, 1*, Albert Lévy, 1929–30, pl. 12. Colour plate. Bibliothèque Nationale de France, Département des Estampes.

Originally an ardent Cubist, Georges Valmier became one of the major French exponents of abstraction during the 1930s. This published collection of his work was a resource for many fabric and wallpaper designers; his wide-ranging graphic invention is reinforced by a remarkably free use of colour. It was his only decorative arts project, apart from the vast murals he painted for the S.N.C.F. pavilion at the 1937 exhibition.

251. Georges VALMIER. *Album no, 1*, Albert Lévy, 1929–30, pl. 10. Colour plate. B.N.F., Département des Estampes.

See previous entry.

252. Georges VALMIER. *Album no, 1*, Albert Lévy, 1929–30, pl. 3. Colour plate. B.N.F., Département des Estampes.

See entry for ill. 250.

253. Anonymous. Pastoral scene. 1928. Print. 25 x 40 cm. [FU]. Musée de l'Impression sur Etoffes, Mulhouse.

254. Anonymous. Leaping gazelle on a composite ground. 1934. Print. 40 x 39 cm. [FU]. Musée de l'Impression sur Etoffes, Mulhouse.

255. Jacques CAMUS. Colour plate from *Dessins*, A. Calavas (Librairie des Arts Décoratifs), 1929, pl. 18. Bibliothèque Forney, Paris.

In 1922 Jacques Camus, a painter, published an album of ornamental motifs entitled *Idées*; with his colleague René Crevel he founded Cactus, a business specializing in designs for printed fabrics and wallpapers. They were members

of the Société des Artistes-Décorateurs, where they showed their work regularly from 1920 onwards, as well as at important exhibitions such as the Exposition des Arts Décoratifs in 1925 and 'Toile Imprimé et Papier Peint' in 1928.

256. Boris LACROIX. Colour plate from *Dessins*, A. Calavas (Librairie des Arts Décoratifs), 1929, pl. 19. Bibliothèque Forney, Paris.

Lacroix began his career as a designer for Madeleine Vionnet, and his first interior decoration projects were private commissions for the couturière. He was primarily interested in larger scale furniture projects, and lighting in particular, and so produced relatively few textile designs. This page is cleverly laid out to show several print designs for fabric or paper, in a single colour scheme.

257. Anonymous. Pattern of planes on ground of sound waves. 1931. Fabric design for Bianchini-Férier. Gouache on paper. 12.5 x 12.5 cm. [CL]. Musée Historique des Tissus, Lyons.

258. Robert BONFILS. Shooting stars. 1930. Fabric design for Bianchini-Férier. Gouache on paper. 56 x 45 cm. [FU/CL]. Musée Historique des Tissus, Lyons.

A sample of fabric from this design is in the Musée des Arts Décoratifs, Paris.

259. Anonymous. Lighted cigarettes. 1930. Fabric design for Bianchini-Férier. Gouache on paper. 10.5 x 9 cm. [CL]. Musée Historique des Tissus, Lyons.

260. Anonymous. Cocktails. 1930. Coudurier, Fructus & Descher, Lyons. Woven silk satin. 18 x 9 cm; HD. [CL]. Musée Historique des Tissus, Lyons.

261. Anonymous. All-over with branches. 1929. Fabric design for Bianchini-Férier. Gouache on paper. 27 x 33 cm. [FU/CL?]. Musée Historique des Tissus, Lyons.

262. Alfred LATOUR. 'Shells'. 1929. Bianchini-Férier. Toile de Tournon. Print. 28 x 31 cm. HD. [FU]. Victoria and Albert Museum, London. Reproduced in *Paris 1930*, A. Calavas (Librairie des Arts Décoratifs), 1930, pl. 18; *Mobilier et Décoration*, 1932, p. 180.

The curators at the Victoria and Albert Museum mistakenly attributed this Toile de Tournon design to Dufy: there is no trade mark, but the graphic woodcut style does have similarities with his designs. After Dufy's departure from his firm, Charles Bianchini chose the painter, illustrator and engraver Latour as an appropriate replacement; as a member of the U.A.M, he followed a modernist aesthetic in keeping with the mood of the 1930s. It was a shrewd choice, as Latour's prints were still popular at the end of the 1940s. See note on the Toiles de Tournon, ill. 26.

263 and 264. Anonymous. Golfers. 1931–32. Coudurier, Fructus & Descher, Lyons. Artificial silk twill print. 12.5 x 10 cm. [CL]. Musée Historique des Tissus, Lyons.

Ill. 264 shows the full range of colourways for this print.

265. Paule MARROT. 'Little Houses'. 1925. Linoprint on cretonne, discharge printed. 12 x 10.5 cm; HD. [FU]. Marrot Archives.

Paule Marrot is in many ways the odd one out among the artists represented in this book; it may appear surprising that she is included in a book on Art Deco textiles, particularly since she only came to fame after the Second World War, and always stressed that she was not part of the Art Deco movement: 'You know what the decorative arts style was like in 1930. I didn't really dislike it,

nor was I against it, but it just didn't move me, and therefore had no influence on my work.' (*Revue de l'ameublement*, August 1964). This young woman who had trained at the Ecole des Arts Décoratifs was, however, well known in artistic circles (she was a protegée of Maurice Denis) and was far from an outsider. She exhibited at the 1921 Salon des Artistes Décorateurs, her fabrics were displayed at the 1925 exhibition, and in 1928 her talent was recognized with the award of the Blumenthal prize, joining other winners at the start of exceptional careers, such as René Buthaud, Louis Sognot, André Arbus and René Herbst. But her inspiration was different; when everyone else converted to geometricism, she continued to scatter her fabrics with bright bouquets of flowers, a throwback to the naive patterns which had ensured the success of the Atelier Martine not long before. She used this deliberately conventional subject matter to create a style stamped with her own determined personality. Marrot's fresh floral images brightened curtains and bed covers, and paradoxically in a decade dominated by functionalism, marked the revival of a once-rejected idea. Through her work, floral decoration not only survived competition with angles and straight lines, but ultimately flourished again in delightful profusion, to the pleasure of a public deprived of poetic fantasy.

266. Paule MARROT. 'Fruits'. 1933. Block print on percale. 33 x 42 cm. HD. [FU]. Reproduced in *Art et Décoration*, 1934, p. 313. Marrot Archives.

267. Paule MARROT. Harlequin print. 1934. Print. [CL]. Shown at the Salon des Artistes Décorateurs, 1934. Reproduced in *Art et Décoration*, 1934, p. 175. Marrot Archives.

The hexagonal (not diamond-shaped) motif of this 'harlequin' design suggests French rustic tiles. Paule Marrot may have chosen this geometric motif, very different from her usual style, in response to the prevailing functionalist trend. She may also have been deliberately attempting to imitate her fellow designer Sonia Delaunay (see ill. 171). Whatever the reason, she quickly realized that this style went against her instincts, and did not continue with the experiment.

268. Emile-Alain SEGUY. *Prismes*, Charles Moreau, 1931, pl. 15. Colour plate. 32 x 24 cm. Bibliothèque Forney, Paris.

See entry for ill. 11.

269. Anonymous. Floral and geometric all-over. 1930. Lisières Fleuries. Print. 81 x 76 cm. [FU]. Musée de l'Impression sur Etoffes, Mulhouse.

The very large repeat size and exceptional number of colours (over twenty) were made possible by the newest technical advances, while the ultra-geometric design reflects the influence of current Paris fashions.

270. Anonymous. Stylized flowers and leaves on a geometric ground. 1929. Print. 44 x 33 cm. [FU]. Musée de l'Impression sur Etoffes, Mulhouse.

This kind of stylization recalls the Viennese graphic style, typified by the work of Dagobert Peche. The Austrian pavilion at the 1925 exhibition widened the influence of the Wiener Werkstätte aesthetic beyond the small circle of Parisian interior decorators who had responded to it before the First World War, including Landry, Süe, Poiret, and Mallet-Stevens (see also ill. 273).

271 and 272. Anonymous. Modernist stripes. 1928. Print. 16 x 65 cm. [FU]. Musée de l'Impression sur Etoffes, Mulhouse.

273. Anonymous. Stylized flowers and leaves. 1930. Print. 62 x 64 cm. [FU]. Musée de l'Impression sur Etoffes, Mulhouse.

See entry for ill. 270.

274. Anonymous. Stylized leaves. 1934. Print. 58 x 46 cm. [CL]. Musée de l'Impression sur Etoffes, Mulhouse.

An early example of the kind of motif fashionable in 1935–40.

275. Anonymous. Frieze of geometric toucans. 1934. Print. 30 x 42 cm. [FU]. Musée de l'Impression sur Etoffes, Mulhouse.

276. Anonymous. Naturalistic palm leaves. 1931. Coudurier, Fructus & Descher, Lyons. Printed on 'Egyptian crêpe'; silk and gold thread. 42 x 60 cm. HD. [CL]. Musée Historique des Tissus, Lyons.

277. Anonymous. Pattern of rectangles and diagonal stripes. 1933. Print. 51 x 42 cm. [FU]. Musée de l'Impression sur Etoffes, Mulhouse.

The small fabric-printing establishments benefited from the recession as they competed with the big manufacturers in northern France and in the Lyons area; their much lower cost prices enabled wide distribution of prints like these, imitating the effect of weaving with a skilful design and the use of textured cloth. See similar effects in ills 278 and 279.

278. Anonymous. Geometric composition inspired by leaves. 1934. Print on textured cotton cloth. 37 x 61 cm. [FU]. Musée de l'Impression sur Etoffes, Mulhouse.

See entry above, and below.

279. Anonymous. Geometric composition with stripes and four-sided shapes. 1933. Print on textured cotton cloth. 68 x 64 cm. [FU]. Musée de l'Impression sur Etoffes, Mulhouse.

The skill here in the handling of an unusual idea is outstanding; this print is a remarkable for the range of geometric motifs within the shapes, and the brilliantly achieved effect of woven cloth. See note for ill. 277.

280. Anonymous. Abstract geometric composition. 1934. Print. 39 x 42 cm. [FU]. Musée de l'Impression sur Etoffes, Mulhouse.

281. Anonymous. Abstract geometric composition. 1934. Print. 37 x 42 cm. [FU]. Musée de l'Impression sur Etoffes, Mulhouse.

282. Anonymous. Geometric composition with perspective effect. 1931. Print. 80 x 63 cm. [FU]. Musée de l'Impression sur Etoffes, Mulhouse.

283. Attr. Jean LURÇAT. Fabric used to cover an armchair by the Lyons cabinetmaker Krass. 1930–35. Cotton weave. [AM]. Galerie De Vos, Paris.

This fabric is probably not by Hélène Henry, whose work is well documented; it is closer to the modernist designs of Jean Lurçat, who worked with Pierre Chareau, notably on the 'Maison de Verre'; he later designed carpets as part of the decorative scheme at Marie Cuttoli's Galerie Myrbor, and in the 1950s went on to become undisputed leader of the revival in modern carpet design.

284. Jean LURÇAT. Print used as a wall covering in a decorative scheme by Pierre Chareau. Colour plate from Henri Delacroix, *La Décoration Moderne dans l'Intérieur*, S. De Bonadona, 1929, pl. 15. [FU]. Bibliothèque Forney, Paris.

285. Emile-Alain SEGUY. *Prismes*, Charles Moreau, 1931, pl. 28. Colour plate. 32 x 24 cm. Bibliothèque Forney, Paris.

286. Marianne CLOUZOT. Fabric swatches for swimwear (mounted in her own album). 1937–38. Designed for the couturier Jacques Heim. Printed jersey. 42 x 50 cm. [CL]. M. Clouzot Archives.

287. Elsa SCHIAPARELLI. Detail of an evening dress with butterfly motif. Summer 1937. Satin print. [CL]. Musée de la Mode et du Textile, UFAC, Paris.

288. Anonymous. Detail of a scarf with geometric design. c. 1920. Printed silk velvet. [CL]. Langer-Martel Archives.

Printed by hand using stencils and very thick inks, including gold. This fragment belonged to Jean Burkhalter, but the design is not characteristic of his own work.

289. Anonymous. Geometric composition with floral motif. 1924–25. Made by Becker, Paris. Printed with metallic pigments on silk panne velvet. 49 x 38 cm. [FU]. Musée de la Mode et du Textile, UCAD, Paris. Shown at the Exposition des Arts Décoratifs, Paris, 1925.

290. Anonymous. Stem of stylized palmettes. 1932. Truchot. Artificial silk damask. Symmetrical motif, HD. [FU]. Prelle Archives.

The forms are derived from ancient Minoan motifs, made popular by the discoveries of Arthur Evans at Knossos, towards the end of the 1920s.

291. Maurice DUFRENE. Interlinked curls of ribbon. 1925–30. Cotton and rayon weave. 12 x 16 cm. [FU]. Musée de la Mode et du Textile, UCAD, Paris.

292. Michel DUBOST. 'Rhythm'. Decorative panel. 1936. Cotton and silk samit (weft-faced twill). 108 x 66 cm. [FU]. Musée Historique des Tissus, Lyons. Shown at the Exposition des Arts et Techniques, Paris, 1937 (Pavillon du Lyonnais).

THE LATE PERIOD (1931–45)

293. Anonymous. Geometric composition with curved, diagonal and straight lines. 1935. Printed on glazed textured cotton. 60 x 43 cm. [FU/CL?]. Musée de l'Impression sur Etoffes, Mulhouse.

This early optical design looks forward the Op Art experiments of the 1960s. As far as is known, Elise Djo-Bourgeois was the only artist in the 1930s to experiment with this type of avant-garde design. See also ill. 295.

294. Attributed to Alfred LATOUR. Calligraphic flourishes. 1942. Fabric design for Bianchini-Férier. Gouache on paper. 28 x 33 cm. [CL]. Musée Historique des Tissus, Lyons.

Classic Art Deco has already been left behind with this 'penstroke' image; it is probably by Alfred Latour, known for his ornamental typography projects,

particularly those for Debergny-Peignot in the Cassandre period: 'Having established the very individual flourish of his typographic designs, Alfred Latour has just tried the same experiment, equally successfully, on printed fabric.' (*Mobilier et Décoration*, 1932, p. 180, which shows two similar designs by Latour for Bianchini). See entry for ill. 262.

295. Anonymous. Trompe-l'oeil pattern. 1935. Print. 31 x 33 cm. [CL]. Musée de l'Impression sur Etoffes, Mulhouse.

A similarly unconventional approach distinguishes this couture fabric; the illusion of relief is brilliantly achieved with the clever interplay of parallel bands and ovals. See entry for ill. 293.

296. Anonymous. Irregularly spaced motif of stylized tulips. 1944–45. Bianchini-Férier. Gouache. 33 x 32 cm. [CL]. Musée Historique des Tissus, Lyons.

This is another good example, not of the collapse of Art Deco, but of a design based on the search for new ideas and reference points, and the prospect of radical change.

297. Anonymous. Fans, including a bullfight motif. 1938. Coudurier, Fructus & Descher, Lyons. Printed on artificial silk crêpe. 19 x 10.5 cm. HD. [CL]. Musée Historique des Tissus, Lyons.

298. Anonymous. Rear windows. 1938. Coudurier, Fructus & Descher, Lyons. Printed on artificial silk satin. 37 x 26 cm. Repeat drops by a third in each row. [CL]. Musée Historique des Tissus, Lyons.

A humorous comment on the craze for shadow plays of a few years earlier.

299. Anonymous. New leisure pursuits, depicted in cartoon-strip style. 1937. Mechanically embroidered. Rayon with gold thread highlights. 18 x 31 cm. [CL]. Musée Historique des Tissus, Lyons.

The date has been established by comparison with a swatch from the same pattern series, depicting 'Arts and Crafts', taking its cue from the 1937 Paris Exhibition.

300. Paule MARROT. 'Hot Sun'. 1938. Screen print on percale. 59 x 41 cm. [FU]. Marrot Archives.

301. Paule MARROT. Tulips. 1937. Screen print on percale. 35 x 40 cm. HD. [FU]. Marrot Archives.

302. Paule MARROT. Butterflies. 1936. Block print on percale. 15 x 20 cm. HD. [FU]. Marrot Archives.

303. Paule MARROT. Hot air balloons. 1938–39. Screen print on glazed percale. 46 x 42 cm. HD. [FU]. Marrot Archives.

304. Paule MARROT. 'The Happy Isle'. 1941. Print. [FU]. Marrot Archives.

305. Madeleine LAGRANGE. Trades. Pre-1943. Brochier, Lyons. Print. 52 x 45 cm. [FU]. Musée de la Mode et du Textile, UCAD, Paris. Shown at the exhibition 'Soieries Lyonnaises', Pavillon de Marsan, 1943.

Like most of the decorative artists of her generation, Madeleine Lagrange studied at the Beaux Arts and the Ecole des Arts Décoratifs. In 1932–33 she became artistic consultant to Coudurier, Fructus & Descher in Lyons, for whom she designed exclusively floral motifs, mostly for prints. She assisted Porteneuve with the decoration and mounting of the 1943 exhibition, where she showed this fabric, which – a sign of the times – reflected the ideology of the Vichy regime. She also collaborated with Leleu the following year on the design of a fabric, manufactured by Bianchini-Férier, to be used on the steamship *Maréchal Pétain*. 'She likes lavish effects, unrestrained mixtures, generous lines and strong colours, although without straying into any of the excess and detail which are no longer fashionable.' (*Art et Décoration*, 1934, p. 269).

306. Anonymous. Travel and tourist attractions. 1939. Coudurier, Fructus & Descher, Lyons. Printed on silk crêpe. 38 x 46 cm. HD. [CL]. Musée Historique des Tissus, Lyons.

While ill. 299 wholeheartedly celebrates the newly won leisure of the majority, the design of this fabric pictures the alluring, cultured tourist destinations accessible to the privileged classes, rather than 'annual holiday' camping.

307. Suzanne JANIN. Oriental hunting scene. Before 1943. Combier et Cie, Lyons. Silk lamé damask. 38.5 x 28 cm. [FU]. Musée de la Mode et du Textile, UCAD, Paris. Shown at the exhibition 'Soieries Lyonnaises', Pavillon de Marsan, 1943.

This fabric, the following two, and ill. 305 were all shown at the Musée des Arts Décoratifs in 1943; the retrospective exhibition concentrated on the twentieth century up to 1925, date of nos. 202–246 in the exhibition. However, a few more recent productions such as these were shown ex-catalogue, and subsequently entered the museum's collections.

308. DESPIERRE. 'Amazons'. Pre-1943. Ducharne. Woven rayon. 77 x 65 cm. [CL]. Musée de la Mode et du Textile, UCAD, Paris. Shown at the exhibition 'Soieries Lyonnaises', Pavillon de Marsan, 1943.

309. MARGIRIER & BERMOND. 'Valses de France'. Pre-1943. Algoud, Lyons. Artificial silk damask. 105 x 70 cm. [CL]. Musée de la Mode et du Textile, UCAD, Paris. Shown at the exhibition 'Soieries Lyonnaises', Pavillon de Marsan, 1943.

Here the colours are hand-painted, not woven or printed, and do not follow the repeat pattern; this creates a greater variety of image and colour, and gives the design the effect of a charcoal drawing with watercolour highlights. Is it the opposite of ill. 305, which celebrates work, or is it fundamentally an expression of the same ideology? Either way, this image of dance intended for the haute couture market blithely ignores the privations of the majority of the French people at this period.

310. Anonymous. Sea and waves. 1939. Coudurier, Fructus & Descher, Lyons. Printed on artificial silk. 35 x 50 cm. (the sample does not show the full height of the repeat). [CL]. Musée Historique des Tissus, Lyons.

INDEX

Figures in *italics* refer to illustration numbers

FURTHER READING

STUDIES AND MONOGRAPHS
(alphabetically, by author)

BARON, Stanley and DAMASE, Jacques, *Sonia Delaunay: the Life of an Artist*, London and New York, 1995

BAYER, Patricia, *Art Deco Interiors*, London and New York, 1990

BENOIST, Luc, *Les Tissus, la tapisserie, les tapis*, Paris, 1926

BRUIGNAC-LA HOUGUE, Véronique de, *Paule Marrot*, Paris, 1996

CLOUZOT, Henri, *Papiers peints et tentures modernes (Toiles et cretonnes imprimées)*, Paris, [1928]

CLOUZOT, Henri, *Le Décor moderne dans la tenture et le tissu*, Paris, [1930]

DAMASE, Jacques, *Sonia Delaunay: Fashion and Fabrics*, London and New York, 1991

FANELLI, Giovanni and Rosalia, *Il tessuto Art Deco e anni Trenta: disegno, moda, architettura*, Florence, 1986

MELLER, Susan and ELFFERS, Joost, *Textile Designs: 200 Years of Patterns for Printed Fabrics arranged by Motif, Colour, Period and Design*, London, 1991

MOUSSINAC, Léon, *Etoffes imprimées et papiers peints*, Paris, 1924

MOUSSINAC, Léon, *Etoffes d'ameublement tissées et brochées*, Paris, 1925

PEREZ-TIBI, Dora, *Dufy*, trans. Shaun Whiteside, London and New York, 1989.

SCHOESER, Mary, *Fabrics and Wallpapers* (*20th-Century Design* series), London, 1986

SCHOESER, Mary and DEJARDIN, Kathleen, *French Textiles, from 1760 to the Present*, London, 1991

TOURLONIAS Anne and VIDAL Jack, *Raoul Dufy, L'oeuvre en soie*, Avignon, 1998

EXHIBITION CATALOGUES
(in chronological order)

Exposition internationale des Arts Décoratifs et industriels modernes. Paris 1925. Rapport général, vol. VI, *Classe 13: Art et Industrie des Textiles*, Paris, 1927.

L'Art de la Soie, Paris, 1927. Exhibition at the Musée Galliera, Paris.

Toile imprimée et Papier peint, Paris, 1928. Exhibition at the Musée Galliera, Paris.

Soieries modernes d'ameublement, Lyons, 1934. Exhibition at the Ecole de Tissage, Lyons.

Soieries lyonnaises de 1800 à nos jours. Tissus pour la robe, la mode, l'ameublement, Paris, 1943. Exhibition at the Pavillon de Marsan (Musée des Arts Décoratifs), Paris.

Sonia Delaunay. Etoffes imprimées des années folles, Mulhouse, 1971. Exhibition at the Musée de l'Impression, Mulhouse.

Raoul Dufy, créateur d'étoffes, Mulhouse, 1973. Exhibition at the Musée de l'Impression.

Les folles années de la soie, Lyons, 1975. Exhibition at the Musée Historique des Tissus, Lyons.

Raoul Dufy, créateur d'étoffes, 1910–1930. Paris, 1977. Exhibition at the Musée d'Art Moderne de la Ville de Paris.

Sonia Delaunay. Dessins. Exhibition at the Nederlands Textielmuseum, Tilburg, 1988.

Raoul Dufy, La passion des tissus, Paris, 1993. Exhibition at the Grenier à Sel, Honfleur.

Tisserands de légende: Rodier et Chanel à Bohain, A.S.P.I.V., St Quentin, 1993. Exhibition at the Abbaye de Royallieu, Compiègne.

PICTURE CREDITS